Glenn Leggett

and

Russelle Jones Leggett

PATRONS DESPITE THEMSELVES:

Taxpayers and Arts Policy

A Twentieth Century Fund Report

ALAN L. FELD
MICHAEL O'HARE
J. MARK DAVIDSON SCHUSTER

New York University Press
New York and London
1983

Copyright © 1983 by the Twentieth Century Fund, Inc.

Library of Congress Cataloging in Publication Data

Feld, Alan L.
Patrons despite themselves.

"A Twentieth Century Fund report."
Includes bibliographical references and index.
1. Federal aid to the arts—United States. 2. United
States—Cultural policy. 3. Income tax—United States
—Deductions—Charitable contributions. 4. Corporations
—Taxation—United States. I. O'Hare, Michael, 1943—
II. Schuster, J. Mark Davidson, 1950—
III. Twentieth Century Fund. IV. Title.

NX735.F45 1983 343.7305'232 83-2234
ISBN 0-8147-2572-4 347.3035232

Manufactured in the United States of America

Clothbound editions of New York University Press books are Smyth-
sewn and printed on permanent and durable acid-free paper.

To our parents

CONTENTS

TABLES AND FIGURES

x **TABLES AND FIGURES**

FOREWORD

The Twentieth Century Fund has had a long and deep interest in public policy toward the arts. Initially that interest was sparked by August Heckscher, my predecessor as director, who, as special consultant on the arts to President Kennedy, had been an advocate of public funding for the arts. Thus, almost twenty years ago the Fund sponsored a proposal for a study by William J. Baumol and William G. Bowen that resulted in *Performing Arts: The Economic Dilemma*, an enormously influential analysis that built support for direct public subsidies to the arts and artists. Once government funding burgeoned in the 1970s, the Fund decided to examine its effects. Consequently, we sponsored a series of policy studies analyzing different aspects of subsidies, among them Dick Netzer's *The Subsidized Muse*, which was a critical and comprehensive examination of direct subsidies, and Karl E. Meyer's *The Art Museum: Power, Money, Ethics*, which focused on the changes in that particular form of arts institution.

This new Fund Report, *Patrons Despite Themselves: Taxpayers and Arts Policy*, is an analysis of indirect subsidies, which of course were an important source of support for the arts—and

still far exceed the amounts provided by direct subsidies—long before the establishment of the National Endowment for the Arts and programs for support of the arts in states and cities. There are a number of forms of indirect subsidies—property tax exemptions and income tax deductions loom particularly large—and once the Trustees of the Fund approved the notion of a series on public policy on the arts, the staff began searching for a project on this least analyzed but very significant source of support.

A short time later, I was approached by Michael O'Hare, then an assistant professor of urban studies at MIT and now lecturer in public policy at Harvard's John F. Kennedy School of Government, who proposed just such a study in collaboration with Alan L. Feld, professor of law at Boston University Law School, and J. Mark Davidson Schuster, lecturer in urban studies and planning at MIT. Their range of knowledge—in public policy, taxation, and not-for-profit institutions—seemed suited to an investigation of indirect subsidies and the implications of changes in the tax laws on institutions and artists who were the recipients of subsidies.

I believe that their work justifies our investment in them. They have provided a well-grounded and detailed description of how the tax system works as it relates to the arts, demonstrating how indirect subsidies affect the allocation of resources, which they contend is often to the detriment of the best interests of the arts and the tax-paying public. The authors have carefully analyzed the benefits of indirect subsidies, which permit private donors to decide which arts activities merit government support, and have looked at the benefits of other systems, such as centralized direct public support. The results of their analysis are particularly important in a period in which changing tax laws, particularly the reforms made by the Reagan administra-

tion, are having an effect upon arts institutions, an effect with as yet unknown consequences.

We are grateful to the authors for their diligence and perseverance. Their work adds to our previous studies and should enrich the continuing debate on public policy toward the arts, a debate for which, I am proud to say, the Fund series serves as a major source of information.

M.J. ROSSANT
Director
Twentieth Century Fund

PREFACE

The present study originated a decade ago in a chance remark by a trustee of the Boston Museum of Fine Arts to Michael O'Hare (during his employment as a planning consultant to the museum): ". . . but, Mr. O'Hare, if you do all those things, they'll all just come here in droves and be all over the place!" This attitude toward the public was not universal among the museum staff or trustees, but it is certainly not an unknown opinion for someone in that environment to hold. How is this possible in a public institution heavily subsidized by government aid?

Alan L. Feld's incautious agreement to help write a short paper on museum investment policy and J. Mark Davidson Schuster's arrival at MIT (where O'Hare was then teaching) created a team with the necessary skills to look systematically at this question, focusing on how government policies of support for the arts affect the arts' condition independently of the amount of subsidy provided. A small grant from the Bemis Fund of the MIT Laboratory of Architecture and Planning allowed us to discover that most of that government aid—in the form of indirect tax support—had never been adequately identified or studied. The Twentieth Century Fund, and particularly its director, M.J.

Rossant, aware from previous experience that interesting and policy-relevant results could be obtained from analysis of cultural policy, were eager to undertake a study of indirect tax support as a complement to its earlier studies of the arts; the Fund, therefore, provided the necessary financial support and—probably more valuable—a critical audience and timely supervision.

The authors are listed alphabetically. Although we would offer the reader an approximate division of our contribution to the work at hand, our collaboration has blurred our specializations so that we cannot even identify who wrote the first draft of a very large part of the manuscript.

Other people and organizations have helped in ways that we can describe specifically. Many arts institution officials spent time and thought in interviews, and many colleagues patiently allowed us to try out our arguments and conclusions over dinners, at seminars, and in corridors. John Coolidge's encouragement of our research was particularly appreciated in view of his lifetime of experience training several generations of America's art museum curators (at Harvard) and as trustee and president of the Boston Museum of Fine Arts. Coolidge's ability to combine exemplary connoisseurship with the hope that "they" *would* all come in and "be all over the place" was an important assurance that we were working on something worthwhile. Lawrence Bacow, Marcia Marker Feld, William Wheaton, and Richard Zeckhauser read and commented upon major portions of the manuscript. Naturally, none of what we present here necessarily reflects the views of these colleagues, nor are any remaining errors theirs.

For the data on philanthropic behavior, we are grateful to the Inter-University Consortium for Political and Social Research, which has requested that we insert the following statement:

The data utilized in this study were made available in part by the Inter-University Consortium for Political and Social Research. The data for a

National Study of Philanthropy were originally collected by James N. Morgan under a grant from the Commission on Private Philanthropy and Public Needs. Neither the original collectors of the data nor the Consortium bear any responsibility for the analyses or interpretations presented here.

We are similarly grateful to the Associated Councils of the Arts (now the American Council for the Arts), which provided the tapes of the *American and the Arts* survey data, conducted for ACA by the National Research Center of the Arts. Once again, the analyses and interpretations are ours.

Carol Barker, at the Fund, perceived the importance of this study at its inception and held to that perception even through our episodes of clouded vision. Cody Barnard and Beverly Goldberg plunged into the penultimate draft and reorganized and slimmed it. If our readers could compare the book at hand with the version with which these editors began, they would be as grateful to them as we are. Beth Frey was invaluable as our administrative assistant extraordinaire. If the authors are the parents of the book, Beth is certainly its godmother. Early in this study, Kerry Vandell, Dan O'Reilly, and Matthew Thall furnished invaluable research assistance.

Many people among our sources explicitly discouraged us from proceeding with this project because "if you write about this system so people understand it, it will go away, and where will the arts be then?" These people no doubt were expressing a view that others will hold. In response, we would make two points:

1. We are enthusiastic advocates for the arts. We think the government should play a significant role in funding culture, and we think more people should enjoy more and better presentations of the fine arts. But we are democrats before we are art enthusiasts. If taxpayers are paying more to support the arts than they would if they understood the situation, then public

support should be reduced until the public is persuaded to pay more.

2. In any case, we do not think the facts will hurt the arts at all. We think much of the failure in expanding the arts audience in the past decade has resulted from ambivalent commitment to this goal on the part of arts institutions (partly due to the funding structure we describe in this book). Although we do not claim to have shown this by our research, we believe the arts to be habit-forming, vigorous, marketable, and widely perceived to be worth having.

In any event, we hope that the present study will occasion a reconsideration of how we distribute most of our public art subsidy money.

<div align="right">

Alan L. Feld
Michael O'Hare
J. Mark Davidson Schuster

</div>

PATRONS DESPITE THEMSELVES:
Taxpayers and Arts Policy

1

INTRODUCTION

This book is about art institutions and philanthropy and their relationship to government policy. Public discussion of these topics more often is marked by strong feelings than by rational thinking and testing.

A few decades ago our subject would have seemed trivial: at that time, artists and arts institutions were generally perceived as private. Most arts institutions were managed by individuals selected from outside government, and they were directly supported by money from admissions and private contributions. Furthermore, the private character of these arts institutions was, as now, considered essential to successfully nourishing a wide range of cultural activities. Government intervention would supposedly undermine the vitality of cultural programs.

Many people involved in the arts, of course, long have looked to the government, especially the federal government, for financial help. They insisted that government grants be made without strings, thus, they asserted, preserving their artistic independence. In the 1930s, the national WPA program employed artists directly as part of the New Deal economic recovery program. The motivation for this program was not, however, that

the arts deserved special government help, but that artists were among the many people to whom government should supply employment in a time of economic crisis. Federal Project Number One included five arts programs: the Federal Art, Music, Theater, Writers, and Historical Records Projects.[1]

In the past twenty years direct government support of the arts has been revived—and rapidly expanded—but in an entirely different form: grant and subsidy programs at the federal, state, and local levels, targeted specifically to arts institutions and sometimes to artists. Current Reagan administration proposals may result in a leveling off, even a contraction, of direct government support for artists and arts institutions.

Enough money has been involved in these direct government aid programs to warrant critical scrutiny, most recently in Dick Netzer's study, *The Subsidized Muse*, an overall assessment of direct aid to the arts in the United States.[2] Other important studies have focused on the importance of direct government subsidy for particular segments of the arts: museums, Karl Meyer's *The Art Museum: Power, Money, Ethics*, and Nathaniel Burt's *Palaces for the People: A Social History of the American Art Museum*; symphony orchestras, Philip Hart's *Orpheus in the New World*; the performing arts, Thomas Moore's *The Economics of the American Theatre*, Glen Withers and C. David Throsby's *The Economics of the Performing Arts*, and, of course, the classic in the literature of cultural policy analysis, Baumol and Bowen's monumental 1966 study *Performing Arts: The Economic Dilemma*.[3]

This book attends to an important gap in that combined research: understanding the indirect government support that flows like an underground river through the tax system. Without directly writing a check drawn on the general treasury, the government provides the arts with about two-thirds of all the government support that they receive.

If the underground river flowed pure and abundant every-where, it would not be interesting. But some aquifers are easy to tap, and some regions are parched; and in every case, the resource is available only at a cost. Similarly, the particular qual-ities of tax support mechanisms affect the arts profoundly. The tax laws as they affect the arts are subject to change, and our analysis suggests that some important changes should be made. Accordingly, our approach is to consider the indirect support system as malleable and subject to redesign by a purposeful legislature.

The dramatic changes in the tax law enacted in 1981 brought about some redesign, although their effect on the arts has been viewed—mostly with alarm—only as an afterthought to the leg-islative process. Some of the 1981 tax changes dealt directly with charities, and their impact on the arts could reasonably be an-ticipated. One example concerns the expansion of the maxi-mum charitable contribution deduction for corporations from 5 to 10 percent of their taxable income. As discussed later, how-ever, this provision will likely have only modest effects on cul-tural institutions, since relatively few corporations were con-tributing anything like the old maximum.

Of far greater significance for the arts are provisions that do not on their face deal with charities, much less with cultural institutions. The centerpiece of the Reagan administration's tax plan consisted of across-the-board individual income tax reduc-tions. Such reductions have two effects on the tax incentives to contribute to charities generally and arts institutions in partic-ular. First, they reduce the value to the donor of the tax de-duction for charitable contributions, which would tend to re-duce the number of contributions and amounts contributed. Second, they increase the net after-tax income available to in-dividuals: with more disposable income, individuals may en-large the amount of their contributions. As we argue later, we

believe that the net result is to reduce the incentive for giving to arts institutions.

Another part of the Reagan tax package reduced estate taxes. The 1981 tax act enlarged the maximum marital deduction so that a surviving spouse can take the decedent's estate free of federal estate tax. Other changes enlarge the amount exempt from estate tax for all estates and reduce the top estate tax bracket from 70 to 50 percent. Again, the effect of these tax changes on arts institutions will likely be negative because the tax savings from bequests to museums and performing arts groups have been reduced. These adverse effects were not widely discussed prior to enactment of the tax legislation, and they highlight the impact of tax changes on the arts. This book, we hope, will make future tax law revisions less of an unknown for arts institutions.

Although previous research has not analyzed government policy on indirect aid, its importance has long been recognized. August Heckscher, in his 1962 report to President Kennedy recommending the creation of an "Advisory Arts Council" and a "National Arts Foundation," made numerous recommendations for changes in tax law, aimed at increasing government assistance to the arts.[4] Several reports released about the time the National Endowment for the Arts was created argued for an increased use of indirect subsidies, primarily to counteract fears of overcentralization of the new government support of the arts.[5] More recently, both Meyer and Netzer have reminded us of the enormous but largely hidden influence of indirect aid mechanisms.[6]

In fact, indirect aid to the arts includes the largest and oldest part of government art subsidies—the millions of dollars the arts and other nonprofit charitable organizations receive through various preferences in federal, state, and local tax laws. Since long before the WPA's Federal Project Number One—since Co-

lonial times, in the case of the property tax exemption—these indirect subsidies have benefited the arts, and now account for two to three times more support than all direct programs. Their importance is illustrated in Table 1.1 with a representative museum budget, first as usually presented, and then with the indirect aid amounts specified and shown by category. In the aggregate, the fraction of this museum's support from government subsidy turns out to be 31 percent rather than 9 percent, an underestimation of more than three to one in the conventional budget presentation.

Our first purpose is to describe indirect government support for the arts, quantifying it when possible. Our second purpose is to illustrate the effects of putting such a large fraction of government support through the particular decisionmaking system that has been chosen, or has evolved, for it. We will see that the effects of this choice are important—independently of the amount of support that is provided—and not always beneficial for society or for the arts. There are other ways to help the arts that would serve both better.

There are several reasons why indirect aid to the arts has not enjoyed widespread public recognition. First, only within the past dozen years has tax expenditure analysis—a method of systematically identifying and estimating the effect of many of the financial forms of indirect aid described above—been assigned a formal role in the budget process. The work of Professor Stanley Surrey, culminating in the publication of his *Pathways to Tax Reform*, has led to the inclusion of this analysis in the federal budget.[7] However, Surrey's work is controversial, and many economists and tax experts express reservations about his theories.[8] In brief, his analysis views taxes foregone by the government for reasons unrelated to the purpose of the tax itself as carrying the same fiscal and incentive effects as direct government expenditures.

Table 1.1
Representative Museum Budget
Receipts (in thousands of dollars)

	Conventional budget		Revised budget	
	Private	*Public*	*Private*	*Public*
A. Operating revenues				
Admissions	374		374	
Tuitions, other fees	686		686	
Sales (and parking)	1,019		1,019	
Total	2,080		2,080	
B. Nonoperating revenues				
Investment income	1,872		1,872	
Gains on disposition of property	208		208	
Total	2,080		2,080	
C. "Private" gifts				
Individual contributions and memberships	1,145		570	575
Corporate donations	86		44	42
Foundation grants	518		215	303
Special fundraising events	259		172	87
Other	151		107	44
Total	2,159		1,108	1,051
D. Public sector gifts				
Local government (direct)		1,075		1,075
Local government (property tax exemption)				381
State		67		67
NEA		17		17
Total		1,159		1,540
E. Items outside general fund				
Contributions, grants and bequests	2,800		1,394	1,406
Gains on disposition of investments	1,240		1,240	
Investment income	780		780	
Other	360		360	
Total	5,180		3,774	1,406
Total of all items	$11,499	$1,159	$9,042	$3,997

Second, the aid we discuss is distributed without ever having to be accounted for explicitly or even called by its right name. The government share of a businessman's gift to his local ballet company, for example, is never identified as such by the businessman or by the institution. The donor is treated in every official version of this transaction, and by the media, as the sole source of the funds, although it is recognized by most people that a gift of this sort means tax savings for the donor. Similarly, the local taxing authority generally does not officially compute and then forego the property tax on exempt cultural institutions; usually it ignores the whole situation. We think this obscurity is itself one of the principal defects of the indirect financial aid system, preventing it from looming in the consciousness of arts administrators, scholars, and the general public.

Of course, tax law and its various provisions are debated publicly, but—especially in the arts—the amounts of money involved in particular preferences are small relative to the tax system as a whole. As a result, considerations of importance to the arts, or to any particular charitable sector for that matter, tend

Note: The conventional budget presentation is based on figures contained in National Research Center of the Arts, *Museums U.S.A.: A Survey Report* (Washington, D.C.: National Endowment for the Arts, January 1975). We selected an operating budget of $8 million (higher than the budget in that year for the Boston Museum of Fine Arts, but lower than that for the Museum of Modern Art, for comparison) and used means for the surveyed museums whose budgets exceeded $500,000 to compute the budget fractions. Total receipts include items normally treated as outside the operating budget.

We have excluded support from federal agencies other than NEA; this support is typically in the form of directly earmarked appropriations and benefits a few institutions, such as the National Gallery of Art, but most cultural institutions receive no such funding, so that the arithmetic mean of $520,800 per institution is not a meaningful number. On the other hand, we have included directly earmarked state and local funding, with the recognition that many receive such aid and many do not. The revised budget treats the federal and state tax expenditure portion of contributions as derived from the public sector. It also adds the estimated value of the property tax exemption. The revised budget includes only those indirect benefits we have been able to quantify. Thus, for example, exemption from state sales tax and free insurance under the Federal Arts & Artifacts Indemnity Act are not included.

to be swamped by the more general concerns of charity and nonprofit institutions, not to mention other considerations applicable to the tax law generally, as happened in 1981.

In this book we speak of "arts" institutions. By this we mean those arts organizations primarily with not-for-profit or charity status—museums, dance companies, regional theaters, symphony orchestras, opera companies, and the like—and those individuals and groups orbiting around them, such as trustees, artists and performers, and visitors and spectators.

We think that much of the value of our approach lies in our focus on one specific area of economic aid to the arts—indirect aid. This book is the first to examine indirect aid in a specific charitable sector; previous work on indirect aid has focused on the various types of indirect aid hidden in a particular revenue-raising instrument such as the income tax or property tax. Our type of problem is not, we must emphasize, exclusive to "arts policy;" it is a problem that encompasses philanthropy and government subsidy. We would be pleased to see parallel studies undertaken for other charitable sectors such as health care or education. Much of the preliminary data necessary for such studies is offered by way of comparison in the chapters that follow.

In Chapter 2 we begin with one direct tie between the tax law and the arts, the tax treatment of artists themselves. When this topic is accorded public discussion, it is almost always by way of deploring the existing rules and regulations. But we find that the principal defect of our taxation of artists is not, as commonly believed, prohibition of a full tax deduction for charitable gifts of an artist's own work, but a more complicated problem involving capital gains tax treatment of art works. Our most important criticisms of the tax law apply to the material in the following chapters, concerning the tax expenditures included in the federal income, estate, and local property taxes.

Chapter 3 describes these tax expenditures by function and estimates their size. We then seek to answer, in successive chapters, four essential questions:

Who pays for indirect aid, and who receives it?
Who decides how it is used?
How does it affect the arts?
How stable is it?

We shall see that indirect aid is not much different in its distribution effects—transfers from payers to beneficiaries—from other, more direct means of supporting the arts, but that it has important defects in each of the other dimensions. Accordingly, we present specific recommendations for change in Chapter 8, with the objective of preserving the virtues of this unique system while correcting its major failings.

2

ARTISTS AS TAXPAYERS

Whether writer, painter, choreographer, or performer, the American artist has benefited only incidentally from most government aid to the arts. In the Depression, the government funded artists directly through WPA arts projects. In more recent times, artists have been employed with funds from the CETA program. And artists receive some aid from government purchase of art for buildings and publications. For the most part, however, government aid does not go directly to the artists; both direct grants and tax incentives to artists are funneled through nonprofit and charitable institutions. For example, the composer receives a substantial part of the grant awarded to a symphony orchestra for the commissioning of a new work. Similarly, a grant to a museum for acquisitions might mean more money for the artist, not merely for one painting but also for the higher prices his other work may bring. Still, the main thrust of government financial aid is directed at shoring up institutions, not individual artists. The same is true of tax benefits that help the arts.

CHARITABLE CONTRIBUTIONS OF ART

The artist needs collectors, but at times he feels that they exploit him by underpaying him. When tax rules that appear disadvantageous to the artist benefit the collector, it is doubly irksome; as a result, much of the controversy about inequitable tax treatment of artists turns on the artist-collector comparison.[1]

Of course, artists not only receive government aid but also, like everyone else, they pay taxes. In principle they are, and should be, taxed just like other people who make and sell things of value or provide services. Indeed, the tax system seems to be regarded with no special resentment by performers, writers, and composers, who, earning their income in irregular spurts, even enjoy a right to average several years' taxable income in a way impossible in most countries.

But the business of art has its own special characteristics, especially in the visual arts where unique things of substance are created and appreciate in value. Visual artists argue vigorously that they are not fairly treated. They compare themselves on the one hand with collectors who buy, sell, and donate art, and, on the other hand, with small businesspeople who, for example, work at home and incur deductible expenses. As our analysis indicates, we think the tax law on the whole does not discriminate against artists; however, some reforms should be made.

The issue that most raises artists' hackles is that an artist donating his own work to a museum can deduct only the value of its materials, while a collector donating the same work could deduct its whole fair market value. A related apparent difference is that the collector who sells the work pays only 40 percent of his regular income tax on the sale, and that only on the part of

its price that represents appreciation above what he paid for it, while the artist pays full income tax on the whole price above materials cost. Third, even cash contributions usually provide greater benefits to the collector than to the artist.

Consider the last of these contrasts, between a working artist of modest income and a wealthy collector, each giving $100 to a museum. The collector claims a federal income tax deduction of $100, which reduces his tax bill by an amount that depends on his marginal tax rate (the rate that would be applied to the last $100 he earned). For a collector in the top bracket in 1982, this rate is 50 percent, so the deduction saves him $50 in taxes; in effect, the collector pays for $50 of the gift and the federal government for $50.

The artist may get no benefit at all out of his contribution. Prior to 1982, unless his itemized deductions exceeded $2,300 (if single) or $3,400 (for a married couple)—and for five-eighths of all tax returns filed it is estimated that they did not—the artist got no tax benefit from his gift. Beginning in 1982 all taxpayers may deduct some part of their charitable giving, but only to a $25 maximum for 1982 and 1983. If the artist does claim a deduction for the full amount, the gift likely produces a smaller tax break: at a 25-percent marginal rate (applicable for taxable income of married couples over $20,000) he would have to pay $75 of the gift, and the government would only provide $25.

The disparity in treatment turns on the marginal rate of income tax that applies to each donor, and in turn on the income. Its effect is much broader than the artist-collector dichotomy and is of great importance in evaluating the effects of tax provisions.

The first two differences mentioned, however, have their roots in provisions of the tax law pertaining to definitions of different kinds of income, not just the different rates on individuals. The relevant provisions of law are somewhat complicated and are

best described as general rules and exceptions. One general tax rule treats income from the sale of assets held for more than a year as capital gains income: a taxpayer buying securities in 1970 for $100 and selling them in 1980 for $300 has capital gains income of $200 (the difference between his *cost basis* and the sale price). Income from wages or salaries is ordinary income. The principal importance of the distinction is that ordinary income is taxed at the taxpayer's full marginal rate, while only 40 percent of capital gains income is taxed.

The first exception to this rule is that certain objects, when held by certain taxpayers, are considered to generate ordinary income when sold no matter how long they have been held. An art dealer, for example, pays full tax on his sales profits; his paintings are considered inventory rather than capital assets. And an artist pays full tax on sales of his own work no matter how long ago it was completed.

The general rule for charitable contribution deductions is that a taxpayer may deduct the market value of anything he gives to a charity. Certain exceptions apply to gifts of property unrelated to a particular charity's purpose, such as a tractor donated to a library, but these do not concern us here. The exception that does matter is that, when property that would produce ordinary income if sold is given, only its *cost basis*—for a painting, usually the value of the materials used to make it—may be deducted.[2] Thus, the collector donating a painting to a museum can deduct its whole value, while a dealer giving the same painting may only deduct what he paid for it, and the artist who made it can only deduct the (usually trivial) cost of paint and canvas.

This controversial provision of the tax code dates only from 1969, and has been bemoaned in the art world. It certainly dramatizes the effect that the dry language of the tax law can have on people's behavior.

One immediate reaction to the change is recounted by Robert Anthoine:

Take your mind back to the last days of 1969. The President has just signed the 1969 Tax Reform Act into law. In New York City the snow is snowing, the wind is blowing, but somehow wagon after wagon weathers the storm and pulls up in front of the Museum of Modern Art and the Whitney Museum of American Art to disgorge a stream of paintings and sculpture. Strange and wonderful indeed—and directly attributable to the new tax law and to the alertness of the administrative directors of those museums. Seldom is it possible to pinpoint so directly the impact of tax law upon human behavior. . . . Those last days of 1969 represented the last chance—perhaps in a lifetime—for the creator of property such as paintings and sculpture to obtain a full fair market value deduction for the donation of his created work.[3]

While it has assuredly reduced artists' gifts of their own work to museums, the limitation on the artist's deduction is well founded, for it is rooted in the most general concept of tax deductions: the only allowable deduction is one involving expenditure of previously taxed income. More specifically, any donor of cash can deduct the gift in full, since he paid taxes previously on the income represented by the cash donation. Similarly, an artist who sells a painting and donates the proceeds to a museum may deduct the whole gift: income tax is paid on the sale price and then reclaimed by the tax deductible gift.

But just as physicians cannot claim deductions for time or services donated to a clinic, since no tax was paid on the labor, the artist who donates a painting to a nonprofit or charitable organization cannot deduct the full market value of the painting because he paid no tax on the value he added to the paint and canvas. The only previously taxed income to deduct is what he paid for the material.

The rules for the collector, however, violate this principle. They allow a deduction both for the previously taxed income used for a purchase and also for the untaxed appreciation in the gift's

value. Notice, however, that any donor of property whose appreciation would be treated as a capital gain upon sale enjoys the same opportunity: philanthropists often give securities to all sorts of charities, and deduct not only the amount they paid for them—money that was taxed when earned—but also the untaxed appreciation. This violation of the general principle is therefore widespread in the charitable area, and not merely a matter of artist-collector discrimination, although it is not general enough to admit the artist giving his own work; later we will recommend changes to correct this inequity. Here we observe that, even if it is not corrected, it is still possible to extend the opportunity to artists to enjoy favorable capital gains tax treatment on appreciation in their own work, if the artist's gain on a sale is divided into two parts, namely, the ordinary income represented by the value added to the materials by the artist's labor, and the appreciation that the work undergoes after it is created. This latter part should be recognized as a capital gain, not services income, and a mechanism to do this will be detailed later.

The alternative policy, that artists again be allowed to deduct the full fair market value of their work, would not restore "fairness" to the system, but would merely multiply an irrational complex of exceptions to basic tax policy; to allow an artist to deduct contributions of his own work would give him an unjustified preference in comparison with other taxpayers. Should doctors also be allowed to deduct the full value of their time when volunteering in clinics? The absurdity can best be illustrated by pursuing this last example: all employees of nonprofit institutions—with independent income (e.g., from investment) equal to their salaries so as to meet the 50-percent-of-income deduction limit—would be able to avoid all income tax on their salaries by agreeing to work half-time for their former full salaries, and contributing the other half. The deduction for the con-

tributed time would offset the income from the paid time, and no tax would be due on the whole salary.

Thus, the nondeductibility of artists' contributions of their own work is not the invidious treatment it might appear to be. There is a gap in the fiscal net allowing appreciation to be deducted without being taxed, but it is available to everyone, and through it may pass art, stocks, and antiques. The mistreatment of artists in the tax code that should be corrected pertains not to deduction rules but to characterization of income, and concerns the inability of the artist to distinguish the ordinary income in the sale of a work of art from the capital gain.

BUSINESS EXPENSES

As entrepreneurs, artists have business expenses such as studio rental, continuing education, and models' fees. The tax code allows a person to deduct expenses associated with a trade or business or incurred with a view of making a profit, but not expenses for a hobby. It may be difficult in practice, especially for the beginning artist, to establish that he is, say, a professional painter and only incidentally a part-time teacher in the local elementary school, rather than a teacher who paints as a hobby. The difficulty is compounded by the absence of any clear dividing line between the activities. Although the criterion is simply stated—whether the taxpayer engages in the art activity for profit—the facts and circumstances to be considered are myriad.[4]

A further tax problem arises because the artist often uses a part of his residence as a studio. In 1976, Congress tightened the rules concerning deductibility of business expenses incurred in a residence.[5] These new provisions are aimed at executives and others who maintain a part-time home office, but

they also affect the artist with a full-time studio in his residence. Formerly, the artist allocated the cost of the residence between the portion used as a studio, which he could deduct, and the portion used to live in, which he could not deduct. Now a deduction is permitted only if the room or other area allocated to business is used exclusively for that purpose and then only up to the amount of income actually produced in the business. In short, an artist who lives and works in one room cannot deduct any part of his rent because the room is not used exclusively for business; the artist who fails to sell any of his work during the year is not entitled to a rent deduction because of the income limit.

Unfortunately, no obvious formula would fairly treat the business expenses of an artist who is not yet established. The rules seem least fair to the artist who supports himself at another job and might otherwise protect a portion of his income with art expense deductions. The tax code itself does not and probably could not spell out a demarcation; the problem is irreducibly judgmental and administrative, the legitimate goal of the IRS being to discourage hobbyists from pretending to be professionals. We note that the rule works quite well in other cases: no one would suggest disallowing the expenses in starting a carpet-cleaning business as hobby-related, nor allowing deduction of equipment for backpacking. The fundamental problem is that artists do for a living what many people do for fun.

While the relatively small number of litigated cases concerned with artists' expenses have been solicitous of the artist, one cannot say the same of collectors' expenses. Indeed the principal case—*Wrightsman* v. *United States* [6]—seems to disallow collectors' deductions in most situations. Generally, investors may deduct expenses incurred in earning income, including property appreciation. Collectors who buy art primarily for financial reasons may deduct costs of security, insurance, climate control,

and related expenses, but the problem lies in convincing the IRS that the motivation for the purchase of art is primarily for financial gain.

The Wrightsmans were recognized as art experts and maintained accurate expense records. However, they surrounded themselves with their art purchases even to the point of using Louis XV furniture in their bedroom. Therefore, the court ruled, personal motivations outweighed profitmaking ones.

There have been a few judicial determinations of whether an artist was engaged in a trade or business. In the Tax Court case concerning Ms. Churchman,[7] there was a record of over twenty years of activities. In none of these years did her income from art exceed her expenses. Nevertheless, and despite the considerable recreational element in her work, the Tax Court found factors indicating an ongoing profit motive and allowed her to deduct her artistic expenses: she had worked hard at marketing her paintings and sculpture, a side of the art business the court characterized as only minimally recreational. She designed an art gallery, ran it for one year, maintained a mailing list for announcements of shows, published a book to promote her own works, and kept adequate accounting records. She had sold a few paintings and had three shows in the year prior to the trial. Finally, she devoted a substantial amount of time to these activities. Ms. Churchman had passed well beyond the beginning-artist stage of her career. Without her experience and manifest devotion to her career, it would have been substantially more difficult for her to prevail.

ESTATE TAXES

Estate taxes affect the artists lucky enough to amass some wealth, and here too the claim is often made that artists are treated unfairly. Such assertions, however, appear to be nothing more than

special pleading for unjustified preferential treatment of artists' estates. Former Congressman Fred Richmond (D., New York) was a leading advocate of such change:

> It has often been the case that estate and income taxes exceed the market value of the work. America is losing thousands of valuable works of art each year as artists destroy their unsold works rather than place an untold financial burden on their families. It is a national disgrace that our current tax system encourages the destruction of our cultural heritage. If this practice continues, future generations will be deprived of the pleasures of viewing contemporary American masterpieces. . . . It is only fair to tax the estates of artists in the same manner in which they are provided deductions for charitable donations.[8]

His proposed bill (H.R. 7896) would have levied estate taxes on the value of the material used in an artist's work rather than on the fair market value of the work itself. We believe that this and similar proposals are, at best, misguided.

First, it is simply not true that the combined federal estate and income taxes on inherited property can exceed the fair market value of the property. At present, inherited property takes a fair market value basis on death, so that any sale by an heir at that price produces no gain and no income tax: death forever wipes out the untaxed appreciation for income tax purposes. When Richmond made his remarks, Congress had recently enacted a "carryover basis rule," since repealed, imposing income tax on the appreciation if the heirs sold the property.[9] Under the rule, the estate taxes attributable to untaxed appreciation were added to the artist's basis in the work of art to determine the heirs' tax. But because income tax rates and estate tax rates are each less than 100 percent, it would still have been impossible for the combined tax to exceed the value of the work.

Second, some artists have destroyed their work to protest estate taxes, possibly because they obtained estate planning advice from Mr. Richmond's press release rather than from a

knowledgeable lawyer or accountant. Arizona artist Ted De-Grazia claims to have destroyed $1.5 million worth of his paintings because his heirs "couldn't afford to inherit his works."[10]

But no one counsels burning highly appreciated stock; we emphasize that even where estates are subject to the highest marginal tax rates, the heirs' tax bill cannot exceed the value of the estate: heirs are never compelled to pay money from their own pockets. Heirs of large art estates usually cannot keep the whole estate tax-free—sometimes they have to sell some of the property to pay the taxes on the whole estate. But artists' estates, and their heirs, are not punished by the tax code. The bequests of an artist, no matter how large the estate may be or to what extent it is composed of an artist's works, are treated exactly the same as those of an investor or any other person. Heirs often find themselves confronted with the prospect of selling some estate assets in order to cover the tax bill, or paying from their own assets if holding the whole estate intact would ultimately prove more profitable.

We wonder if Richmond would have agreed that stocks and bonds should also be valued for estate taxation at their initial purchase price rather than at their appreciated value. Probably not, for how could he justify giving such a tax break to the very wealthy? Here equity enters the argument—artists whose heirs would benefit from his legislation are never poor. The Tax Reform Act of 1976 and the Economic Recovery Tax Act of 1981 have eliminated estate taxes altogether (by 1987) for individual estates smaller than $600,000. Why should a wealthy artist be treated differently from any other wealthy person?

Finally, the advocates of preferential treatment for artists have ignored the fact that charitable bequests of property are entirely tax deductible. Why Mr. DeGrazia elected to burn his work rather than leave it to a public museum has never been adequately explained.

There used to be a real problem in the settlement of artists' estates, but it was cleared up by the Tax Reform Act of 1976. The works of artists differ from stocks and bonds, for example, in that they are unique, identifiable commodities. The accumulated work in an artist's estate may represent a substantial part of his lifelong output. A forced sale of a significant part of the art in order to pay estate taxes could reduce market prices substantially because of oversupply. (But notice that even in such a case, the estate value taxed is the sale price; sale at public auction establishes a market value that the Internal Revenue Service would be hard put to reject. The result still holds: heirs can afford to inherit art.) Contrastingly, a forced sale of publicly traded stocks and bonds would not normally affect their price. The Tax Reform Act of 1976 eased artists' estate liquidity by allowing up to fifteen years to pay the estate tax on a closely held business (see Chapter 7). Thus, the heirs may sell the work slowly. This provision is a good example of an equitable modification in tax law that does relieve specific burdens on artists.

OTHER PROPOSALS

Some recent legislative proposals discriminate blatantly in favor of artists and collectors both. For example, a proposal introduced in the 94th Congress by Thomas M. Rees (D., California), H.R. 3999, would have allowed a full income tax deduction for purchases of contemporary American art up to a maximum of $10,000, the excess eligible to be spread over nine years.

Designed to stimulate the art market and reward living artists, Rees's proposal in effect makes all other taxpayers partners in the purchase of art for private consumption through its tax-deductible feature. Of course, the higher the tax bracket of the purchaser, the more money will be lost in tax revenues. We can-

not applaud a plan that uses public money to finance private purchases that will appreciate to the sole advantage of the private owner. Congressman Rees might have at least included a public-display requirement in his proposal. The Rees proposal is also dubious on equity grounds: it focuses its effect on purchases by wealthy collectors, who have high tax brackets and for whom the deduction could be worth as much as 50 percent (70 percent at the time of the proposal) of the value of the purchase. Why should the tax law give rich art buyers an additional competitive advantage in the art market—beyond their wealth itself—over purchasers of moderate means? All in all, this proposal, which resurfaces from time to time in the art-advocacy literature, is a good example of the poor analysis often given to tax expenditure measures, possibly because they appear to cost the government nothing.

Some of these proposals may be in reaction to the special tax breaks artists are thought to enjoy in various foreign countries. Just as American cities and states use tax-exempt inducements to attract industry, at least some foreign countries use tax laws to attract artists. Ireland is the most famous example, for there the work of painters, sculptors, writers, and composers (but not performing artists) is exempt from income taxes if the work is found to be "original and creative and of cultural or artistic merit." Between 1969 and 1976, close to 600 people qualified for tax relief, nearly half of them non-Irish (68 percent were writers, 23 percent painters, 6 percent sculptors, and 3 percent composers).[11] Ireland has also eliminated estate taxes for artists' families. Since the Irish can enjoy novels, plays, and music written anywhere in the world, the benefit gained for the taxpayers who finance this scheme is obscure, especially as performers, whose presence really is essential to a vigorous cultural life, are ineligible for this tax break.

Such schemes are presumably meant to transcend econom-

ics, enhancing national prestige and other intangibles. We find it curious that foregone taxes are considered the appropriate public subsidy for these artists, and note that those who benefit (under a progressive income tax) are always the affluent rather than the struggling artists, or are not artists at all.

CONCLUSIONS

Two significant problems concern artists as taxpayers: the first is the issue of the artist who lives in his studio or loft; the second is the current inability of artists to treat appreciation in their work as capital gain for tax purposes. The solution for the first is fairly straightforward—the IRS should modify its "office-in-home" rule for artists to account for the very common convention of visual and performing artists whose studios are a single space in which they also live; there is no point in making people build partitions they don't want or need merely to make the IRS's administrative life easier. In the case of the second, the solution is more complex, and because it involves broader tax reform issues, will be treated later.

The principal or special consequences of the tax law for artists are outside the direct interactions between the artist and the government. The important flows of funds on the subsidy side are through institutions; in the remaining chapters of this book, we turn to these important tax subsidies and their effects.

3

TYPES OF INDIRECT AID

In the United States, local, state, and federal governments distribute indirect aid to the arts through tax expenditures—taxes that are "normally" applicable but that governments do not collect because of deductions, credits, and exemptions.

The quantity of indirect aid to the arts far exceeds the amount of aid distributed directly. For 1973, the last year for which complete data exist, indirect aid reached nearly $500 million, while direct aid to the arts was approximately $200 million. (Table 3.1 summarizes the components of the indirect aid.) The indirect aid to the arts came primarily through provisions of the federal income tax code.

THE FEDERAL INCOME TAX

The federal income tax code accounts for three significant income tax expenditures for the arts: individual charitable income tax deductions, corporate charitable income tax deductions, and capital gains tax foregone on gifts of property.

The charitable contribution deduction lies at the center of

Table 3.1
Total Estimated Tax Expenditures for the Arts, 1973

Tax		Source of tax expenditure		Amounts in millions of $ [a]
Federal	Income tax:	Individual charitable deductions		182
		Capital gains tax foregone		26
		Corporate charitable deductions		64
		Capital gains tax foregone [b]		—
	Estate tax:	Charitable gift deduction		40
	Gift tax:	Charitable gift deduction		6
	Miscellaneous:	Gifts made through private foundations		24
State	Income tax:	Individual charitable deductions and capital gains tax foregone	24	
		Less federal tax offset [c]	−13	
				11
		Corporate charitable deductions and capital gains tax foregone	9	
		Less federal tax offset	−4	
				5
Local	Property tax:	Exemptions		100
Total estimated tax expenditure				$458

Notes: [a] Property tax exemption is estimated with 1976 data, but deflated to 1973 dollars; all others are estimated with 1973 data.

[b] Data are insufficient to give a reasonable estimate.

[c] As discussed in the text, part of the state tax expenditure for the arts actually inures to the benefit of the federal government, rather than arts institutions.

indirect federal support for the arts. Charitable contributions to the arts result from decisions made by individuals, corporations, or foundations. Each contribution reflects the donor's response to three questions:

How much money shall I give?
To whom shall I give it?
Under what conditions shall I give it?

Each contribution proceeds from the donor's tastes and preferences, as affected by the economic incentives provided by the indirect aid system.

Individual Charitable Income Tax Deductions

Since 1917, individual taxpayers have been allowed to deduct contributions to nonprofit, charitable institutions, including arts institutions, when computing their federal income taxes, thereby reducing their total income tax liability. The purpose of this provision within a tax based on net income has been frequently debated. Some scholars argue that income devoted to a charitable purpose is not available to the donor for personal consumption and should not be taxed to him. Others argue that the deduction bears little relationship to a proper definition of net income and should be addressed frankly as a mechanism for increasing philanthropic support.[1]

Effects on the price of giving. The tax deduction provision rewards generosity after the fact, but donors who write checks to charity generally understand the nature and amount of the tax benefit when they make their contributions, especially that the amount of the gifts exceeds their net cost. (Many donors have not enjoyed a tax benefit because they did not itemize deductions. We discuss this phenomenon below.) The tax deduction changes the price of a charitable gift, that is, the net amount a donor must give to enrich a charity by a certain amount. A truism of economic analysis is that as the price of a commodity goes down relative to others, its consumption will generally increase. For philanthropy, therefore, if we treat the charity's benefit as a commodity and the net cost of a contribution to the donor as its price, the donor will "buy" more increase in the charity's wealth as the cost to the donor of enriching a specified charity

Figure 3.1
Components of the Total Charitable Contribution

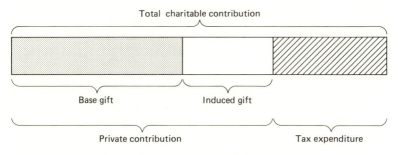

by one dollar decreases. The deduction provides an economic incentive for the donor to give more, perhaps in private dollars as well as in tax expenditure dollars.

To facilitate the discussion of the incentive effects of tax expenditures, we divide the total charitable contribution into two major components: the tax expenditure and the private contribution. The private contribution is that portion of the total gift made up of the donor's own money; it excludes all taxes foregone in the transaction. The private contribution is further divided into two components: the base gift and the induced gift. The base gift is the amount the donor would give if there were no tax expenditure provision (i.e., if the price of giving $1 were exactly $1); the induced gift is the increase in the donation of the donor's own money resulting from the economic incentive presented by the tax provision. A donor's reaction to the economic incentive presented by a tax expenditure will determine whether the induced gift is positive or negative. These components of the charitable contribution are illustrated in Figure 3.1.

Table 3.2 presents three examples illustrating possible donor reactions to the charitable income tax deduction. For purposes of comparison each of the examples assumes a base gift of $1.

Table 3.2
Price Effect of the Tax Expenditure

Donor's marginal tax rate	Example 1			Example 2			Example 3		
	0%	14%	50%	0%	14%	50%	0%	14%	50%
Base gift	$1.00	$1.00	$1.00	$1.00	$1.00	$1.00	$1.00	$1.00	$1.00
Induced gift	0	−.14	−.50	0	0	0	0	.04*	.18*
Private contribution	1.00	.86	.50	1.00	1.00	1.00	1.00	1.04	1.18
Tax expenditure	0	.14	.50	0	.16	1.00	0	.17	1.18
Total charitable contribution	$1.00	$1.00	$1.00	$1.00	$1.16	$2.00	$1.00	$1.21	$2.36
Net cost of $1.00 contribution	$1.00	$.86	$.50	$1.00	$.86	$.50	$1.00	$.86	$.50

Note: *Assumes a price elasticity of total giving= −1.24

Example 1 depicts a donor who decides to give the same total charitable contribution no matter what the tax consequences of his donation. In this case, the donor takes advantage of the charitable deduction to reduce his taxes, and the charity receives no more as a result of that action: the tax expenditure substitutes government money for money the donor otherwise would give. Example 2 represents a donor who chooses to spend the same amount of his own money—his private contribution—without regard to the size of the tax expenditure. The amount of money flowing to the charity increases by exactly the amount of the tax expenditure. This example highlights the dependent nature of the government contribution—the higher the donor's tax bracket, the greater the tax expenditure per private dollar given.

Example 3, the most realistic of the three, illustrates a donor who increases his private contribution in response to the charitable contribution deduction. In accordance with research concerning the price elasticity of giving discussed later in the chapter, this example assumes that, as the price of giving decreases, the donor will increase his total charitable contribution more than proportionally. (The price elasticity of giving is the percentage change in the total charitable contribution given a 1 percent increase in the net cost of the total donation.) If this happens the induced gift will be positive, and the amount of money flowing to the charity will be increased by the amount of the tax expenditure plus the induced gift. In addition, as the donor's marginal tax rate increases, the deduction produces a greater net tax benefit, the price to the donor drops more steeply, and the induced gift rises more rapidly.

Disproportionate matching. The deduction form of the tax benefit means that the benefit to the donor rises with donor income. The tax expenditure can range from 0 to 50 percent of

the total contribution depending on the donor's marginal income tax bracket. A related consequence of the tax expenditure provision is that the donor's decisionmaking power over the government share rises with his tax bracket. Although the price to a donor of giving a dollar may decline to 50 cents, he decides which charity receives the full dollar, including the 50-cent tax expenditure portion. Thus, the tax expenditure provision is related directly to the private contributor rather than to a per capita base or to private dollars paid.

Often, the tax expenditure provision provides no matching funds—and no incentive to give more. In fact, nearly two-thirds of all individual tax-return filers in 1973 (52 million of 81 million) used the standard deduction (now called the zero bracket amount) which precluded the deduction of charitable contributions.[2] For 1978 the proportion was about the same (60 million of 90 million). These taxpayers derived no tax advantage from charitable contributions, and they had no voice in the allocation of a tax expenditure, even though they made charitable contributions. The Economic Recovery Tax Act of 1981 allows full deductibility of charitable contributions, even for non-itemizers, commencing in 1986.

Conversely, wealthy individuals control the distribution of large tax expenditure amounts. This result follows inevitably from the effects of a tax deduction within a progressive rate tax system. This configuration of tax benefits has been criticized as inequitable—a criticism we will discuss later. As it happens, the arts benefit from the lopsided control over the tax expenditure provision because, as we shall see, the type of charitable recipient selected changes significantly with the income of the donor and wealthier individuals tend to be more supportive of the arts.

Legal constraints on the deductions. A charitable contribution must meet certain conditions to be deductible.[3] Most bear only

tangentially on this study, but a few are particularly important for donations to cultural institutions. Specifically, the contribution must go to an institution organized and operated exclusively for religious, charitable, scientific, literary, or educational purposes, to foster certain amateur sports competition, or for prevention of cruelty to children or animals.[4] Internal Revenue Service regulations resolve doubts as to whether most cultural institutions qualify, classifying museums and symphony orchestras (and, by implication, other nonprofit performing arts institutions) as educational institutions.[5]

The statute limits the amount of the annual charitable deduction an individual may claim depending on the type of gift and charitable recipient. Gifts of cash to favored charities, including publicly supported ones, are limited to 50 percent of the donor's contribution base (the adjusted gross income with minor modifications); most arts institutions qualify as 50-percent charities. Gifts to privately supported charities are limited to 20 percent. Gifts of property whose sale would have produced long-term capital gains are limited to 30 percent; gifts to museums of stocks or bonds or artworks generally fall under this limitation.

In practice these limitations affect only substantial donors. Should a donation to a 50-percent charity exceed the limits, the excess may be deducted over the following five years. As we shall see, additional rules apply to charitable gifts of property, particularly property where the value exceeds the donor's tax basis in it.

The dollar amount of the tax expenditures. As part of its tax expenditure budget, the Treasury Department estimates tax expenditures for charity. For 1980, as for prior years, the Treasury Department divided its estimate for individual giving into three parts: tax expenditures through charitable contributions to health

institutions amounted to $1.1 billion; to educational institutions, $765 million; and to "other" charities, $5.7 billion. Cultural institutions are subsumed under "other." For 1973, these three items totaled $3.4 billion.[6] We also know the amount claimed as charitable deductions by individuals: in 1973, our base year, individual taxpayers deducted more than $13.9 billion for gifts to charities. But the government has not analyzed these figures to determine the amount going to cultural institutions. The IRS last analyzed recipients of charitable contributions based on 1962 data.[7] The IRS subdivided charitable recipients of donations into five types: religious, other charitable, educational, hospitals, and other. Cultural institutions were categorized as "other." The classification of cultural data as an indeterminate fraction of a miscellaneous category, usually labeled "other," has plagued arts policy researchers.

The absence of data on tax expenditures for cultural institutions is not surprising. First, the amounts donated to arts institutions are not considered a large enough feature of all charitable gifts to warrant separate tabulation. Second, tax expenditure reporting is a relatively new element of the budget process and the collection of pertinent information is still in an early stage of development. In any case, the IRS would be incapable of a more detailed analysis, since taxpayers are not required to divulge the type of charity that the donation was given to.

As the analysis of tax expenditures comes to have greater bearing on the formulation of tax policy, the process of information gathering and analysis should be developed to meet the needs of analysts. At present, however, any quantification of the tax expenditure for the arts must draw on sources outside the IRS.

In 1973 the Commission on Private Philanthropy and Public Needs, a privately funded citizens' panel, was formed to study the role of philanthropic giving and voluntary public-oriented

activity in the United States and to make recommendations to Congress and to the American public to strengthen and improve philanthropic activity. As part of the commission's research, James N. Morgan directed the National Study of Philanthropy, a comprehensive survey of household donations made to charity in 1973 that collected data on the amount, type (cash, property, or volunteer time) and recipient of each contribution.[8] Fortunately, cultural institutions were categorized separately.

We have grouped the National Study of Philanthropy data as follows:

Culture	Arts, humanities, sciences, symphony orchestras, theater, ballet, museums, public television
Religion	Churches and church groups
Education	Elementary and secondary schools (including religious schools) and higher education
Health	Research and prevention, health centers, medical appeals (e.g., March of Dimes) and other medically related groups (Planned Parenthood, Alcoholics Anonymous)
Other Social Welfare	Combined appeals (United Way), community activities and services, aid to the poor or disadvantaged, public affairs (ACLU, League of Women Voters), environmental affairs, and international programs
Other Charitable	Private foundations, trusts, and miscellaneous charitable contributions

Some categories other than culture have been combined to form the categories above. Aggregate giving includes gifts in each cat-

egory. Although the National Study's culture category includes science and natural history museums and television, it is nevertheless a substantial improvement over previous studies that lumped culture together with the other parts of the usual "other" category. We have treated the National Study's definition of all charitable recipients as substantially congruent with that of the Internal Revenue Service.

Using these data we first estimated total charitable contributions to all charity in 1973 and then to each charitable sector by income of the donor. The estimates were derived using the following procedure. First, we aggregated and weighted the data according to the procedure developed by Morgan, Dye, and Hybels. Second, we adjusted the figures within each income group according to the actual mix of taxpayers who itemized deductions on their returns as given in *Statistics of Income—1973*.[9] Third, we adjusted the data according to the amount of gifts actually deducted by itemizers in each income group on their 1973 income tax returns. As a result of the second and third steps, our estimates differ from those of Morgan, Dye, and Hybels. We deemed these steps necessary to minimize—although they cannot eliminate—the effects of taxpayers' overstatements of their charitable gifts in the survey relative to the amounts claimed on their returns. Poor memory or a desire to appear more philanthropic may account for the difference. Without the corrections, the National Study data can be used only for relative comparisons of giving patterns, not for absolute estimates. Fourth, the tax expenditures were calculated by multiplying the adjusted charitable gift totals by the estimated marginal tax rate for each individual donor.

Note that our estimates overstate the benefits received by charities where taxpayers have overstated their donations on their returns. This second kind of overstatement does not affect the tax expenditure estimates, although it means charities actually received amounts less than donors declared.

Table 3.3
Individual Charitable Giving, 1973

Modified income class	Number of households (thousands)	Aggregate charitable giving				Giving to cultural institutions			
		Total charitable gifts—cash	Total charitable gifts—property	Total charitable gifts	Mean total gift per household in income class (dollars)	Gifts to culture—cash	Gifts to culture—property	Total gifts to culture	Mean total gift per household in income class (dollars)
$ 1– 9,999	33,097	$ 3,539	$ 115	$ 3,655	$ 110	$ 0**	$ 0**	$ 0**	$ 0**
10–14,999	15,787	3,467	221	3,688	234	.8	0**	.8	.06
15–19,999	10,999	3,090	91	3,181	289	3.0	0**	3.0	.27
20–29,999	6,270	2,197	570	2,767	441	7.3	9.2	16.5	2.63
30–49,999	2,205	1,425	80	1,504	682	34.7	19.7	54.4	24.66
50–99,999	729	947	262	1,209	1,658	34.6	89.8	124.4	170.64
100,000– 199,999	140	370	233	603	4,304	3.2	56.2	59.4	423.52
200,000– 499,999	28	253	160	413	14,597	25.6	11.0	36.6	1,293.95
500,000– 999,999	4	104	68	172	44,167	22.9	0**	22.9	5,872.62
1,000,000+	2	217	28	245	153,427	6.2	0**	6.2	3,874.19
Totals	69,261	$15,609	$1,828	$17,437	$252*	$138.3	$185.9	$324.2	$4.68*

Source: The Commission on Private Philanthropy and Public Needs, National Study of Philanthropy, 1974.

Notes: All figures are presented in millions of dollars unless otherwise indicated.

*Average figure for all households.

**Zeroes are due to sample size; see pages 46 and 47.

Table 3.4
Individual Charitable Giving by Sector, 1973 ($ millions)

Modified income class	Culture	Religion	Education	Health	Other social welfare	Other charitable	Aggregate
$ 1– 9,999	$ 0	$ 3,269	$ 84	$141	$ 158	$ 0	$ 3,655
10–14,999	0.8	3,261	34	109	279	0	3,688
15–19,999	3.0	2,727	39	127	282	3	3,181
20–29,999	16.5	2,052	88	158	452	1	2,767
30–49,999	54.4	881	240	70	260	1	1,504
50–99,999	124.4	313	182	89	379	119	1,209
100,000– 199,999	59.4	131	184	113	108	7	603
200,000– 499,999	36.6	36	181	58	86	16	413
500,000– 999,999	22.9	11	77	11	36	0	172
1,000,000+	6.2	60	97	25	30	25	245
Totals	$324.2	$12,741	$1,206	$901	$2,070	$172	$17,437

Source: The Commission on Private Philanthropy and Public Needs, National Study of Philanthropy, 1974.

Note: Rows may not add exactly because of rounding.

Table 3.5

Individual Charitable Giving by Sector, Column Percentages, 1973

Boldface figures indicate the median income class in each column.

Modified income class	Percent of total households	Culture	Religion	Education	Health	Other social welfare	Other charitable	Aggregate
$ 1– 9,999	48%	0%	26%	7%	16%	8%	0%	21%
10–14,999	**23**	0.2	**26**	3	12	13	0	21
15–19,999	16	1	21	3	14	14	2	**18**
20–29,999	9	5	16	7	**18**	**22**	1	16
30–49,999	3	17	7	20	8	13	1	9
50–99,999	1	**38**	2	**15**	10	18	**69**	7
100,000–199,999	0.2	18	1	15	13	5	4	3
200,000–499,999	*	11	0.3	15	6	4	9	2
500,000–999,999	*	7	0.1	6	1	2	0	1
1,000,000+	*	2	0.5	8	3	1	15	1
Totals	100%	100%	100%	100%	100%	100%	100%	100%

Source: The Commission on Private Philanthropy and Public Needs, National Study of Philanthropy, 1974.

Note: Columns may not add to 100% because of rounding.

*Less than 0.1%

The estimates for households are presented in Tables 3.3, 3.4, and 3.5. Table 3.3 compares total charitable giving with the charitable donation figures for cultural institutions. Tables 3.4 and 3.5 break down 1973 charitable donations by, respectively, the dollar amounts given to each sector and the percentage of total charitable dollars donated to each sector. In 1973 charitable institutions received $17 billion in contributions ($14 billion was deducted by individual taxpayers,[10] while the remainder was donated by individuals who did not or could not take advantage of income tax deductions). Cultural institutions received $320 million, slightly less than 2 percent of the total. Religion received the most substantial portion, 73 percent, and other social welfare institutions accounted for an additional 12 percent of the total.

Patterns of support for charitable categories, or sectors, vary with income. For each sector in Table 3.5 we indicate the income class that contains the median-dollar amount. (Half of all contribution dollars come from that income level or higher ones and half from that level or lower ones.) As the tables show, cultural institutions depend more on high-income donors than any other charitable sector except education. As Table 3.5 reveals, the median dollar for arts institutions is in the $50,000—$99,999 income class, while for charity generally the median dollar is in the $15,000—$19,999 range. A similar pattern emerges when we examine giving by households. Households with incomes below $30,000 (96 percent of all households) account for 76 percent of the total charitable contribution, but only 6 percent of the total charitable contributions to culture. (These same households accounted for 89 percent of the total charitable contribution to religion.) Most of the contribution to culture came from households with income between $30,000 and $199,999: $240 million or 73 percent. Yet these 3.1 million households constituted only 4.4 percent of all households in 1973. (See Tables 3.3 and 3.5.)

Table 3.6
Tax Expenditures—Individual Federal Charitable Contribution Deductions, 1973

Modified income class	Number of households (thousands)	Aggregate charitable giving			Giving to cultural institutions		
		Tax expenditure	Effective price of $1.00 gift (dollars)	Mean tax expenditure per income class member (dollars)	Tax expenditure	Effective price of $1.00 gift (dollars)	Mean tax expenditure per income class member (dollars)
$ 1– 9,999	33,097	$ 323	$.91	$ 10	$ 0	$1.00	$ 0
10–14,999	15,787	611	.83	39	.2	.78	.01
15–19,999	10,999	639	.80	58	.8	.71	.07
20–29,999	6,270	862	.69	138	5.9	.64	.94
30–49,999	2,205	603	.60	274	22.8	.58	10.36
50–99,999	729	605	.50	830	66.0	.47	90.53
100,000–199,999	140	381	.37	2,719	41.2	.31	293.82
200,000–499,999	28	258	.38	9,127	24.3	.34	858.12
500,000–999,999	4	117	.32	29,977	16.0	.30	4,110.84
1,000,000+	2	171	.30	106,961	4.4	.30	2,711.93
Totals	69,261	$4,570	$.74*	$70*	$181.6	$.44*	$2.62*

Source: The Commission on Private Philanthropy and Public Needs, National Study of Philanthropy, 1974.

Notes: Figures are presented in millions of dollars unless otherwise indicated.

These estimated tax expenditures do not include capital gains taxes foregone on gifts of property.

*Average figure for all households.

Table 3.7

Tax Expenditures by Sector—Individual Federal Charitable Contribution Deductions, 1973 ($ millions)

Modified income class	Culture	Religion	Education	Health	Other social welfare	Other charitable	Aggregate
$ 1– 9,999	$ 0	$ 295.8	$ 9.4	$ 7.1	$ 10.1	$ 0	$ 323
10–14,999	0.2	546.4	3.7	19.1	41.0	0	611
15–19,999	0.8	547.7	10.3	30.3	51.3	0.7	639
20–29,999	5.9	653.2	27.7	40.3	135.1	0.2	862
30–49,999	22.8	359.6	90.1	26.4	104.4	0.3	603
50–99,999	66.0	153.4	93.0	50.1	181.9	62.9	605
100,000– 199,999	41.2	83.2	114.1	72.4	65.8	4.4	381
200,000– 499,999	24.3	24.1	109.5	40.0	49.2	11.3	258
500,000– 999,999	16.0	7.5	50.8	7.2	25.0	0	117
1,000,000+	4.4	41.1	68.6	17.8	20.3	18.5	171
Totals	$181.6	$2,712.0	$577.2	$310.7	$683.7	$98.3	$4,570

Source: The Commission on Private Philanthropy and Public Needs, National Study of Philanthropy, 1974.

Notes: Columns may not add exactly because of rounding.

Estimates do not include capital gains taxes foregone on gifts of property.

Table 3.8

Tax Expenditures by Sector—Individual Federal Charitable Contribution Deductions, Column Percentages, 1973

Modified income class	Percent of total households	Culture	Religion	Education	Health	Other social welfare	Other charitable	Aggregate
$ 1– 9,999	48%	0%	11%	2%	2%	1%	0%	7%
10–14,999	**23**	0.1	20	1	6	6	0	13
15–19,999	16	0.4	**20**	2	10	8	1	**19**
20–29,999	9	3	24	5	13	20	0.2	13
30–49,999	3	13	13	16	8	**15**	0.3	13
50–99,999	1	**36**	6	**16**	16	27	**64**	13
100,000–199,999	0.2	23	3	**20**	23	10	4	8
200,000–499,999	*	13	1	19	13	7	11	6
500,000–999,999	*	9	0.3	9	2	4	0	3
1,000,000+	*	2	2	12	6	3	19	4
Totals	100%	100%	100%	100%	100%	100%	100%	100%

Source: The Commission on Private Philanthropy and Public Needs, National Study of Philanthropy, 1974.

Notes: Columns may not add to 100% because of rounding.

Estimates do not include capital gains taxes foregone on gifts of property.

Boldface figures indicate the median income class in each column.

*Less than 0.1%

The 15 percent of "other charitable" giving made by donors in the $1,000,000+ income bracket went mostly to private foundations and trusts, and then was transferred to other charitable uses.

In Table 3.6 estimated tax expenditures are given by income class. Tables 3.7 and 3.8 complement Tables 3.4 and 3.5, analyzing the income distribution of tax expenditures for each charitable sector in dollars and percentages.

In Table 3.6 we see that one-fourth of the total charitable contributions, $4.6 billion, consisted of tax expenditures (see Figure 3.1). For culture, the tax expenditure portion was $181.6 million, 56 percent, of the total charitable contribution—the only sector where government funds exceed private funds. (The corresponding percentages for each of the other major sectors were: religion, 21 percent; education, 48 percent; health, 34 percent; other social welfare, 33 percent.) Table 3.6 also shows the effective prices of gifts to all charity and to culture by donor income group. It cost a donor an average 74 cents to give a dollar to charity, while the donor to culture gave a dollar at an average cost of 44 cents; culture thus received proportionally more of the tax expenditure dollar. While cultural institutions received 2 percent of the total charitable contributions, they received 4 percent of the total tax expenditures.

The data for these tables include gifts of both cash and property. While gifts of property constitute a relatively small part of total giving, they exceed gifts of cash in the culture sector. This disproportion may affect the income-class correlation. A separate tax expenditure estimate for gifts of property, in the form of capital gains tax foregone, is discussed below.

Households with incomes greater than $100,000 made 38 percent of all contributions to culture and allocated 47 percent of the total tax expenditure for culture (Tables 3.5 and 3.8). To a lesser extent, the influence of high-income households holds for other charitable sectors: the 96 percent of all households

Table 3.9

Components of Individual Charitable Giving, 1973

Modified income class	Aggregate charitable giving				Giving to cultural institutions			
	Private contribution		Tax expenditure	Total charitable contribution	Private contribution		Tax expenditure	Total charitable contribution
	Base gift	Induced gift*			Base gift	Induced gift*		
$ 1–9,999	$ 3,253	$ 79	$ 323	$ 3,655	0	0	0	0
10–14,999	2,914	163	611	3,688	.59	.01	.2	.8
15–19,999	2,418	124	639	3,181	1.96	.24	.8	3.0
20–29,999	1,743	162	862	2,767	9.49	1.11	5.9	16.5
30–49,999	797	104	603	1,504	27.69	3.91	22.8	54.4
50–99,999	508	96	605	1,209	48.78	9.62	66.0	124.4
100,000–199,999	175	47	381	603	13.90	4.30	41.2	59.4
200,000–499,999	124	31	258	413	9.61	2.69	24.3	36.6
500,000–999,999	41	14	117	172	5.15	1.75	16.0	22.9
1,000,000+	54	20	171	245	1.39	.41	4.4	6.2
Totals	$12,027	$840	$4,570	$17,437	$118.56	$24.04	$181.6	$324.2

Source: The Commission on Private Philanthropy and Public Needs, National Study of Philanthropy, 1974.

Notes: All figures are presented in millions of dollars.

Estimated tax expenditures do not include capital gains taxes foregone.

*An elasticity of −1.24 is used for all income classes and all charitable sectors; see note 11.

43

with income less than $30,000 accounted for 76 percent of total contributions to charity, but allocated only 53 percent of total tax expenditures.

Yet another dimension concerns the influence of the tax expenditure provision on private giving. Table 3.9 is based on crude estimates concerning overall elasticity of giving. It assumes that the donor will increase his private contribution in response to the tax expenditure, that is, that the induced gift is positive as illustrated in Example 3 of Table 3.2. On the other hand, if the tax deductible feature encourages the donor to decrease the private share of his gift, taxpayers subsidize the decrease through the tax expenditure provision. Without the tax expenditure provision, the donor would give the original base gift, the recipient would receive the original sum, and the taxpayers, of course, would not subsidize the transaction. If the induced gift is negative, charities would receive more money if the government paid them the tax expenditure amount via direct grants and scrapped the tax deduction; if it is positive, charities fare somewhat better than if direct grants were substituted for tax deductions. Several studies have addressed the question of whether the induced gift is positive or negative and its relative magnitude. Recent studies by Martin Feldstein and others suggest that the induced gift is positive, though earlier studies disagree.[11]

Following this view, Table 3.9 estimates the induced gift for each income class. It shows that the $182 million in tax expenditures for culture induces an additional $24 million more than donors would give ($119 million) were contributions not tax deductible.

Gifts of Property

Works of art are often donated to museums, while stocks and bonds are donated to the full range of charitable enterprises. When a gift is property rather than cash, the tax law induces a second federal income tax expenditure: capital gains tax foregone. In general, the donor of property claims a deduction equal to its current fair market value. Of course, the donor may have

paid less for the property when he acquired it. On any sale of the property at the market value, the donor would pay tax on the gain, and would net the sale price less this capital gains tax. If instead the property is given to charity, the donor pays no tax on any market appreciation but includes it when computing income tax deductions. Thus, the tax provisions render a contribution of appreciated property more attractive to the donor than selling a property and contributing the proceeds to charity.

A numerical example illustrates this last point. Consider a potential donor in the highest (50 percent) tax bracket who compares donation of a painting to a museum with the sale of the same painting and the donation of the sale proceeds. Assume the painting originally cost the donor $60 and is now worth $160:

	Gift of property	*Sale of property and gift of $160*
Proceeds of sale:	$ 0	$160
Less: investment in painting	0	−60
Gain on sale (G)	0	100
Tax on capital gain (0.4 × 0.5 × G)	0	20
Amount of charitable contribution deduction	160	160
Tax saving on deduction (.50 × $160)	80	80
Net tax saving (tax saving on deduction minus tax on capital gain) (S)	80	60
Net cost of gift ($160 − S)*	80	100

*Note that the capital gains tax expenditure on charitable gifts of property flows from the fact that the charity, because of its tax-free status as regards its own income—not the deductibility of gifts it may receive—will pay no capital gains tax when it disposes of the property.

However, not all gifts of property are deductible at full value. For example, when the contribution is property such as business inventory, which would give rise to ordinary income rather than a capital gain if sold at a profit, the allowable charitable deduction is reduced by this ordinary income element. As we saw in Chapter 2, this rule, created under the Tax Reform Act of 1969, is of special interest to visual artists, for their work is ordinary income property when they own it. An artist can now deduct only the value of the materials in a work of art when he gives a painting to a museum.

Another condition for a deduction at full value requires a gift of tangible personal property to be related to the purpose of the receiving institution. A gift of a painting to a museum (assuming it is given neither by the artist nor a dealer) is fully deductible, but not one to the March of Dimes with the expectation that it will sell the painting and use the proceeds. In the latter case only the original cost to the donor (the basis) and 60 percent of the appreciation could be deducted. (A tricky case arises when the March of Dimes does not sell the painting but hangs it in its administrative offices. Such gifts are usually treated as "related" to the charity's purpose and are deductible in full.) Stocks and other intangible property are deductible at full value when given to any public charity.

Cultural institutions are more dependent on gifts of property than charities as a whole (see Table 3.3). Gifts of property total only slightly more than 10 percent of the overall value of charitable donations, while property donations are 57 percent of the total value of gifts to culture. The major portion of the property gifts to culture came from households with incomes between $50,000 and $199,999—79 percent of the total property contributions.

The zeroes in Tables 3.3 and 3.10 require comment at this point. Gifts of property to cultural institutions for these income

classes were not zero. However, the sample represented by the data, though adequate for significant estimates elsewhere, did not include any cases in these categories, which represent a very small fraction of the population.

In estimating the total tax expenditure of property donations, we must account for both tax expenditures in the charitable transfer of property, that is, the tax saving on the deduction as determined by the donor's marginal tax bracket, and the uncollected capital gains tax on the appreciation of the property. The former has been included in the estimates presented in Tables 3.6 and 3.7. The second of these tax expenditures, the capital gains tax foregone, must be estimated separately. In 1973 long-term capital gains in effect were taxed at half the rate of other income. The primary capital gains benefit for individuals in 1973 derived from deduction of half the net capital gain (code section 1202) rather than a separate rate. (The mechanics of capital gains taxation can be far more complex in individual cases and might be affected by capital losses in other transactions, the alternative minimum tax or other considerations.) But what proportion of property donations constituted appreciation? Although the National Study of Philanthropy samples values of donated property, it contains no data pertaining to taxable appreciation. We must therefore use a rough estimate.

For our estimate we assume that donors, on the average, hold property until it doubles in value. The tax expenditure is then estimated by halving the value of donated property—to arrive at the appreciation—and then multiplying by one-half of the effective marginal tax rate for each income class (Table 3.10). Under this formula the capital gains tax expenditure for 1973 for all charitable gifts amounted to $179.6 million; for the cultural sector the tax expenditure was $26.3 million. Again, the cultural sector benefited disproportionately from the tax expenditure provision. While cultural charities received 10 percent of all gifts

of property, they received 15 percent of the total capital gains tax expenditure.

Corporate Charitable Income Tax Deductions

Since 1935 corporations have been allowed income tax deductions for charitable contributions. The mechanism is identical to that for individuals except that annual corporate charitable deductions are limited to 10 percent of the corporation's taxable income (5 percent prior to 1982), and corporations are subject to a different marginal tax rate schedule. In 1973 the federal corporate income tax was 22 percent on the first $25,000 of taxable income and 48 percent on taxable income over that amount. For 1983 the rates range from 15 percent to 46 percent. It seems quite reasonable to assume that the bulk of corporate charitable contributions are made by firms in the highest marginal tax bracket, but unfortunately there are no data to support this assumption.

The Business Committee for the Arts, an organization established by businessmen to encourage corporate giving to culture, has estimated that in 1973 corporate donations to the cultural sector totaled $140 million.[12] For the same year, the IRS reported total corporate charitable deductions of $1.2 billion.[13]

To estimate the tax expenditures generated by corporate charitable donations for 1973 we applied an average marginal tax rate of 45.4 percent, obtained by dividing total corporate income taxes before the application of investment credits, $54.4 billion, by income subject to tax, $115.5 billion.[14] We estimate the 1973 corporate income tax expenditure for all charity sectors as $533 million and the tax expenditure for the cultural sector as $63.6 million.

The above figures probably understate the total corporate support for charity because philanthropic contributions are often

Table 3.10

Tax Expenditures—Capital Gains Taxes Foregone on Individual Gifts of Property, 1973

Modified income class	Charitable gifts of property, aggregate			Charitable gifts of property to culture		
	Total charitable gifts—property ($ millions)	Effective marginal tax rate ×50% ×	×50% = Tax expenditure ($ millions)	Gifts to culture—property ($ millions)	Effective marginal tax rate ×50% ×	×50% = Tax expenditure ($ millions)
$ 1– 9,999	$ 115	.09	$ 2.6	$ 0*	.00	$ 0*
10–14,999	221	.17	9.4	0*	.22	0*
15–19,999	91	.20	4.6	0*	.29	0*
20–29,999	570	.31	44.2	9.2	.36	0.8
30–49,999	80	.40	8.0	19.7	.42	2.1
50–99,999	262	.50	32.8	89.8	.53	11.9
100,000–199,999	233	.63	36.7	56.2	.69	9.7
200,000–499,999	160	.62	24.8	11.0	.66	1.8
500,000–999,999	68	.68	11.6	0*	.70	0*
1,000,000+	28	.70	4.9	0*	.70	0*
Totals	$1,828		$179.6	$185.9		$26.3

Source: The Commission on Private Philanthropy and Public Needs, National Study of Philanthropy, 1974.
*See pages 46 and 47.

carried on a corporation's books as part of the company's normal business expenses—which are, of course, also deductible. This is particularly true of sponsorship of cultural programs as part of the general advertising and public relations expenditures.

Corporations, like individuals, may donate property to charitable institutions, but again no data are available to estimate the tax expenditures attributable to the capital gains tax foregone.

THE STATE INCOME TAX

The income tax laws of numerous states follow the federal practice and allow charitable income tax deductions. In these cases the state government makes charitable income tax expenditures, financed by the state's taxpayers. In particular, forty-one states and the District of Columbia impose broad-based individual income taxes, and thirty-five permit a donor to deduct charitable contributions either by an explicit deduction or by allowing the deduction in the federal income tax to be incorporated into the state income tax. Some states impose corporate income taxes and allow charitable deductions for corporate donations.

A rough estimate of state income tax expenditures is possible using the National Study of Philanthropy data. Our analysis assumes (in view of the piggyback nature of most state income tax codes) that the ratio of tax expenditures for charity to tax revenues is about the same for all states as for the federal government. In 1973 the total federal revenue from personal income taxes was $108 billion.[15] The total revenue from income taxes in states that allowed a charitable contribution deduction was $12.6 billion.[16] Using the ratio of 8.6:1, we estimate that cultural institutions, which benefited from $208 million in individual federal income tax expenditures (individual charitable income tax de-

ductions plus capital gains tax foregone), are the intended ben-
eficiaries of $24 million in state individual income tax expendi-
tures.

Federal corporate income taxes in 1973 were $39 billion, and
state corporate income tax revenues were $5.4 billion, a ratio of
7.2:1. Federal corporate income tax expenditures for the cultural
sector were $63.6 million. We thus estimate that state corporate
income tax expenditures for culture were $8.8 million. Similarly,
all charities were the intended beneficiaries of $480 million in
state individual income tax expenditures and $74 million in state
corporate income tax expenditures.

Because of the interrelationship between state income taxes
and the federal income tax, the state income tax expenditures
intended for cultural and other charitable institutions do not
accrue entirely to the benefit of these institutions. Donors who
itemize their federal income tax deductions may deduct state
income taxes. A saving in state taxes from charitable deductions
results in a smaller deduction for state taxes on the federal in-
come tax return, which then increases the federal income tax
liability. Part of the tax expenditure benefit is thus lost to the
donor.

Consider a simple example: A donor in the 25-percent federal
income tax bracket and an 8-percent state income tax bracket
donates $300 to a museum. The state makes a $24 tax expendi-
ture ($300 × .08) as its part of the contribution. This contribution
reduces the donor's state tax deduction from federal taxable in-
come by $24. Therefore, the donor has to pay an additional $6
($24 × .25) in federal income taxes. The net benefit to the donor
from the state is only $18. The state still expends $24, but it
divides into two parts: $18 benefits the donor (and through him
the museum), and $6 benefits the federal treasury.

The higher the income bracket, the higher the percentage of
the state tax expenditure that flows directly to the federal gov-

ernment. In lower income brackets, where the state income tax deduction has proportionately less effect, the proportional benefit to the donor is greater.

In summary, only a portion of the state tax expenditures intended for charitable institutions reaches the target. The proportion of the state tax expenditure passed on to charitable institutions is greatest in the lower income brackets, declining as the donor's income (and hence federal marginal tax rate) increases. (In states that do have a progressive state income tax, the rise in income tax rates over income does not offset the effect of the rise in the federal marginal tax rates.) The latter conclusion is particularly significant for cultural institutions, which depend on higher-income donors for the bulk of their contributions. This is the only income tax expenditure for culture where the incentive effect is *inversely* related to the donor's income.

How much, then, of the state tax expenditures actually benefit charitable institutions? Table 3.6 shows the average effective price of a $1 gift to the cultural sector as 44 cents; this figure is $1 minus the average effective federal tax rate. Therefore, for the cultural sector this tax rate is 56 percent. At this average rate, $13.4 million of the $24 million individual state income tax expenditure accrues to the federal government, and only $10.6 million is an incentive to donors and a benefit to arts institutions. (We have not treated this $13.4 million or the $4 million of corporate state income tax expenditure that accrues to the federal government as a partial offset to the latter's tax expenditure for the arts, since it flows from state law. The piggyback nature of the state tax law would plausibly allow it to be so treated.) Similarly, the average federal corporate income tax rate was estimated above at 45.4 percent. At this rate, $4.8 million of the $8.8 million corporate state income tax expenditure benefits arts institutions. (By similar calculations, $355 million of the state

individual tax expenditures for all charities actually accrues to the benefit of charitable institutions, along with $40 million of the state corporate tax expenditure.)

TAX EXPENDITURES THROUGH FOUNDATIONS

Donors may make gifts or bequests to intermediate charitable entities, such as foundations or trusts, that do not provide charitable services but rather support operating charities. Thus, for example, a donor pays his contribution to a foundation and gets a current tax benefit. The foundation later distributes income or principal to a museum. The transactions operate in a fashion similar to the direct donor-museum contribution with one exception: there is a time lag between the government's expenditure through the donor's tax benefit and the museum'receipt of funds. Accordingly, a grant to a private foundation can be seen as containing a tax expenditure in suspense, that is, as a tax subsidy undelivered to a not-yet-named charity. Donations to foundations that are passed through to arts institutions should therefore be added to the total tax expenditure for culture.

The Foundation Center reports total foundation grants of $2.13 billion for the three years 1974 through 1976. Of this amount, $176.9 million went to museums, performing arts institutions, and music, art, and architecture programs.[17] To estimate the tax expenditure component in private foundation grants to the arts, we begin with the average annual amount of foundation grants to such recipients, $59 million. It is impossible to determine the correct marginal tax rate to apply to this figure because it encompasses a variety of taxes, and very likely, a different configuration of donors than is typical for direct cultural contributions. However, considering the average marginal rates applicable in the cases of individual taxes, corporate income taxes, and the

estate tax, we believe a 40-percent tax rate offers a conservative estimate of the total tax expenditure. At this rate, the tax expenditure implicit in foundation grants to cultural activities is $23.6 million.

This figure may overlap one element of tax expenditure calculated above. Estimates of total corporate donations to the arts that we relied on sometimes include money channeled through private foundations. We believe, however, that the amount of double-counting is small.

We have not estimated separately the tax expenditure for private foundation giving to all charitable institutions; it is subsumed in the estimate for aggregate charitable giving.

TAX-EXEMPT STATUS

Another, although relatively minor, income tax expenditure derives from the fact that cultural institutions, like other nonprofit institutions, can generally qualify for exemption from federal income tax under Section 501(c)(3) and from state income tax on their income from investments and on their admissions income. Recall that a substantial tax expenditure is incurred by the loss of capital gains tax on gifts of appreciated property. As we have noted, the tax expenditure results, at least in part, from the tax-exempt status of the institutions receiving such gifts.

Cultural institutions are taxed, however, on unrelated business income, defined as income from a trade or business not substantially related to the charity's exempt purpose. For example, profits of a museum-owned apartment house are taxable just like the profits of any other business. The definition of unrelated business income is liberally interpreted for arts institutions with ancillary commercial activities like a book and print shop in a museum, or a bar or refreshment counter in a sym-

phony orchestra's concert hall. For the most part, arts institutions have succeeded in avoiding income tax on these business activities, which are, though often quite profitable in the conventional business sense, judged to be related to the basic artistic activity of the institutions.[18] Arts administrators apparently have treated the preservation of tax-exempt status for all the institution's activities as an important goal. Most have been extremely reluctant to engage in arguably unrelated activities whose profits might be taxable, even when an after-tax return from the activities would be advantageous to the institution and even when fears that such activities might threaten the institution's entire tax-exempt status are groundless.[19]

Tax exemption provides financial assistance only when taxes would otherwise be owed. Gifts are not generally considered income, and no profitmaking corporation pays taxes if its expenses exceed its income. An arts institution that applies all of its income to paying current operating expenses pays no income taxes whether tax exempt or not. (The tax code allows income peaks in one year to be offset by losses in another.) Only in cases where wealth is being accumulated through capital acquisitions or a growing endowment does cultural institution income generate a tax expenditure.

The primary tax importance of tax-exempt status, then, lies not in a charity's exemption from tax on its own income, but rather in its qualifying to receive deductible contributions. As a result of this status charities also benefit from special bulk-mailing privileges. In addition, nonprofit status frequently operates to legitimize the institution when it applies for state and local tax exemptions and allows noncompetitive application for certain federal grants and contracts. Accordingly, although the collateral benefits of tax-exempt status are substantial, the direct financial importance is significant in only a few instances, and we treat it as providing no financial aid to the arts.

The practical identity between tax-exempt and nonprofit status obscures an important distinction that has been analyzed by Hansmann in two important papers. While nonprofit organization is obviously advantageous in permitting tax-deductible contributions, it is not the case that the tax deduction is "the reason" that arts institutions are so commonly organized as nonprofits. In Hansmann's view, nonprofit organization is more important as a device for price discrimination (in the case of the performing arts) and quality control (for charities generally) that are economically efficient and difficult to obtain with for-profit organization.[20]

IMPORT DUTIES

Works of art are exempt from import duties. This exemption—the only tax expenditure clearly targeted to benefit the arts—is important to museums, collectors, and foreign artists and dealers, but we have not been able to estimate its (small) total value because of uncertainty as to what rate of duty would apply if the exemption were not in place.

THE ESTATE AND GIFT TAXES

The federal government taxes gratuitous transfers of property, whether during an individual's lifetime or on his death. The primary tax is the estate tax, a gift tax having been imposed to prevent avoidance of the estate tax by lifetime transfers. The Tax Reform Act of 1976 unified the two tax schedules at a rate graduated from 18 percent to 70 percent. It replaced the former exemptions with a tax credit. The Economic Recovery Act of 1981 reduced the top rate to 50 percent by 1985 and increased the

credit to $192,800 by 1987, the equivalent of an exemption of $600,000. Unlike the federal income tax law, with its myriad deductions and credits, the estate and gift taxes offer relatively few deductions. In addition to the debts and expenses of administering the estate, there are two deductions—the charitable contribution deduction and the marital deduction—that present important tax reduction possibilities. In the first case, amounts given to charity may be deducted without limitation; like the income tax deduction, this deduction affects relative prices.

Consider the choices a testator already in the highest estate tax bracket may face concerning the next $1 million. In the 50-percent bracket he may choose to leave children and grandchildren an additional $1 million (in addition to the millions already left them), of which the federal government will take $500,000. Or the full $1 million could be given to charity. The $500,000 lost to heirs or legatees may be considered a small price for directing $1 million toward a purpose the donor strongly favors.

Moreover, the donor is giving up wealth for others, not himself. He simply chooses how to allocate resources after his death. The psychological effects of estate planning on the testator may make it easier to direct more of an estate than of current income to charity.

The estate tax charitable deduction differs from its income tax counterpart in the economic strata affected. Specifically, the rules regarding the estate tax are important only to individuals of relative wealth, while the income tax has a broad democratic reach. This rarefied quality of the estate tax derives from two of its provisions. First, a marital deduction permits a deduction from a taxable estate of the amounts given to a surviving spouse, formerly up to a statutory ceiling but now in unlimited amounts. A similar rule applies for the gift tax. As a result, estate and gift taxes can, for the most part, be ignored for smaller estates where

there is a surviving spouse. Second, the tax credit allows for the transfer of an added substantial amount—$175,000 in 1981 and, in gradual increments, $600,000 in 1987—free of any estate tax. Thus, for all but the wealthiest estates, the tax provides no economic incentive for charitable contributions. Additionally, the gift tax allows a donor to make gifts free of tax up to $10,000 annually per donee. Grandparents concerned about estate and gift taxes can make lifetime transfers to family members without tax, thus reducing their estate to a low or zero estate tax level.

The difference in scale of the income tax and the estate tax is dramatically apparent in the tax return data. The income tax affects broad segments of American society, with perhaps 75 percent of all households filing returns: approximately 81 million returns were filed for 1973, of which 80 percent reported income tax owing for the year. By contrast, the 174,900 estate tax returns filed in 1973 represented only about 9 percent of the year's deaths (of these returns, 70 percent reported some estate tax liability). It is estimated that the changes mandated by the 1976 Tax Reform Act, when fully phased in, will further reduce the number of estate tax returns by almost half, and the 1981 act changes will reduce the number of taxable returns to .3 of 1 percent of all decedents.[21] Thus, when the 1981 act is fully phased in, less than 1 percent of American society will actually incur any estate tax.

When taxpayers subject to the income tax and the estate tax are classified by marginal rates, the difference is equally striking: 25,000 filers of income tax returns reported adjusted gross incomes of $200,000 or more in 1973 (the highest income tax bracket), but only 89 estate tax returns reached the highest estate tax bracket. The number of living people contemplating estate planning and responding to the price incentives of the estate tax is manifestly many times the number who die annually. But if we increase the number of top-bracket estate return filers

ten- or twenty-fold, they constitute a fraction of the top income tax return filers—less than 10 percent. When we refer to households in the top income tax brackets, we include many who may be regarded as well-to-do rather than wealthy; the top estate tax brackets are far more rarefied.

The IRS publishes statistics concerning charitable contribution deductions from the estate and gift taxes, but the data do not accommodate analysis by charitable sector. The IRS survey of estate tax returns filed in 1973 reported $2 billion of charitable contribution deductions claimed in a total gross estate pool of $38.8 billion, divided into $1.4 billion on taxable returns (returns reporting taxes owed) and $.6 billion on nontaxable returns.[22]

Charitable deductions for nontaxable returns were mostly in estates of under $1 million. However, for returns with a tax liability, the charitable contributions were strongly correlated with size. More than one-fourth of the $2 billion total charitable contribution deductions (and more than 40 percent of the $1.4 billion deducted on taxable returns)—$592 million—was deducted by 67 estates, each worth $10 million or more. In fact, for all the 89 taxable returns with a gross estate of at least $10 million, the average charitable contribution per return far exceeded the average marital deduction, the only category where this was true.

The IRS data are silent on the amounts or percentages benefiting each charitable sector, including the arts. To fill this lacuna, we requested the IRS to include such an analysis in their survey of 1977 estate tax returns. The IRS did undertake a pilot survey, but elected not to proceed with a more complete investigation. In the pilot study, however, the IRS scanned 4,200 randomly selected estate tax returns, representing approximately 8 percent of the total number of returns included in the general sample, so that its conclusions cannot be extended to the full

class of estate tax returns, but the results are suggestive: of the returns scanned, 542, or 13 percent, contained a charitable bequest deduction. The pilot study classified the bequests into seven recipient types. Some returns reported bequests to more than one type of charity, for a total of 896 charitable gifts (see Table 3.11).

Cultural bequests appeared in 9 percent of all returns reporting charitable contributions, constituted 6 percent of the total number of gifts, and constituted 5 percent of the dollar amount of the testamentary contributions. Recall that, for income tax purposes, cultural institutions receive 2 percent of the charitable contributions: the difference is consistent with the observed increase in the proportion of charitable gifts to cultural institutions from donors in higher income brackets, and the higher income characteristic of decedents whose estates file returns. Another measure used by the IRS in the estate tax analysis emphasizes the importance of a small number of wealthy individuals. The pilot survey identified the percentage of the total dollar amount for each recipient category attributable to the five largest gifts. For the arts, the five largest gifts accounted for 81 percent of the total dollar amount.

The absence of other data forces us to extrapolate from the pilot study in order to estimate, even roughly, the tax expenditure to the cultural sector attributable to estate taxes. We used the aggregate data from the 1973 survey, but relied on the pilot study for an estimate of the cultural proportion: about 5 percent of the dollars bequeathed to charity. We made two separate estimates. The first assumes, notwithstanding the trend observed for the income tax, that the 5-percent cultural share of charitable contributions is ratably distributed across sizes of gross estates. The second assumes that the estate tax contributions follow a distribution trend similar to the income tax, that is, increasing with size. (One indication that estate tax deductions

Table 3.11

Data From Test Sample of Individual Estate Tax Forms Filed During 1977 (n = 542)

Charitable sector	Returns with a charitable bequest to this sector*		Value of bequests to each sector		Value of five largest bequests to each sector	
	Number of returns	Percent of all returns with charitable bequest	Value ($ millions)	Percent of value of bequests to all sectors	Value ($ millions)	Percent of total bequests to this sector
Cultural organizations	51	9%	$ 4.092	5%	$ 3.309	81%
Churches and church-related organizations	375	69	20.800	26	8.253	40
Educational institutions	131	24	17.757	22	6.482	37
Hospitals	118	22	10.882	14	4.190	39
Other charitable organizations	191	35	17.391	22	8.574	49
Organizations not specified	17	3	7.684	10	6.204	81
U.S., state and local governments	13	2	.838	1	.731	87
Totals			$79.444		$16.671	

Source: Internal Revenue Service, Statistics Division, Feasibility Study Conducted for the Twentieth Century Fund Project on Indirect Aid to the Arts, June 1977.

*Some returns include bequests to more than one sector.

61

for culture can be correlated positively with the size of gross estates comes from a professional journal, *Trusts and Estates*. This journal is published for bank and trust officers and others dealing with estate administration and includes a monthly column, "Wills of the Month," that covers bequests of prominent decedents, selected for reader interest. Of 351 wills reported from January 1968 to March 1977, 140 contained at least one charitable bequest, and of these, 22 percent were to tax-exempt arts institutions. Since these wills were primarily from wealthy decedents, the pattern complements the notion that the distribution of arts contributors is correlated positively with gross estate size.) Accordingly, the second estimate mentioned above assumes that 3 percent of the arts contributions come from the lower half of charitable contributions and 7 percent from the upper half.[23]

For each estimate we have calculated the tax expenditure by gross estate size. We estimate estate tax expenditures for all charity at $809 million. Five percent is $40 million, the "uniform allocation" estimate; allocating cultural sector contributions of 3 percent in the lower half and 7 percent in the upper half produces a tax expenditure estimate of $46 million. We favor the lower estimate.

As mentioned previously, the federal government also levies a tax on transfers by gift, with a deduction for gifts to charity. We have even less data here than for the estate tax expenditure. To arrive at an approximation, we have assumed that the gift tax expenditure to the arts bears the same ratio to the gift tax collected as the estate tax expenditure bears to the total estate tax. By this assumption, the gift tax expenditure for the arts is approximately $6 million.

We note that almost all states impose some form of death tax, whether labeled an estate tax or an inheritance tax. Bequests to charity are generally exempt, but we have not attempted to

quantify this tax expenditure. Although the bulk of state death taxes are creditable against federal estate taxes, almost all states impose an additional "soak-up" death tax equal to the maximum allowable credit. A change in state law rendering charitable bequests taxable might have no effect at the margin on larger estates: the tax increase would just reduce the soak-up tax to meet the credit. We believe the tax expenditure that exceeds any credit ceiling to be quite small relative to the federal estate tax expenditure.

THE LOCAL REAL PROPERTY TAX

The only significant local government tax expenditure for the arts relates to the exemption from property tax of real property owned by charitable institutions. Under a general real property tax, a government assesses all forms of real property with the same measure of value and taxes them at the same rate. Deliberate departures from this norm imply policy choices: a property tax exemption for charities, including cultural institutions, reflects the choice to allocate elsewhere the normally applicable tax burden. The tax exemption thus provides a tax expenditure to institutions deemed worthy of public support. A direct aid system could achieve an equivalent financial effect if the institution paid its full property tax and the government made a separate grant to the institution equal to its tax bill. For example, if a museum owned a $1 million property and paid a 2-percent tax, the exemption has the same financial impact were the museum to pay the $20,000 tax and receive a corresponding $20,000 grant. (See Chapter 6 for a full discussion of the economic effects of the property tax exemption, which generally makes it considerably less expensive for nonprofits to own rather than rent property.)

Viewing a property tax exemption as a subsidy raises several issues not encountered in the context of other taxes. First, why is the property tax due the correct local subsidy to a nonprofit tax-exempt institution? All we know about the museum above is that its corporate entity owns a $1 million building; the museum may display masterpieces or schlock; it may serve large numbers of children or poor people or none; but the tax-exempt benefit remains the same. It is difficult to imagine any public decision process that would choose a uniform direct subsidy for each property-owning, nonprofit institution.

Second, not only is this subsidy hidden from public scrutiny, like other forms of indirect aid, but state law commonly imposes it on local governments; hence the decision to subsidize is beyond the control of the government that provides the subsidy.

Third, not only are the local tax expenditures difficult to estimate, but most localities do not know how much tax is lost in this way. Nonprofit institutions rarely transfer their property for full market value. Comparable properties may be difficult to find; how many marble-columned museums are bought and sold? Nor is the property regularly assessed: why assess property that is exempt from the tax rolls?

Fourth, property tax exemption does not subsidize all arts institutions; unlike the applicable federal law—section 501(c)(3)—it does not extend to all nonprofit arts institutions. To be eligible for exemption the institution must own property, making the subsidy available only to a small number of arts institutions. For example, the Studio Museum of Harlem, the Opera Company of Boston (until 1978), and thousands of other institutions rent their space. Unless the owner also happens to be nonprofit and passes his exemption along to renters via lower rent, the institutions, through their rent, pay property tax on the buildings and land.

Fifth, property tax exemption for arts institutions, although widely accepted, is by no means universal. In surveying a number of state tax departments, we asked about the exempt status of arts institutions. Surprisingly, no clear pattern emerged. In California there is no general exemption for arts institutions unless they qualify under religious or charitable provisions of the law,[24] although certain counties explicitly exempt art museums. New York state law, as amended in 1981, exempts similar general classes of charitable property, but also specifies exemptions for certain opera houses, performing arts buildings, theatrical corporations created by act of Congress, and academies of music.[25] Washington state law currently exempts art collections and the buildings and property used to house and safeguard them.[26] (Prior to 1973, however, only the collections were exempt, and attempts were made to assess the buildings.) During a special state legislative session in 1976, unsuccessful attempts were made to extend the Washington exemption to the performing arts.

In summary, property tax exemptions for arts institutions are neither as well nor as uniformly established as exemptions for other types of nonprofit institutions. Arts institutions such as the Guthrie Theatre in Minneapolis have successfully defended themselves against attempts to remove their tax exemption;[27] others, such as the Philadelphia Academy of Music, have settled for paying property taxes on part of their property.[28] Still others, such as A Contemporary Theater of Seattle (which led the drive to exempt performing arts institutions in Washington), were unable to obtain an exemption.[29]

Sometimes, however, the principle of tax exemption is pushed well beyond the usual bounds. Recently, the Museum of Modern Art succeeded in winning tax-exempt status for an apartment house built on top of the museum building. The museum will be a participant in the apartment house development—

which otherwise is unconnected to the museum's operation. MOMA had sought a direct subsidy from New York City (which certain other major museums in the city receive), but the city's budget crisis made this request impossible to grant.

We wonder if the MOMA case is a harbinger of a new era in property tax exemption during which, for example, every museum or concert hall will be allowed its own tax-exempt apartment building.[30]

Any estimation of the annual national property tax expenditure for the arts is complicated by the great diversity in administration of the tax. Two parameters, the assessed value of property and the property tax rate, determine the tax bill for an individual property. But in the fifty states, thousands of taxing authorities assess property, and taxation practices differ considerably.

First, consider assessment practices. Ideally, and as required by law in many states, the assessed value of property should equal its full market value—the price it would command if put on the real estate market.[31] Assessed values, however, often fall far below the full market values. Properties change hands infrequently, and market data on which to base assessment changes is collected infrequently; in periods of inflation, values rise constantly, and continual updating is a task generally beyond the resources of the taxing government. State laws, perhaps in recognition of the difficulty of ascertaining full market values or perhaps to make it appear that the taxpayer is getting a bargain on his tax bill, sometimes expressly peg assessment to a percentage of full market value.[32] Some states require different valuation schedules according to the type of property. Moreover, the partly subjective nature of the assessment process empowers assessors to selectively grant low assessments.

The total assessed value of tax-exempt property, and especially property owned by arts institutions, is very hard to esti-

mate because, as mentioned previously, many states and localities consider assessment wasteful if a property produces no revenue. Two related trends in state and municipal finance have, however, partly altered this attitude. First, a number of states have made serious attempts to compile property tax exemption rolls. The *1972 Census of Governments* collected aggregate data on property tax exemptions from sixteen states plus the District of Columbia.[33] Although incomplete in some cases, those data represented a serious attempt to define the financial implications of property tax exemption.

Second, political figures have sometimes used property tax exemption data to political advantage. For example, Mayor Kevin H. White of Boston sought increased state aid to compensate the city for the 58 percent of its property tax base that in 1974 was tax-exempt. The very high percentage of tax-exempt properties arose from the concentraton of state and federal facilities, public and private universities, religious institutions, and other tax-exempt institutions. Sometimes a state does mitigate an excessive exemption burden, recognizing that the catchment areas of many tax-exempt institutions extend beyond the property tax jurisdiction that bears the cost of the exemption. This is particularly true for arts institutions, which tend to draw a suburban audience to their urban locations. (See Chapter 7 for a fuller discussion of developments in spreading the burden of property tax exemptions.)

Currently, five states (Connecticut, Maryland, Massachusetts, Hawaii, and New Jersey) collect data that adequately identify arts institutions. Several cities also maintain excellent data on property tax exemptions for the arts including New York City, Baltimore, the District of Columbia, and all cities in Massachusetts and New Jersey.

Even these data are based on assumptions critical to an estimate of the total assessed value of arts institutions' tax-exempt

property.[34] Whatever the difficulties in valuing residences and office buildings, they are surpassed by those involved, for example, in assessing a nineteenth-century masonry structure which no one could use except as a museum, and which no museum would build for itself if beginning anew.

For the purposes of our analysis, we have accepted the assessed values reported. Assessments for nonprofit institutions, once made, are changed infrequently. The same assessments are retained year after year, and this practice is probably the dominant characteristic in assessing art institutions' property. (If the institution actually paid tax, these assessment deficiencies of course might be corrected and the tax liability might rise.)

Another element in estimating the property tax expenditure is the tax rate by which the property value is multiplied to arrive at the tax due. Tax rates are set by local authorities in order to collect the revenues necessary to meet the jurisdiction's budget requirements. Thus, every taxing jurisdiction—including special districts such as water districts and transportation districts as well as the more common government subdivisions such as towns, cities, and counties—determines its own tax rate.

We estimated the property tax expenditure to arts institutions in two steps. First, we arrived at an estimate of the total assessed value of tax-exempt property owned by arts institutions in the United States in 1976. (We used several procedures, which are described in detail in the Appendix.) Despite the poor quality of available data, the two best estimates were reasonably close: $1.7 and $1.5 billion.

We used $1.6 billion, the average of these two figures, as our estimate of the total value of property owned by tax-exempt arts institutions. In order to calculate the property tax expenditure for the arts, we applied an appropriate nominal property tax rate to this estimate. The *1972 Census of Governments* reported

1971 nominal property tax rates for selected cities,[35] and we used this information to formulate a median nominal tax rate. Including all cities with populations above 50,000 yielded an estimated nominal tax rate of 8 percent. Applied to the total assessed value of exempted arts property estimated above, this tax rate implies a tax expenditure of $128 million ($1.6 billion x .08) for 1976; deflating this figure into 1973 dollars gives $101.4 million for the total property tax expenditure for the arts in 1973.[36]

This estimate is, if anything, low. The state data from which we estimated the total assessed value of arts property in the United States did not include New York City, which has the greatest single concentration of tax-exempt arts institutions. (Data for Boston, Baltimore, and New York City are summarized in the Appendix.) The total assessed value of arts institutions in New York City is $258 million—$84 million in land and $174 million in buildings. Lincoln Center and the Metropolitan Museum of Art together account for nearly half of the land value, two-thirds of the building value, and about 60 percent of the total assessed value. Lincoln Center's total assessed value is $117 million—$20 million in land and $97 million in buildings—while the Metropolitan's total assessed value is $42 million—$15 million in land and $27 million in buildings. The 1976 property tax expenditure for these two institutions exceeded $14 million—more than 10 percent of the total estimated national property tax expenditures for the arts.

Another factor that renders the estimate conservative is our omission of exemption from the personal property tax that some states impose. Institutions exempt from real estate taxes typically are also exempt from any personal property taxes. The tax expenditure is, therefore, greater than what we have estimated, since we ignored art collections, equipment, and the like. Also, our use of a 1971 median nominal tax rate probably depresses the estimate, since some tax rates rose between 1971 and 1973.

4

WHO BENEFITS?
WHO PAYS?

Two questions critical in any public policy debate involving government support are:

Who benefits?
Who pays?

These questions—whose answers define the incidence of money transfers in the system—take on particular importance for government support of the arts through the tax system. The wealthy have long played a dominant role in patronage of the arts both as beneficiaries and as donors. In consequence, two inconsistent views concerning the arts have developed: (1) cultural institutions represent a gift from the rich to the rest of society and (2) all of society pays to support an entertainment for the rich. Neither view is correct. Instead, on the average, subsidies to the arts, including those financed through the tax system, flow from the very wealthy to the moderately wealthy and the well-educated. Notwithstanding the stated goals of government support, such as, for example, through the National Endowment for the Arts, poor and moderate-income people apparently do not benefit much.

The incidence of those flows of money attributable to the existence of the individual income tax deduction for charitable contributions is in need of thorough examination. As we have seen, this portion of the indirect aid system is the most significant in financial terms and is the portion for which the most complete data are available. The incidence of this piece of arts aid in the context of the incidence of all sources of income received by arts institutions must also be examined. And it is important to explore alternative funding mechanisms, which might be substituted for the individual charitable contribution deduction, to see how they would affect the overall incidence of the arts support system.

WHO BENEFITS?

The benefits that flow from the arts can be described in a number of ways. The benefits of artistic creation, performance, and exhibition extend throughout our society. A resident painter or a symphony orchestra in a community touches even residents who do not see the paintings or attend the concerts. These considerations of broad benefit underpin the arguments for support of the arts from society as a whole. But a more specific group of arts beneficiaries are those who actually go to concerts, opera, ballet performances, museums, and experience the presentations of arts institutions directly. The benefits they receive are distinct; attendance at arts events constitutes a reasonable measure for helping to determine the benefit side of incidence.

Who attends the theater, dance performances, museums, classical music concerts, and the like? Cross-sectional surveys of an entire population portray the arts audience and allow comparison with those who are not in it. Unfortunately, these

surveys are very costly by reason of the large sample size required to obtain sufficient numbers of responses in the specific audience categories. The only major cross-sectional arts attendance surveys conducted in the United States are the 1973 and 1975 *Americans and the Arts* studies (this chapter draws on the 1975 data) by the National Research Center of the Arts, a subsidiary of Louis Harris Associates.[1] These studies suffer from many of the problems generic to survey research—particularly overestimation of attendance by respondents[2]—but they contain much useful information that has been only partially explored.

Arts institutions have conducted numerous surveys of their own visitors.[3] Unfortunately, few meet the standards required for a definitive study of incidence. Furthermore, their questions, categories, and sampling methods are not comparable, so their results cannot be aggregated. Nor do these surveys comprise a representative sample of the overall audience of arts institutions, much less arts consumers; even Baumol and Bowen's 1964–65 Twentieth Century Fund Audience Survey[4] included only the performing arts and is now outdated.

For our purposes—measuring benefits derived from arts institutions—visits by demographic class is an appropriate indicator. We have assumed that each time an individual visits an arts institution he or she benefits from part of the indirect government subsidy to that institution, and that, on average, the benefit is constant from visit to visit. We could refine this assumption: the length of museum visits varies greatly and the subsidy might be deemed proportional to the time actually spent, and while performances are more consistent in duration, seat locations and prices vary. Not surprisingly, data on length of visit or demographic data on seat location are very scarce. In any case, such refinements are unlikely to alter substantially the primary conclusions of our analysis.

A more important refinement concerns the distinction between "visits" and "visitors." Either may be useful in public policy analysis for the arts, but each relates to a distinct set of questions. To illustrate the difference between the two, consider the museum reporting attendance—visits—of 200,000 per year. This figure might represent 50,000 different individuals—visitors—each of whom came to the museum four times during the year, or it might represent 200,000 different visitors, each of whom attended once. A policy designed to improve the quality of public contact with the arts might be judged by the mean number of visits per visitor and by how a particular program has affected this statistic. On the other hand, an outreach program designed to capture new audiences probably should be more affected by how many visitors—particularly new visitors—attend. When the sample consists of the audience during a particular performance or time period, it is a sample of visits. In such a sample, individuals who attend frequently are much more likely to be sampled than visitors who attend less frequently.[5] Since we wish to take account of the fact that a person who attends the museum twice benefits from the museum's subsidies more than one who attends once, we use visits to indicate who benefits.

A special data problem arises in connection with college students, an important part of the arts audience. Students typically have lower incomes than either the families in which they grew up or the households they will soon form. A student's tastes and preferences are closer to the tastes and preferences of those who have completed the educational program than they are to those of individuals who have terminated their educations at the point the student has reached when he is surveyed. An audience-development program designed to increase attendance among low-income people with little higher education would not be thought a success if it merely drew thousands of college

students to the institution. Thus, it is deceptive to classify a college sophomore earning $5,000 per year at a summer job and part-time work with individuals permanently living on a $5,000 per year income, or with individuals whose total formal education consists of high school and a one-year bookkeeping course. We therefore imputed to all those respondents who identified their occupations as "student," income levels and education levels higher than those reported in the Harris survey data. For example, a respondent with two years of college and an occupation of "student" was classified as a college graduate and assigned an income equal to the average income of recent college graduates.

Incomes

Tables 4.1 and 4.2 compare the distribution of visits and visitors by income class with the population as a whole. The arts audience, which comprises all visits, is much wealthier than the general population: the median household income of the audience is almost exactly $5,000 more than the median household income in the population—$17,765 as compared with $12,742. This finding is underscored when differences between income brackets are examined: although 57.9 percent of the total population were arts institution visitors, the percentage in each adjusted gross income bracket varied from 20.6 percent at the bottom to 89.6 percent in the highest income bracket.

Other surveys support these median income findings. For example, DiMaggio, Useem, and Brown noted a substantial, though smaller, differential between the median incomes reported in 270 selected arts institutions audience surveys and the general population's median income.[6] Baumol and Bowen found that the performing-arts audience surveyed between 1963 and 1965 had a median family income of $12,804, while the median family income of the general population was $6,166.[7]

Table 4.1
Visits to Art Museums, Theater, Classical Music and Opera, and Dance by Adjusted Gross Income, 1974–1975

Adjusted gross income bracket	Income distribution of population		Income distribution of visits (the audience)		Mean number of visits per individual in this AGI bracket
	Percentage	Cumulative percentage	Percentage	Cumulative percentage	
$ 0–$2,999	8.1%	8.1%	1.9%	1.9%	1.05
3,000– 4,999	9.4	17.5	3.2	5.1	1.55
5,000– 6,999	8.5	26.0	6.9	12.0	3.60
7,000– 9,999	10.9	36.9	8.0	20.0	3.33
10,000–14,999	23.8	60.7	18.3	38.3	3.44
15,000–19,999	17.5	78.2	20.6	58.9	5.24
20,000–24,999	8.6	86.8	13.3	72.2	6.75
25,000–29,999	5.3	92.1	9.3	81.5	7.75
30,000+	7.9	100.0	18.5	100.0	10.44
Average for all income brackets					4.46
Median incomes	$12,742		$17,765		

Source: National Research Center of the Arts, *Americans and the Arts*, 1975.

Notes: All columns impute predicted incomes at graduation to students.
All columns include only individuals age 16 or over.

Table 4.2

Visitors to Art Museums, Theater, Classical Music and Opera, and Dance by Adjusted Gross Income, 1974–1975

Adjusted gross income bracket	Income distribution of population		Income distribution of visitors		Percent of individuals in this AGI bracket who were visitors	Mean number of visits per visitor in this AGI bracket
	Percentage	Cumulative percentage	Percentage	Cumulative percentage		
$ 0–$2,999	8.1%	8.1%	2.9%	2.9%	20.6%	5.10
3,000– 4,999	9.4	17.5	4.9	7.8	30.3	5.12
5,000– 6,999	8.5	26.0	7.1	14.9	47.8	5.14
7,000– 9,999	10.9	36.9	9.5	24.4	50.7	6.57
10,000–14,999	23.8	60.7	23.5	47.9	57.8	6.95
15,000–19,999	17.5	78.2	20.5	68.4	67.1	7.81
20,000–24,999	8.6	86.8	11.9	80.3	79.1	8.53
25,000–29,999	5.3	92.1	7.6	87.9	82.3	9.42
30,000+	7.9	100.0	12.1	100.0	89.6	11.65
Averages for all income brackets					57.9%	7.70
Median incomes	$12,742		$15,454			

Source: National Research Center of the Arts, *Americans and the Arts*, 1975.

Notes: All columns impute predicted incomes at graduation to students.

All columns include only individuals age 16 or over.

Interestingly, Baumol and Bowen surveyed audiences before the creation of the National Endowment for the Arts and before almost all the substantial state direct aid programs for the arts were operating. Thus, it appears that ten years of direct government involvement in arts funding did not do much to broaden the audience for the arts; the income gap between the audience and the population remained substantial.

These data may not disclose other, more subtle effects. Perhaps visitors now represent a wider range of family incomes than they did prior to direct government intervention, but this effect is offset by different attendance patterns across income groups (i.e., visits per visitor may vary from the Baumol and Bowen data). Unfortunately, the earlier data are not sufficiently detailed to test such hypotheses.

Figure 4.1 is a histogram summarizing the income distributions of visits, visitors, and individuals in the population. The figure shows which income groups are overrepresented or underrepresented in the audience (visits) and in the art institutions' public (visitors). (We use the term "overrepresented" to indicate a percentage in a given demographic category greater than the percentage of individuals in the general population in that category. For example, in Table 4.1 individuals in the $25,000–$29,999 bracket comprise 5.3 percent of the population but made 9.3 percent of visits to arts institutions. Thus, they are overrepresented in the arts audience.) The cutoff point is $15,000; individuals in households with incomes below this point are underrepresented, and those with household incomes above this point are overrepresented. The distribution of visitors falls below visits in the higher income categories, but this indicates only that such people tend to make more visits to the arts in a year than do visitors with lower incomes.

Tables 4.1 and 4.2 report the mean number of visits per individual and per visitor in each income group, but these numbers

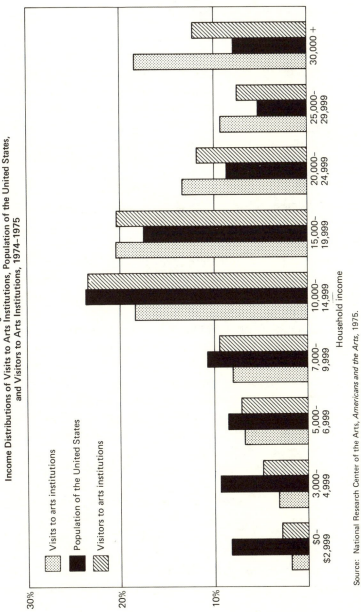

Figure 4.1
Income Distributions of Visits to Arts Institutions, Population of the United States, and Visitors to Arts Institutions, 1974-1975

Visits to arts institutions

Population of the United States

Visitors to arts institutions

Household income

Source: National Research Center of the Arts, *Americans and the Arts*, 1975.

Note: All data include only individuals age 16 or over.

ought to be treated with less confidence than the relative per-
centages reported in these tables. Because the data are based
on survey results, they may suffer from overstatement by re-
spondents who wish to appear more cultured (to the inter-
viewer or to themselves) than they in fact are. When extrapo-
lated, the number of visits reported in the survey substantially
exceeds the number of actual visits reported by various arts
service organizations such as the American Association of Mu-
seums. Relative frequencies are more resistant to this bias and,
therefore, can be used with more confidence.

The foregoing National Research Center of the Arts data in-
clude some attendance at arts events and institutions that are
ineligible for government subsidy. The data in Tables 4.1 and 4.2
and Figure 4.1 are calculated from the survey respondents' an-
swers to questions on attendance at "classical music or opera
performances; ballet, modern dance, folk or ethnic dance per-
formances; theater performances; and art museums or galler-
ies." Commercial dinner theaters, Broadway theater, profit-
making art galleries, and local, amateur performances are all
included, so the audience described might not be the audience
that benefits from government aid to the arts.

In order to ensure that we were looking at the right distribu-
tion, at least approximately, we compared attendance by in-
come at events and institutions of a variety of different subsec-
tions of the arts. The distribution of visits over income groups
is remarkably similar whether we compare the performing with
the visual arts (Figure 4.2), or even the "pop" arts with entertain-
ments of higher brow (Figure 4.3).[8] The size of these different
audiences varies widely; it is the relative fraction of each audi-
ence that falls in each income category that remains much the
same.

This consistency allows us to use the distributions of attend-
ance over income from the Harris survey as a reasonable por-

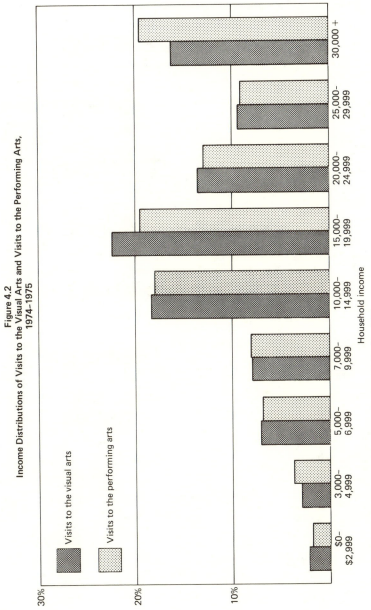

Figure 4.2
Income Distributions of Visits to the Visual Arts and Visits to the Performing Arts, 1974–1975

Visits to the visual arts

Visits to the performing arts

30%

20%

10%

$0–$2,999 3,000–4,999 5,000–6,999 7,000–9,999 10,000–14,999 15,000–19,999 20,000–24,999 25,000–29,999 30,000 +

Household income

Source: National Research Center of the Arts, *Americans and the Arts*, 1975.

82

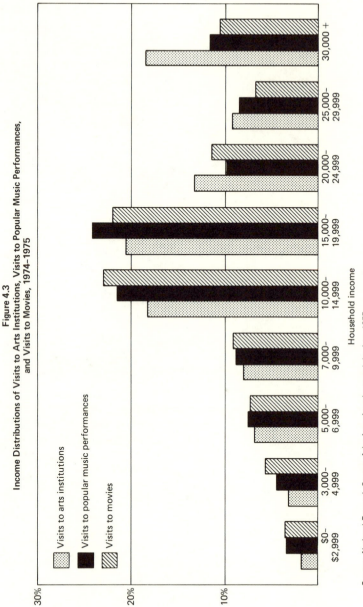

Figure 4.3
Income Distributions of Visits to Arts Institutions, Visits to Popular Music Performances,
and Visits to Movies, 1974–1975

Visits to arts institutions

Visits to popular music performances

Visits to movies

Household income

$0–
$2,999

3,000–
4,999

5,000–
6,999

7,000–
9,999

10,000–
14,999

15,000–
19,999

20,000–
24,999

25,000–
29,999

30,000 +

30%

20%

10%

Source: National Research Center of the Arts, *Americans and the Arts*, 1975.

trait of art-subsidy benefits, even though those attendees did not all enjoy subsidized events.

We conclude, more generally, that the audience for the arts is quite similar across all art forms. In 1963–65, Baumol and Bowen found much the same result for various performing arts; the audiences for each art form were very similar with respect to several demographic characteristics.[9]

Education

Demographic characteristics other than income can be useful in studying incidence. We might also examine the distribution of arts support by region of the country, race, age, or formal education of the audience. In particular, previous research on arts attendance has found that education level better predicts an individual's attendance at the arts than income.[10] Even though we will not be able to match education level with support for the arts (data on who pays for government support of the arts by education of the payer do not exist), we can look at the educational distribution of arts consumption.

Figure 4.4 describes the educational distributions of visits, visitors, and the population sixteen years of age or older.[11] Individuals with a high school education or less consume less than their proportionate share of the arts experience measured by visits and visitors, while individuals with more education consume more. Analyzed by education rather than income, the distribution of visitors drops off much more sharply than the distribution of visits, indicating a more dramatic rise in visits per visitor over educational levels than over income levels. The arts institution audience is extremely well educated.

In summary, the 58 percent of the population that visits the arts is wealthier and much better educated than the population in general. The wealthier and better educated therefore receive more government art support benefits. But while this analysis

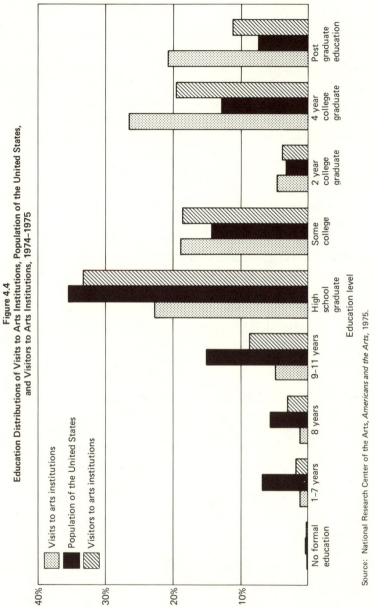

Figure 4.4
Education Distributions of Visits to Arts Institutions, Population of the United States, and Visitors to Arts Institutions, 1974–1975

Source: National Research Center of the Arts, *Americans and the Arts*, 1975.

Note: All data include only individuals age 16 or over.

84

describes the distribution of aggregate government aid, it does not apply to the beneficiaries (or benefits) of any particular government support program. The analysis does not, for example, distinguish between the beneficiaries of the NEA's federal-state-local Partnership Program and the beneficiaries of the Dance Program, each of which might plausibly and justifiably aim to distribute its benefits in a different manner. Similarly, it does not distinguish between the benefits that accrue to the audience of property-tax-exempt institutions and the benefits to individuals attending institutions that receive charitable contributions.

The foregoing discussion described the arts audience only by income and education, and only as consumers. There are other ways to consider the distribution of arts support benefits, although existing data for the most part do not support an analysis like the foregoing; that we have attended carefully to income and somewhat less thoroughly to education should not be taken to mean that we consider these other dimensions unimportant.

For example, if we consider the population as divided into amateur artists, professional artists, and nonartists, we will find: (1) that the analysis above applies for the most part to the nonartists; (2) that artists benefit, directly or indirectly, from subsidy programs ranging from direct grants to institutional support; but (3) that amateur artists receive almost no benefits from government support programs except insofar as they resemble nonartist consumers. Whether amateur artists should be objects of government art support is an important question without an obvious answer. If the object of subsidy programs in general is to increase or improve the experience of art by citizens, amateur participation may be thought to deserve greater support. Our purpose here is not to make that argument, but to point out dimensions other than income and education along which

incidence analysis at some level of formality or detail could better inform arts policy debate.

WHO PAYS?

It is harder to know who pays for the arts than to know who enjoys them. In the previous section we could turn to reasonably good data describing the people who visit the institutions and thus receive the primary benefit of government arts support. However, these institutions receive their funding from many different sources, and these sources in turn impose costs on different groups in different ways. Nevertheless, we can describe the incidence of the charitable deduction tax expenditure and compare it with the incidence of other existing and potential sources of support for the arts.

As always, our emphasis is on describing what might happen if the system were different. First, we will consider who would be richer, and by how much, if the charitable contribution flow of funds to the arts were simply stopped. Then we will make the more reasonable assumption that, if it were to end, arts institutions or government would use different methods to make up the shortfall in revenues. It bears repeating that our results are much more informative for small changes in policy than for very large adjustments: the incidence we portray describes who would pay more or less following an increase or decrease of a few percent in the charitable deduction better than it describes the large adjustment that would occur should the cataclysm of "no more deductions" take place.

The results of this investigation are important: (1) modest redistribution from the wealthy to the less wealthy results from the individual charitable deduction in the arts; (2) the individual

charitable deduction is not markedly more or less progressive in this sense than other sources of arts support.

Who Pays for Tax Expenditures?

The existence of the charitable deduction provision of the income tax law causes government revenues collected by the income tax to be less than they would otherwise be, at least in the first instance. A more precise way to put this is that, if a new tax expenditure deduction were to magically appear overnight, government revenues would decrease. Other events would also be set in motion. First, the federal government would respond to this loss in revenue in one of three ways: increasing taxes—possibly the same tax—by a countervailing provision; decreasing expenditures; or doing neither and increasing its deficit. Second, the people whose taxes changed as a result of the appearance of the tax expenditure and the federal government's response would adjust their behavior in ways that could pass the costs or benefits on to others. Estimating the incidence of a tax expenditure—or any provision of the tax law—thus requires assumptions regarding the response the federal government would make to its presence or absence and the response the market would make to the federal government's actions. Consider the choices:

Increase taxes. The federal government might couple the creation of a tax expenditure to an equivalent increase in taxes. Setting aside for the moment the question of market response to changes in tax laws, those who pay the increase may be said to pay for the tax expenditure. But predictions of where the burden will fall depend on which taxes are increased to support the new expenditure. Often the federal government offsets

changes within a particular tax with other changes in the same tax in order to keep the net revenue from that tax relatively constant. But even if this is done, the burden can vary widely depending on how the changes are made. Will the tax be increased across the board? By tightening administration and catching a few tax evaders? By increasing the highest bracket rate only? By removing other special provisions in the tax?

Reduce spending. The federal government may pay for the tax expenditure by reduced spending on some other program(s). In this case, the cost of the tax expenditure is borne by those who previously benefited from the curtailed programs. Often, creation of one government spending program is linked to decreased spending of some other kind for the same constituency. The cost of a new type of aid to the arts might be discontinuation or slowing of another program for the arts.

Hold other taxes and spending constant. If the federal government makes no adjustment and maintains the previous level of expenditure for all services with the reduced tax revenues, then the government's deficit will increase or its surplus will decrease by the amount of the tax expenditure. This will result in increased inflation throughout the economy. When this occurs, all consumers finance the marginal cost of the tax expenditure as they experience increased real costs due to inflation.

Market response to changes in taxation further cloud this picture. A tax increase that falls initially on one group may be passed on to others. For example, a sudden increase in property taxes falls initially on landlords. But landlords would quickly realize that they could shift some part of the increase into tenants' rents, thus passing along some of the burden. Economists have widely varying views as to the net economic response to

each type of tax, since the incidence or burden of a tax is usu-
ally difficult to determine. It depends on the market structure
of the sector to which the tax applies. Fortunately, our results
for the arts turn out not to be particularly sensitive to changes
in assumptions. We will treat the revenue lost through the tax
expenditure as made up within the same tax in the same pro-
portion as taxpayers currently pay it. As to shifting, we have
adopted the benchmark burden-shifting assumptions identified
by Musgrave, Case, and Leonard for each tax.[12]

The Charitable Contribution Deduction

We now turn to the charitable contribution deduction as used
by individual donors. Its incidence creates a further complica-
tion: the deductibility of contributions from federal taxable in-
come causes three analytically distinct streams of funds to flow
to the arts (leaving aside the capital gains tax expenditure): (1)
the federal income tax expenditure; (2) a state income tax ex-
penditure (only part of which actually benefits the charities);
and (3) the increase in the donor's private contribution, which
we have called the "induced gift" (see Chapter 3). In 1973, the
individual charitable deduction sent $217 million to the arts:
$182 million and $11 million from the federal and state tax ex-
penditures, respectively, and $24 million as induced gifts. In de-
termining incidence we must account for all three flows of funds.

In assessing the incidence of the tax expenditure, we assume
that the federal government makes up the tax expenditure
amounts through proportional increases in income taxes. In
other words, all taxpayers pay for it in proportion to their in-
come tax bills. Economists generally agree that personal income
taxes lie where they fall; the incidence of an income tax is the
same as the distribution of the tax payments themselves. On the
other hand, the donor pays the induced gift as part of his pri-
vate contribution.

Table 4.3

**Income Distributions of Who Benefits from and Who Pays for the
Individual Charitable Income Tax Deduction, 1974**

Adjusted gross income bracket	1. Benefits Income distribution of visits		2. Payments Federal tax expenditure + state tax expenditure + induced gift	
	Percentage	Cumulative percentage	Percentage	Cumulative percentage
$ 0–$2,999	1.9%	1.9%	0.2%	0.2%
3,000– 4,999	3.2	5.1	1.4	1.6
5,000– 6,999	6.9	12.0	2.9	4.5
7,000– 9,999	8.0	20.0	6.7	11.2
10,000–14,999	18.3	38.3	15.4	26.6
15,000–19,999	20.6	58.9	16.0	42.6
20,000–24,999	13.3	72.2	11.9	54.5
25,000–29,999	9.3	81.5	7.4	61.9
30,000+	18.5	100.0	38.1	100.0
Median incomes	$17,765		$22,889	

Sources: Column 1. National Research Center of the Arts, *Americans and the Arts,* 1975.

Column 2. The Commission on Private Philanthropy and Public Needs, National Study of Philanthropy, 1974.

Notes: Column 1 includes only individuals age 16 or over.

Column 1 imputes predicted incomes at graduation to students.

See text for full explanation of calculation of Column 2.

Based on these assumptions, Table 4.3 and Figure 4.5 compare the income distribution of the arts audience—visits to the arts—with that of the payments induced through the charitable income tax deduction. Benefits exceed payments in every income bracket below the highest. Put another way, if we introduce another dollar of aid into the system, it will, on the whole, be moved down the income scale: the money will be raised

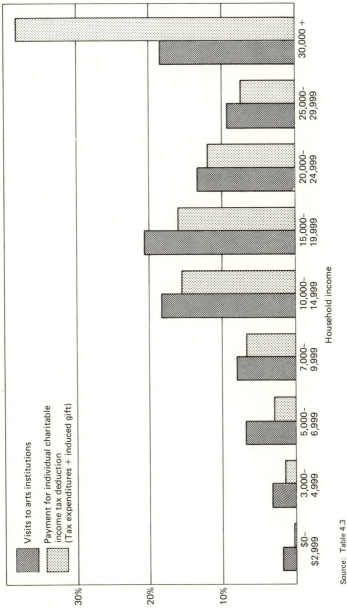

Figure 4.5
Income Distributions of Who Benefits from and Who Pays for the
Individual Charitable Income Tax Deduction, 1974

Visits to arts institutions

Payment for individual charitable
income tax deduction
(Tax expenditures + induced gift)

Household income

Source: Table 4.3

Table 4.4
Income of Performing Arts Institutions, 1970–1971

1. Income item	2. Amount	3. Percentage	4. Distribution [a]
Earned income			
Ticket income	$ 62,723,000	40.0%	B
Services income from government	6,011,000	3.8	D
Services income from other sources	11,663,000	7.4	A
Recordings/films/ radio/TV	2,579,000	1.6	O
Income from performances of other groups	(938,000)	b	b
School/class/ training income	1,108,000	0.7	N
Other nonperformance earned income	6,321,000	4.0	A
Unearned income			
Individual contributions	17,700,000	11.3	I
Business contributions	6,173,000	3.9	K
Combined/united art fund contributions	4,675,000	3.0	H
Local foundation contributions	6,073,000	3.9	I
Other local contributions	4,869,000	3.1	I
Federal government grants	3,390,000	2.2	C
State government grants	2,755,000	1.8	F
Local government grants	2,151,000	1.4	F
National foundation grants	8,193,000	5.2	I
Corpus earnings used for operations	7,840,000	5.0	M

1. Income item	2. Amount	3. Percentage	4. Distribution [a]
Other income			
Corpus principal transfer to operations	2,661,000	1.7	M
Corpus increase—gifts/grants/other	11,204,000[c]	n.i.	M
Total	$156,885,000		

Source: Columns 1 and 2, Ford Foundation, *The Finances of the Performing Arts*, 1974.

Notes: [a] Refers to distribution contained in Table 4.6.

[b] Item is distributed according to the aggregate distribution of all other income items. It is iterated into the analysis.

[c] 1970–1971 was the last year of the major Ford Foundation program to supplement the endowments of symphony orchestras. During this program corpus increase figures were abnormally high. The estimate which is used here allocates the Ford Program over 10 years and adds corpus increases not attributable to that program.

n.i. = Not included.

rather more from the rich and given rather more to the less rich. But as Figure 4.5 illustrates, the benefits will not accrue to the poor; the lion's share will be received by people with incomes between $10,000 and $25,000, and nearly a fifth still will be spent to benefit those with incomes over $30,000. Most of the redistributional effect lies in that more than a third of the funds come from the over-$30,000 income groups.

The individual charitable income tax deduction thus performs reasonably well when measured according to a redistributive criterion. But we also need to compare this source of funding to all income for the arts, since the rest of the system might generate even more redistribution. Would greater reliance, say, on paid admissions (and less on tax expenditures) be a more highly distributive way of supporting the arts?

All Sources of Arts Income

Our analysis of institutional income relies heavily on two major surveys of the finances of arts organization: *The Finances of the Performing Arts* by the Ford Foundation [13] and *Museums U.S.A.: A Survey Report* conducted by the National Research Center of the Arts for the National Endowment for the Arts.[14] The data provided by these two reports, when combined, represent most of the income flow to arts institutions.[15] We include as income only such endowment appreciation as was realized and spent for programs.[16]

Tables 4.4 and 4.5 display arts institutions' incomes by source. The incidence—the percent of each type of institutional income paid by each income class in the population—is shown in turn in Table 4.6. Note that since paid museum visits are usually priced equally, we distributed admissions income according to the audience as a whole, that is, by visits. On the other hand, paid admissions to the performing arts typically represent a range of prices, differing by income class. In the only study on the relationship between average ticket price paid and income, Thomas Moore estimated the elasticity of the average ticket cost with respect to purchaser income as .191. In other words, for every 1 percent increase in income the individual purchased a ticket that was approximately 0.2 percent more expensive; this elasticity allowed us to allocate performing arts admission over income classes.[17]

Table 4.7 distills the information in Tables 4.4, 4.5, and 4.6, including the $128 million per year property tax expenditure. The results are comparable to the estimated percentages by income class reported for the tax expenditures generated by individual charitable income tax deductions also reported in Table 4.7. Thus we can conclude that tax expenditures redistribute benefits in roughly the same way as does the entire arts institutions' support system.

Table 4.5
Income of Art and Art/History Museums, 1971–1972

1. Income item	2. Amount	3. Percentage	4. Distribution [a]
Operating revenues			
General and special exhibit admissions	$ 12,286,000	5.6%	A
Admissions to lectures, films, performances	2,517,000	1.2	A
Tuition payments	7,501,000	3.4	N
Other program charges	974,000	0.4	A
Sales of articles and materials from museum shop and by other means	19,682,000	9.0	A
Restaurants and parking facilities and related activities	21,897,000	10.1	A
Fees for services to other museums	(373,000)	[b]	[b]
Miscellaneous	5,101,000	2.3	A
Private support			
Individuals	27,302,000	12.5	I
Corporations	3,211,000	1.5	K
Foundations	13,965,000	6.4	I
Special fundraising events	6,976,000	3.2	I
United fund organizations	1,305,000	0.6	H
Allocated by colleges and universities	6,814,000	3.1	J
Other	1,216,000	0.6	I
Nonoperating revenues			
Investment income	$ 38,489,000	17.7	L
Gain/loss on disposition of investment properties and other fixed assets	3,665,000	1.7	L

Table 4.5 (*Continued*)
Income of Art and Art/History Museums, 1971–1972

1. Income item	2. Amount	3. Percentage	4. Distribution [a]
Public sector support			
Local government	21,642,000	9.9	F
State arts council			
or commission	2,279,000	1.0	F
Other state government	2,951,000	1.4	F
NEA	668,000	0.3	D
NEH	578,000	0.3	D
NSF	21,000	*	D
National Museum Act	51,000	*	D
U.S. Office of			
Education	804,000	0.4	D
Other federal government	9,341,000	4.3	D
Transfers			
Transfers from			
other funds	6,448,000	3.0	L
Additions to fund balances of all funds other than current funds			
Contributions, grants,			
bequests, etc.	47,000,000	n.i.	L
Gain/loss on disposition			
of investments	22,715,000	n.i.	L
Investment income	14,775,000	n.i.	L
Other	5,502,000	n.i.	L
Total	$217,684,000		

Source: Columns 1 and 2, National Research Center of the Arts, *Museums USA: A Survey Report,* January 1975.

Notes: [a] Refers to distributions contained in Table 4.6.

[b] Item is distributed according to the aggregate distribution of all other income items. It is iterated into the analysis.

*Less than 0.1%.

n.i.= Not included.

Table 4.6

Income Distributions of Incidence of Variables in the Aggregate Incidence Analysis

Variable	$0–$2,999	3,000–4,999	5,000–6,999	7,000–9,999	10,000–14,999	15,000–19,999	20,000–24,999	25,000–29,999	30,000+	Source(s)
Variables used in present income model:										
A. Arts audience (visits)	1.9%	3.2%	6.9%	8.0%	18.3%	20.6%	13.3%	9.3%	18.5%	a
B. Paid admissions—performing arts	1.1	2.7	5.8	7.1	17.0	19.6	13.7	10.0	23.0	a, b
C. Federal income taxes	0.2	1.6	3.4	7.7	17.4	17.9	12.8	7.9	31.2	c
D. Total federal taxes	0.7	4.8	5.5	10.3	19.6	18.1	11.9	6.8	22.3	d
E. State income taxes	0.0	0.4	1.7	5.5	15.9	18.0	15.4	12.1	30.9	d
F. Total state and local taxes	1.3	8.3	7.1	12.3	21.2	18.2	11.4	6.0	14.1	d
G. Property taxes	1.7	10.4	7.5	12.2	20.1	16.8	10.4	5.4	15.4	d
H. Aggregate individual charitable giving (private contribution + state and federal tax expenditures)	2.2	3.8	5.5	10.5	22.0	19.3	10.5	6.2	20.1	d, e
I. Individual charitable giving to culture (private contribution + state and federal tax expenditures)	0.1	0.9	2.0	4.5	10.5	11.3	9.7	6.0	55.0	d, e

Table 4.6 (Continued)

Income Distributions of Incidence of Variables in the Aggregate Incidence Analysis

Variable	$0–$2,999	3,000–4,999	5,000–6,999	7,000–9,999	10,000–14,999	15,000–19,999	20,000–24,999	25,000–29,999	30,000+	Source(s)
Variables used in present income model:										
J. Individual charitable giving to education (private contribution + state and federal tax expenditures)	1.6	3.1	4.8	9.6	20.5	18.8	11.3	6.8	23.5	d, e
K. Corporate charitable giving to culture (private contribution + state and federal tax expenditures)	1.0	7.2	5.7	8.3	14.5	14.0	10.4	7.1	31.7	See text
L. Investment income—museums (including tax expenditures)	0.2	1.4	2.3	4.8	10.8	11.5	9.8	6.1	53.3	d, e
M. Investment income—performing arts (including tax expenditures)	0.2	1.9	2.6	5.1	11.1	11.7	9.8	6.2	51.2	d, e
N. Consumer expenditures for education	1.5	2.1	2.2	5.5	15.4	21.3	18.9	9.4	23.8	f
O. Consumer expenditures for "other recreation"	3.5	4.5	6.0	11.4	23.1	20.6	13.7	4.9	12.3	f

Additional variables used in models 1, 2, and 3:

P. Individual base gift to all charity	3.1	4.9	6.7	12.3	24.2	20.1	9.3	5.2	14.0	e
Q. Individual base gift to culture	0.0	0.0	0.0	0.0	0.5	1.7	5.1	2.9	89.8	e
R. Individual base gift to education	1.5	2.4	3.3	6.1	5.4	4.9	6.5	3.6	66.2	e
S. Corporate base gift to culture	0.7	6.0	4.9	6.6	11.7	12.2	10.1	7.8	40.0	See text
T. Base gifts in investment income—museums	0.1	0.5	0.4	0.6	1.5	2.6	5.6	3.3	85.3	e
U. Base gifts in investment income—performing arts	0.1	1.1	0.9	1.2	2.5	3.6	6.0	3.8	80.8	e

Variables included for purposes of comparison:

V. Adjusted gross income	2.7	4.3	5.9	10.8	21.4	19.1	12.0	6.7	17.0	c
W. Population	8.1	9.4	8.5	10.9	23.8	17.5	8.6	5.3	7.9	a
X. Individual induced gift to culture	0.0	0.0	0.0	0.0	0.04	1.0	3.0	1.6	94.3	e

Sources: a. National Research Center of the Arts, *Americans and the Arts*, 1975.

b. Moore, "The Demand for Broadway Theatre Tickets," *The Review of Economics and Statistics*, February 1966.

c. Internal Revenue Service, *Statistics of Income—1974: Individual Income Tax Returns.*

d. Musgrave, Case, and Leonard, "The Distribution of Fiscal Burdens and Benefits," *Public Finance Quarterly*, July 1974.

e. The Commission on Private Philanthropy and Public Needs, National Study of Philanthropy, 1974.

f. U.S. Department of Labor, Bureau of Labor Statistics, *Consumer Expenditure Survey Series: Interview Survey, 1972–73.*

Note: For further discussion of how each distribution was calculated, see text.

Table 4.7

Incidence of Income of Arts Institutions, Various Models

Adjusted gross income bracket	Audience	Income of arts institutions attributable to individual charitable income tax deduction*	Aggregate incidence models			
			Current income configuration	1.	Alternative income configuration	
					2.	3.
$ 0–$2,999	1.9%	0.2%	1.0%	1.3%	1.1%	1.4%
3,000– 4,999	3.2	1.4	4.1	4.6	4.7	4.3
5,000– 6,999	6.9	2.9	5.1	5.4	5.4	5.7
7,000– 9,999	8.0	6.7	7.9	7.8	8.3	7.8
10,000–14,999	18.3	15.4	16.2	15.6	16.4	16.1
15,000–19,999	20.6	16.0	16.5	15.8	16.3	16.8
20,000–24,999	13.3	11.9	11.5	11.1	11.3	11.7
25,000–29,999	9.3	7.4	7.2	7.0	7.0	7.6
30,000+	18.5	38.1	30.5	31.3	29.3	28.9

Note: See text for full explanation of calculations.

*Federal and state income tax expenditures plus induced gifts.

Figure 4.6
Incidence of Income of Arts Institutions, 1974

Visits to arts institutions

Aggregate current income
of arts institutions

30%

20%

10%

$0–
$2,999

3,000–
4,999

5,000–
6,999

7,000–
9,999

10,000–
14,999

15,000–
19,999

20,000–
24,999

25,000–
29,999

30,000 +

Household income

Source: Table 4.7

101

The aggregate model for current income in table 4.7 is the most complete picture of the distribution of arts institutions' income that we are able to draw with existing data. Once again, the results differ but modestly from the other distributions. The source of arts support by household income is compared with the income distribution of visits in Figure 4.6.

Alternatives to the Charitable Deduction

The remainder of Table 4.7 displays the incidence of support for the arts if the charitable contribution deduction were replaced in any of the following ways:

1. The lost income is made up from all other sources in proportion to their present relative share of arts support (Alternative Income Configuration 1).

2. The charitable contribution tax expenditure is replaced by direct federal grants paid for by taxes proportional to different income brackets' share of federal taxes (Alternative Income Configuration 2).

3. The lost income is replaced entirely by admissions paid as admissions income is currently distributed over income brackets (Alternative Income Configuration 3).

Again, the figures in these columns differ little from our previous incidence analyses; moving even significant amounts of current arts support from the charitable deduction to any of the alternatives would not significantly change the distributive effects of the whole system.

Conclusions

The existing system is mildly redistributive, transferring relatively small amounts of benefits down the income scale. In general, one dollar of payment into the system shifts downward

only slightly to benefit individuals somewhat less wealthy than those who paid. The present system as a whole and the individual charitable income tax deduction cannot be faulted as regressive; these results confound popular wisdom.

On balance, income to the arts is paid for disproportionately by the very wealthy and is enjoyed more by the moderately wealthy and the well educated. The demographic characteristics of the audience—the beneficiaries of the government aid—do not vary much across art forms. While the system tends to be redistributive, it is so only in a limited sense: from the very wealthy to the moderately wealthy.

Not only is the tax expenditure system distributionally flat in absolute terms, but in this regard it also resembles the other existing sources of support for the arts. Two public policy implications result from these observations. The tax expenditure system cannot be faulted as obviously inequitable in its gross distributive effects so as to justify dismantling it or doing major surgery on that ground. At the same time, however, the system does not contain such virtues of economic fairness as to insulate it from changes that might be justified for other reasons. We continue to treat it as open to reform if reforms are indicated by further analysis.

It might have surprised the reader that nowhere in this chapter have we referred to the income distribution of the individual charitable contribution tax expenditure, which was carefully constructed in Chapter 3 (see Tables 3.7 and 3.8). But it should now be clear that this distribution does not describe who pays for the tax expenditure; it indicates who decides how the tax expenditure will be spent. We analyze the distribution of this decisionmaking power in the next chapter.

5

DECISIONMAKING

A frequently applauded virtue of tax-based government aid as a subsidy for charity is that it distributes the decisionmaking power over charitable funds. Particularly as regards the arts, this diffusion of power is perceived as a valuable counterbalance to the bureaucratic centralization implicit in direct aid distribution through grants.

Four related questions frame our inquiry in this chapter:

If diffusion of decisionmaking means anything more than increasing the absolute number of decisionmakers, what kinds of diffusion are desirable?

Are those the kinds that the existing rules encourage?

Is decisionmaking over the funds more diffuse than would be the case if the same money were distributed through a system of direct aid?

Can decisionmaking in the indirect aid system be diffused even more widely than it is now?

A socially valuable diffusion of philanthropic decisionmaking implies more than simply having many people give out money. We suggest that the legitimacy of art support mechanisms should be tested against the following criteria:

First, decisions should reflect expertise in the subject. Decisionmakers who spend public money on the arts should support art of high quality; their decisions should reflect training and expertise.

Second, there should be diversity of opinion. Aesthetic appreciation cannot be defined by experts alone, nor by a few experts. Even the trained eye or ear is constrained by its time and place. The accepted wisdom of the present may reject the great art of the future. Public decisions in allocation of government support for the arts should reflect many varied kinds of tastes.

Third, arts decisionmaking must be independent of malign influence, that is, influence represented by narrow partisan politics or self-serving interests.

A system for dispensing aid that diffuses the power to allocate money, like the indirect aid system, tends to emphasize these last two criteria. When many people decide how to allocate arts support, the decisions reflect differing tastes and appreciations. Thus, malign influence is less able to enter into these decisions. On the other hand, expertise tends to decline when many people participate in the process. More centralized decisionmaking, as in a direct aid system, appears to favor expertise, but it may provide less diversity and less protection against malign influence.

DIFFUSION OF DECISIONMAKING

A statement by the Commission on Private Philanthropy and Public Needs exemplifies a popular view of the individual charitable income tax deduction.

It is entirely appropriate . . . [that] we encourage private giving to nonprofit "charitable" organizations and that we do so by governmental means . . . because giving provides an important mode of citizen

expression. By saying with his or her own dollars what needs should be met, what objectives pursued, what values served, every contributor exercises, in a profound sense, a form of self-government, a form that parallels, complements, and enriches the democratic electoral process itself.[1]

Although this statement naively considers charitable contributions solely as private money, ignoring the tax expenditure component, it does summarize widespread sentiment about the "pluralistic" nature of the deduction.

A similar statement is made by Bittker:

I would argue that the deduction can be viewed as a mechanism for permitting the taxpayer to direct, within modest limits, the social functions to be supported by his tax payments. We have heard much in recent years of alienation, of discontent with bureaucracy, and of the citizen's inability to exert influence over governmental activity. It has often been asserted—with good reason, in my opinion—that voluntary nonprofit agencies under private control provide an antidote to the citizen's feeling that he is ineffectual and powerless, at the mercy of big business and big government. It has, therefore, been customary to defend tax exemption for these organizations and deductions for their benefactors as enhancing their ability to function as independent, decentralized centers of power. Of at least equal importance, in my view, is the fact that the deduction gives the taxpayer a chance to divert funds that would otherwise be spent as Washington determines, and to allocate them to other socially approved functions. One need not be an anarchist to applaud the modest opportunity that this gives the citizen to control the use of funds that will in any event be taken from him.[2]

And the editorial page of *The Boston Globe*, advocating a tax credit system to replace the individual charitable income tax deduction, finds "something very appealing—one is tempted to say very American—about this system of the individual personally directing the flow of some 'government' dollars."[3]

We agree with the intentions of these critics. We also agree, for the reasons suggested earlier, with the wisdom of distribu-

Table 5.1

Comparison of Who Pays for and Who Decides the Allocation of the Federal Tax Expenditure for All Charity: Individual Charitable Income Tax Deductions, 1973

Modified income class	1. Who pays		2. Who decides	
	Income distribution of total income taxes paid		Income distribution of aggregate tax expenditure	
	Percentage	Cumulative percentage	Percentage	Cumulative percentage
$ 1– 9,999	14.3%	14.3%	7.1%	7.1%
10– 14,999	19.6	33.9	13.4	20.5
15– 19,999	18.2	52.1	14.0	34.5
20– 29,999	18.5	70.6	18.9	53.4
30– 49,999	11.3	81.9	13.2	66.6
50,000– 99,999	9.6	91.5	13.2	79.8
100,000–199,999	4.6	96.1	8.3	88.1
200,000–499,999	2.3	98.4	5.6	93.7
500,000–999,999	0.7	99.1	2.6	96.3
1,000,000+	0.8	99.9	3.7	100.0

Sources: Column 1. Internal Revenue Service, *Statistics of Income—1973: Individual Income Tax Returns.*

Column 2. The Commission on Private Philanthropy and Public Needs, National Study of Philanthropy, 1974.

Note: This table does not include the tax expenditure due to capital gains tax foregone on gifts of property.

ting a significant fraction of arts support through a highly diffused mechanism. But we cannot join the easy endorsement of the charitable deduction in its current form on these grounds. The extent to which direct aid embodies qualities of diffusion will have to be carefully considered since the kind of diffusion provided by the charitable deduction requires further analysis.

In considering how the indirect government aid system diffuses decisionmaking power, recall that those who pay for the

tax expenditure do not necessarily decide how the money is to be spent. In the previous chapter, we described the techniques used by the government to allocate the financial cost of the tax expenditure and estimated who pays for it. A different group decides how to spend the money: the people who make the charitable gifts that include a tax expenditure. Thus, the data in Table 3.8, which reports the income distributions for culture and for all charitable giving, also reflect who decided how the tax expenditure will be spent. These decisionmakers are described by only one distinguishing characteristic, household income.

Our analysis focuses on this variable because of the strong relationship between donor income and the type of charitable recipient, a general concern as to how much public decision-making power rests in the hands of the wealthy, and the availability of data. The analysis that follows could also be done with a variety of other demographic variables if the data were available. In Table 5.1, we can see the difference in income between those who pay for the tax expenditure and those who decide how it is to be spent.

MODELS OF DIFFUSION

Diffusion of decisionmaking means that the society has delegated or left the power to make decisions to some large group rather than a centralized authority. It suggests no standards for the delegation. Nor is there a single, widely adopted theory about the type of delegation society expects when individuals allocate the tax expenditure component of charitable contributions. We examine the question of diffusion by proposing plausible models for the distribution of decisionmaking, and then comparing the present system's performance with the standard implied by each model. The models are our own attempt to make precise what

reasonable people seem to mean by "diffusion"; we recognize that other, different models might be equally appropriate. In the analysis that follows we take the household as the decisionmaking unit for the purposes of allocating charitable contributions. Decisions about charitable expenditures tend to be household decisions, coming out of the common household budget or at least implicitly agreed to by members of the household. Most of the data are readily available by households.

MODEL I: "One Person, One Vote"

A common democratic ideal gives each citizen an equal share of power to exert over public decisions: every voter casts a vote of equal strength. By analogy, decisionmaking power over the tax expenditure for the arts could go equally to each donor. Model I allocates decisionmaking equally among households: one household allocates one share of the tax expenditure.

This model is probably the most widely held view of what decentralization should be. Indeed, the Commission on Private Philanthropy and Public Needs, in the statement cited at the beginning of this chapter, implies exactly that:

By saying with his or her own dollars what needs should be met, what objectives pursued, what values served, every contributor exercises, in a profound sense, a form of self-government, a form that *parallels, complements, and enriches the democratic electoral process itself.* [italics added] [4]

MODEL II: "Flat Matching Grant"

Another model allows a household to decide the allocations of public money to the extent that it contributes its own money. The tax expenditure is allocated according to the donor's "effort" as measured by the private contribution. In Model II, the

"Flat Matching Grant" model, each dollar of private contribution (gift minus tax expenditure) entitles the household to allocate one share of the tax expenditure.

MODEL III: "Relative Effort"

Model III takes into account relative effort in that it allocates the power of decisionmaking according to the percentage of income the donor contributes, rather than the total amount given: the higher the percentage, the more of the total tax expenditure the donor is allowed to distribute.

MODEL IV: "Benefit Theory of Taxation"

Model IV allocates decisionmaking power to households in proportion to how much they have helped pay for the support program itself. For example, those households that have paid 25 percent of the government's revenue are entitled to decide how to disburse 25 percent of the total tax expenditure (and, as a corollary, 25 percent of the tax expenditure to each charitable sector). In other words, one dollar in taxes paid entitles the household to allocate one share of the tax expenditure.

This model simply inverts the usual statement of the "benefit theory of taxation," that a tax should be imposed proportionally to the value of public services used. Here a household is allowed to "consume" (i.e., determine the allocation of the tax expenditure) in accordance with how much that household has paid in taxes.

MODELS V AND VI: "One Dollar of Income, One Vote" and "One Dollar of Wealth, One Vote"

The last two models allocate decisionmaking by economic entitlement in other areas. Model V correlates decisionmaking with

income: for each dollar of income the household allocates one share of the tax expenditure. Model VI correlates decisionmaking with the distribution of total wealth.

Some justification for these two models lies in the high correlation between education level and economic level. Society might wish to diffuse decisionmaking among individuals or households that have developed expertise or knowledge about the possible funding areas, and level of income or wealth might provide a practical proxy for such expertise. This reasoning may conflict with some of the reasons for decentralizing the decisionmaking in the first place, but it is not far removed from a common ideal of philanthropy as enlightened benevolence.

But whether desirable or not, Models V and VI are widely believed to be true. Individuals of higher income or wealth dominate the allocation of charitable contributions as the Commission on Private Philanthropy and Public Needs recognizes:

The fact that the wealthy make the largest gifts is referred to as inequitable and undemocratic. Yet it is the essence of equity and democracy for people who have the largest means to make the largest philanthropic contributions. It is also the essence of democracy and pluralism, and the strength of voluntary philanthropy, that givers should be able to designate the objects of their gifts.[5]

Note again that the Commission does not separate the charitable donation into the private contribution and the tax expenditure; whether this argument about the whole would be equally applied by the Commission to the pieces is not clear.

TESTING THE MODELS

We have compared each model with the existing indirect aid system, treating separately aid to cultural institutions, to each of the other charitable sectors, and to all charity; as we will see, the effects of the indirect aid system differ markedly across the

sectors. We adapt a graphic device used by economists, the Lorenz curve, to display the results in a useful way. A Lorenz curve plots fractions of two total quantities on its two axes: its conventional use is to display the distribution of income, by ordering the people represented by increasing income and plotting fractions of the total population from left to right across the horizontal axis. Thus, the first 5 percent of the abscissa represents the poorest twentieth of the population, the next 5 percent the next poorest group, and so on.

On the vertical axis is plotted the fraction of total income, at each point of the curve, represented by the individuals to the left of that point. If everyone had the same income, the Lorenz curve would be a diagonal straight line at a 45-degree angle: the poorest 50 percent of the population would have 50 percent of total income, the poorest 75 percent would have 75 percent,and so on. If all but 1 percent of the population had no income, the Lorenz curve would be a horizontal line from zero to 99, and then a nearly vertical line across the last 1 percent. Thus, the extent to which the variable on the vertical axis is not distributed equally with the variable on the horizontal axis is revealed by the extent to which the Lorenz curve is displaced from the 45-degree line.

Figures 5.1 to 5.6 display the extent to which actual charitable giving corresponds to each of our models. If the pattern of giving corresponded exactly to one of the models being tested, the curve for that model would lie along the 45-degree line—also known as the "curve of absolute equality"—that divides the diagram in half. For example, if aggregate giving corresponded perfectly to Model IV, the "Benefit Theory of Taxation" model, then the households that allocate 25 percent of the aggregate tax expenditure would also account for 25 percent of the total taxes paid by donors; 60 percent of the tax expenditure would correspond to 60 percent of the total taxes paid by donors.

Deviations of the Lorenz curve from the 45-degree line indicate deviations from the theory of the model being tested. To the extent that decisionmaking power is more in the hands of a few than is the variable of comparison, the Lorenz curve will deviate more away from the 45-degree line toward the lower right-hand corner of the diagram. Thus, the further a Lorenz curve is from the line of equality, the less the data being measured agree with the model at hand and the less decentralized is the decisionmaking power.

In each case, we have included only donors in the analysis. If we included all taxpayers in the test of Model I, for example, we would find that many taxpayers made no contributions to certain sectors, and therefore allocated no tax expenditure; the Lorenz curve would display a meaningless inequality of distribution. It seems much more reasonable to interpret each model to mean that all those who wish to contribute—not all citizens—are entitled to the share of control implied by the model under review. We have already discussed the fact that the charitable deduction is restricted to a small fraction of the population by being useless to those who do not contribute and unavailable to those who pay no tax; here we are concerned with the extent to which the charitable contribution fails to diffuse decisionmaking on its own terms—that is, among donors.

Figure 5.1 displays the correspondence of the existing tax deduction to Model I, the "one household, one vote" hypothesis. Whatever the deduction is supposed to do, it does not allocate decisionmaking power this way; the 20 percent of donors (to all charities) who allocate the largest individual tax expenditures control 80 percent of the subsidy. For culture alone, the correspondence is even worse: the 20 percent of donors to this set of charities with the largest tax expenditures control about 95 percent of the resource.

Figure 5.2 displays the same analysis on the assumption of

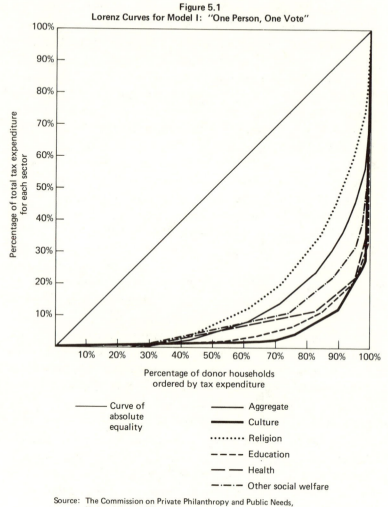

Figure 5.1
Lorenz Curves for Model I: "One Person, One Vote"

Percentage of total tax expenditure for each sector

Percentage of donor households
ordered by tax expenditure

—————— Curve of
absolute
equality

—————— Aggregate

——— Culture

·········· Religion

– – – – Education

— — Health

—·—·— Other social welfare

Source: The Commission on Private Philanthropy and Public Needs,
National Study of Philanthropy, 1974.

Model II: each dollar of contribution would entitle a donor to a constant share of the tax expenditure to control. This is much more like what actually happens than Model I: the donors who give the largest 20 percent of contributions control about 40 percent of the tax expenditure for all charities except religion. Still, the correspondence is far from perfect. Notice that this model is one whose goals could be achieved perfectly by a relatively simple policy decision: if the tax deduction were replaced by a fixed-percentage tax credit, all these lines would be along the 45-degree line.

The next model assumes that control of the tax expenditure should be diffused according to "sacrifice" as measured, not by absolute value of the gift, but by fraction of income given. Figure 5.3 analyzes this model, ranking donors from left to right in order of increasing percentage of income given. For culture and religion, and for aggregate giving, the correspondence is only moderately good. But note that the line for culture is below the 45-degree line: the donors who give large percentages of their incomes control more than their share of the tax expenditure than this model would allot them. The data for this comparison excluded cases in which donors gave more than their annual income, which occasionally happens when very wealthy persons give a very large donation and spread the tax deduction forward over more than one year. Without being able to allocate the tax expenditure over the several years of deduction, these few cases would have greatly distorted the diagram.

Apparently, donors to culture are concentrated in high tax-bracket groups and within that group among professionals, rather than among inherited-wealth parts of that stratum, so that large gifts are a larger percentage of income than they would be for the very wealthy. Consequently, the pattern for other charities—where large gifts with large tax expenditures come

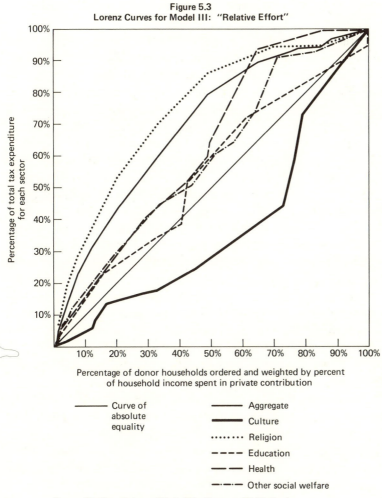

Figure 5.3
Lorenz Curves for Model III: "Relative Effort"

Percentage of total tax expenditure for each sector

Percentage of donor households ordered and weighted by percent of household income spent in private contribution

——— Curve of absolute equality

——— Aggregate

▬▬▬ Culture

········ Religion

– – – Education

— — Health

—·—·— Other social welfare

Source: The Commission on Private Philanthropy and Public Needs, National Study of Philanthropy, 1974.

from people for whom they represent only a small sacrifice—is reversed.

If this model of relative sacrifice is thought to reflect an appropriate standard for diffusion, a simple alteration in the income tax deduction would bring the deduction closer to it. A statutory "floor" under the charitable deduction (like that for the medical expense deduction) subtracting, say, 5 percent of adjusted gross income from charitable gifts in order to determine the deductible amount would limit the tax expenditure to the "extra" effort of the taxpayer in contributing to charity. Since such a floor is a percentage of adjusted gross income, it rises with the adjusted gross income of the taxpayer. The deductible amount is thus limited to the amount above that "normally" contributed by the taxpayer relative to his own income.

Our next model, in which the tax expenditure is controlled according to payments of the taxes that provide it, is reviewed in Figure 5.4. The performance of different charitable sectors varies somewhat, but most of these lines—especially culture and aggregate giving—are quite close to the 45-degree line. Intended or not, the charitable deduction seems to diffuse decisionmaking pretty much according to tax payments.

Figure 5.5 tests Model V, according to which greater income should yield greater control of the tax expenditure funds. Giving to religion seems to accord with the model extremely well, but for the other sectors, the wealthy allocate significantly more than the share of funds Model V allots them: in the aggregate, the richest donors with the highest 20 percent of incomes control more than twice as large a share of the tax expenditure; for health and education, almost three times as large.

The National Study of Philanthropy survey data include several questions from which crude estimates of wealth can be made (data on household wealth is generally very scarce), and Figure 5.6 displays the correspondence of the system to a model

Figure 5.4
Lorenz Curves for Model IV: "Benefit Theory of Taxation"

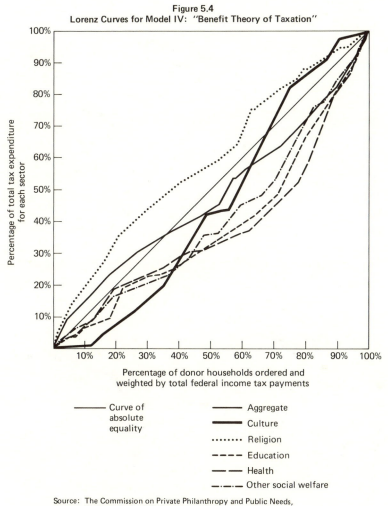

Percentage of donor households ordered and
weighted by total federal income tax payments

——— Curve of absolute equality	———	Aggregate
	▬▬▬	Culture
	········	Religion
	― ― ―	Education
	— —	Health
	—·—·—	Other social welfare

Source: The Commission on Private Philanthropy and Public Needs,
 National Study of Philanthropy, 1974.

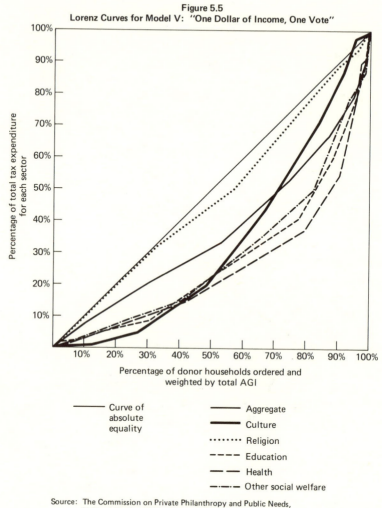

Figure 5.5
Lorenz Curves for Model V: "One Dollar of Income, One Vote"

Percentage of total tax expenditure for each sector

Percentage of donor households ordered and
weighted by total AGI

——— Curve of
absolute
equality

——— Aggregate

▬▬▬ Culture

•••••••• Religion

– – – Education

— — Health

—•—•— Other social welfare

Source: The Commission on Private Philanthropy and Public Needs,
National Study of Philanthropy, 1974.

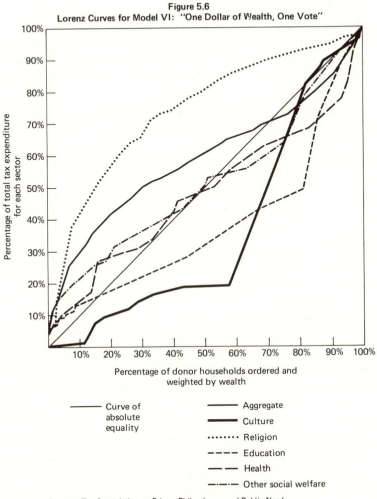

Figure 5.6
Lorenz Curves for Model VI: "One Dollar of Wealth, One Vote"

Percentage of total tax expenditure for each sector

Percentage of donor households ordered and
weighted by wealth

——— Curve of
absolute
equality

——— Aggregate

━━━ Culture

·········· Religion

– – – – Education

— — Health

—·—·— Other social welfare

Source: The Commission on Private Philanthropy and Public Needs,
National Study of Philanthropy, 1974.

that would allocate a share of tax expenditure control to each dollar of wealth. The variation among sectors is quite wide: the rich control much less than their share—in this model's sense—of cultural funds. The system as a whole has a better fit, though it overenfranchises both the poorest and the wealthiest.

DIFFUSION OF DECISIONMAKING WITHIN INSTITUTIONS

Donors select particular charitable institutions in allocating the tax expenditure. Each recipient then decides how to use the donations. Conceivably, the system could infuse additional diversity if the governance of institutions lay with decisionmakers whose demographic characteristics differed from the donors'. If the decisionmakers within cultural institutions bore heterogeneous demographic characteristics, concentration of the tax expenditure allocation power in the hands of wealthy donors might be less disturbing. However, as a growing body of literature indicates, board-level decisionmaking within cultural institutions usually rests in the hands of the socially prominent wealthy.[6]

If art has anything to do with life, individuals with common backgrounds and a shared social life probably will agree more often than a cross section of the population when acting as board members of institutions. Thus, the range of opinion within boards of trustees of arts institutions probably is narrower than would be the case if the boards reflected a broader and more diverse makeup. According to *Museums USA*,[7] 63 percent of art museum trustees are male, 85 percent are white, (an additional 12 percent were not reported) and 44 percent are more than 50 years old (an additional 24 percent not reported); 23 percent are business executives, 6 percent are lawyers, and 7 percent are bankers (an additional 17 percent not reported).

An unpublished 1969 sample of board members conducted

by the Twentieth Century Fund[8] revealed an even more rarefied pattern: 60 percent graduated from Ivy League or "Little Ivy League" schools; nearly a third were in banking and finance, and 20 percent were lawyers; 60 percent were at least 60 years old, 38 percent listed Episcopalian as their religious denomination; and they held an average of three trusteeships in other cultural or educational institutions.

This pattern is no less true for performing arts institutions. In 1971, Hart[9] surveyed the board members of major and metropolitan orchestras and reported that 85 percent of the board members were drawn from the business community: 40 percent were industrial executives, 16 percent were from banking, 12 percent from law, 5 percent from insurance, and 12 percent from other businesses. Arian's study of the Philadelphia Orchestra[10] indicates that the orchestra's board has always been predominantly drawn from the membership of the *Social Register of Philadelphia*. Furthermore, these studies may understate the influence of the socioeconomic elite if they do not include in this category many trustees who share these characteristics: the wives of wealthy businessmen.

In most cases, trustees of arts institutions resemble donors more closely than the general public; the trustees' allocation of tax expenditure funds thus is likely to be closer to donors' preferences than those of the general public. The problem is not that the allocation decisions necessarily are bad, but that diversity is more likely to suffer than would be the case if the trustees were more representative of the public at large. Public policy might plausibly and justifiably delegate a disproportionate share of public decisionmaking power to the rich, to wealthy trustees, and to managers of arts institutions, but that argument cannot be based on diffusion of power to induce diversity. Of course, tradition has played a large role in the composition of boards of trustees in cultural institutions, and cultural institu-

tions remain dependent on contributions from wealthy donors, who then become likely candidates for board membership. Thomas Hoving has unblushingly expressed a criterion of trusteeship: "Any trustee should be able to write a check for at least three million dollars and not even feel it."[11] Ironically it is the public support—the tax expenditure—hidden in such large contributions that makes it far easier for the rich to give each dollar than for others.

Expertise (one of our criteria for decisionmaking legitimacy) is represented at the institutional level by the professional staff members, who exercise considerable judgment within the boundaries of the trustees' policies, and of course can advise the trustees in policymaking. Both direct and indirect methods of aid distribution funnel resources through these expert decisionmakers. Specific illustrations of the effects of indirect aid distribution are discussed in Chapter 6.

DIFFUSION IN THE DIRECT AID SYSTEM

As regards the direct system, several points should be noted in its favor. The government authority empowered to distribute funds, even in the simplest description of the direct aid system, should not be viewed as a usurper of rights that legitimately reside with the governed. A more appropriate view is of a willing exchange by the decisionmakers of their individual decisionmaking power for the greater efficiency and expertise found in a centralized agency.

Evidence of such a voluntary exchange also is found outside government in the existence of United Funds and, say, the March of Dimes. (In fact, some communities are now witnessing the birth of United Arts Funds.) Individuals, of course, give their money directly to hospitals and laboratories, but most elect to

make their contributions more effective by delegating to a centralized bureaucracy power to make the allocation. (Historically, some of these institutions came to assume these intermediate roles for different reasons, such as the elimination of intercharity competition for donors. Functionally, however, they satisfy the donor concerns indicated.) The establishment and funding of government charitable agencies like the National Endowment for the Arts operate similarly.[12]

Moreover, the National Endowment for the Arts displays considerable diversity as well as insulation against political influence—in addition to the expertise we would expect to find in a centralized agency. The basic statute that established the NEA, as well as the agency's internal policy, provides for varying levels of expert decisionmaking. For example, there is no "arts czar" within the NEA: no one person can veto a particular project or reject a specific artist. Applications to the NEA go through a variety of review stages, the most important of which is the advisory panel review. NEA grants most often go indirectly to arts institutions and arts projects through state arts councils or arts service organizations. The NEA imposes no guidelines on substance. Thus, diversity is protected both geographically and by the wide range of people and projects receiving money.[13] In practice, NEA grants have been divided between established institutions and experimental ones. The NEA also has funded arts research.

CONCLUSIONS

Among the candidate models for diffusion, we can identify one that fits the indirect aid system best, and one that is clearly furthest from reality. (Figure 5.7 compares the "aggregate" curves, and Figure 5.8 those for culture, for all the models.) For all charity,

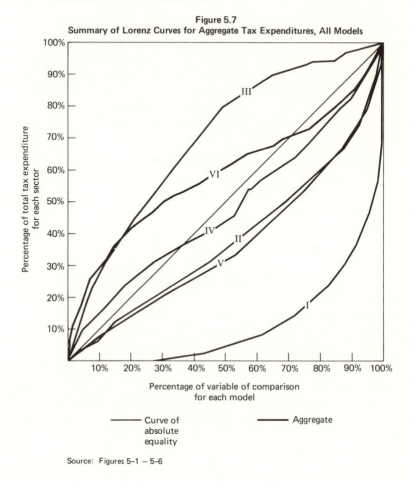

Figure 5.7
Summary of Lorenz Curves for Aggregate Tax Expenditures, All Models

Percentage of variable of comparison
for each model

———— Curve of
absolute
equality

———— Aggregate

Source: Figures 5-1 — 5-6

the best is Model IV, the tax payment model; the worst is the "one household, one vote" model. The others are fairly close together in explanatory effectiveness. (The data for the wealth model, Model VI, are so spotty that we regard our results as suggestive rather than definitive.) Interestingly, the best and

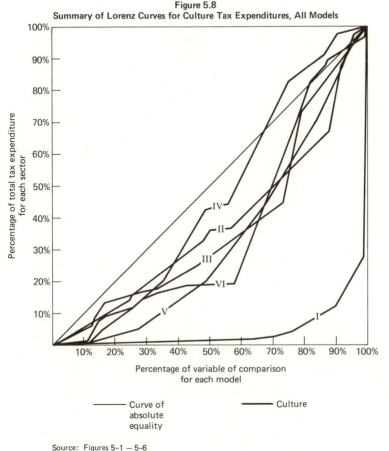

Figure 5.8
Summary of Lorenz Curves for Culture Tax Expenditures, All Models

Source: Figures 5-1 — 5-6

worst fits are, we think, the two that most people would favor as specific interpretations of the general concept of diffusion or decentralization.

In other words, if you think the indirect aid system should diffuse decisionmaking power equally to all households who

wish to donate, you will not be pleased with the performance of the charitable contribution. If you think the system should diffuse decisionmaking power according to how much people pay to support the public purse in the first place, you will find it a well-focused and effective policy instrument.

There are advocates of the "matching grant" standard as a good compromise between expertise, commitment to the charitable purpose, and democracy; the authors include themselves in this group. The system does not perform nearly as poorly by this standard as by Model I, and most charities perform about equally here. Clearly there is room for improvement.

As regards diffusion according to income (Model V), we see that by this standard the system is not merely fair to the rich— it is conspicuously generous. The belief that the charitable contribution rewards high-income people with excessive control over the charitable tax expenditure is well founded, even if one believes that control should increase in proportion to income.

We have seen several important results bearing on the diffusion of decisionmaking provided by the charitable contribution:

1. How well it serves the goal of diffusion depends very much on what specific meaning is given to "diffusion," even when the term is applied only to indirect aid mechanisms.

2. The same dependency exists when the indirect aid system is compared with the direct aid system, which is itself seen to decentralize power (in different ways) when the whole system is taken into account.

3. The familiar pattern of increasing control of the charitable tax expenditure dollars by the wealthy, seen also in earlier chapters, continues to be the dominant characteristic in the data.

These results, especially the third, highlight an important distinction between two virtues sought by diffused decision mechanisms: plurality and diversity. The charitable contribution scores well on the first, but much less well on the second insofar as

the rich are less diverse, in the ways art supporters should be, than the population as a whole. However, the basic principle that each citizen should have the power to allocate some of the funds is important in encouraging support for the deduction. It preserves at least the opportunity for many different cultural policies to be pursued at the same time.

6

EFFECTS ON ARTS INSTITUTIONS

The ways in which indirect government aid to arts institutions has been described and evaluated so far might be applied to almost any government program; the distribution of costs over different income groups and the diffusion of decisionmaking power over public funds are important dimensions of public policies generally. One of the major questions to ask when looking at indirect aid to the arts is, what does the existing system do for, or to, the arts that would not be done if the aid were distributed in a different way? For one thing, it discourages diversity and innovation by concentrating decisionmaking in the hands of a relatively small, demographically homogeneous group, whose members are not typical of the broader population to whom the bill is presented and for whom the government aid system is presumably dedicated. For another, the current system of indirect aid promotes inefficient decisions and sometimes corrupt or unfair ones.

These assertions must be qualified carefully. Not all decisions made under this system are bad, nor are the decisionmakers necessarily wrongheaded. The problem is that the indirect aid system frequently confronts a perfectly well-meaning or well-

important information to the arts institution: they represent the value of what society has to forego when the institution uses a particular input. For example, to build an opera set with real bricks and mortar, convincing or realistic as it might be, would be enormously more expensive than to construct it with canvas and wood frames. The difference in expense indicates to most producers that the extra material and labor required to build a set as a real building is more valuable to society used in another way, perhaps to build usable housing. Economists from a wide range of ideological positions agree that unless specific evidence exists that certain observed prices do not represent social costs, firms—including arts organizations—operate most efficiently when they purchase the inputs that produce outputs (arts experiences) for the lowest cost. Indeed, cases of so-called market failure do cause prices to differ from social costs. Often government is well advised to step into the marketplace and adjust prices, as by subsidy or excise tax, to bring them into line with the costs they represent. Unfortunately, the indirect aid system often does exactly the reverse: it changes the prices of many goods and services used by arts institutions from reasonably accurate indications of social cost into erroneous indicators.

In particular, much indirect aid varies in amount with the use of a particular input: the arts institution receives nothing if it uses none of the input, but obtains increasing benefits as it uses more. Aid tied to use of a particular good or service has the effect of reducing its price to the arts institution, which usually responds, to minimize its own costs, by using more of the particular input and less of others. From a public policy standpoint, therefore, the institution often must operate inefficiently. Moreover, a change in an arts institution's use of inputs affects its outputs, that is, the art experience. The expense of a new building to house a ballet company, for example, may mean curtailing the number of tours the company can make.

The discussion is further complicated by donor influence over the choices of inputs and outputs. Donors choose to donate to one cultural activity, but not to another. They choose to donate to one fundraising drive, but not to a different drive by the same institution. All such decisions affect which artistic experiences the general public is able to see and enjoy. In addition, art institutions' anticipation of future decisions by donors often dictates the decisions of their managers to a significant degree.[1] Thus, the indirect government aid system places decisionmakers in art institutions in a position where their own interests and the interests of their institutions conflict with the public interest.

In-kind subsidies—programs that supply aid in the form of, or conditioned on the use of, a particular good used in production—have the clearest distorting effects on the production of art. By making that good seem cheaper, they encourage its use relative to others. Some types of subsidy encourage the use of capital in the form of real estate or art.

Capital Intensity: Ownership of Real Estate

Some indirect government aid encourages arts institutions to use more real estate, relative to other inputs. The most important example of this effect is the exemption arts institutions usually enjoy from local real property taxes. The subsidy is, of course, proportional to the ownership of real estate and not simply a yes-or-no proposition. Moreover, it is keyed to ownership of property, not use: no exemption is available to nonprofit renters. The real property tax exemption has exactly the same effect on an arts institution as would an artificial decrease in the price of buildings and land or a direct grant restricted to the purchase of real estate. These comparisons are most clearly demonstrated in measuring the annual costs of building ownership. Each year of owner occupancy involves costs (analogous

to a rental payment) such as depreciation, maintenance, heat, lighting, and taxes. The tax exemption reduces the annual costs, making the use of tax-exempt buildings appear less expensive.

The discount is substantial, too: tax rates vary, but in the United States, they tend to be about 3 percent of the value of taxable real estate. To be competitive with other investments, the building must provide benefits of about 10 percent of its value per year. Instead of buying the building, the institution could lease space and put the cost of the building (say, $1 million) into its endowment, which should be yielding a long-term average of 10 percent (at this writing) in appreciation and income combined. If the institution prefers using the million dollars for a building, the benefits from the building must be greater than the benefits from the investment, or at least 10 percent. Therefore, the tax amounts to nearly a third of the net annual cost of owning a building, or a quarter of what taxable building users pay. The relationship between a property's use cost (rent) and its value is so close that it is standard appraisal practice for commercial properties to infer values directly from rents.

A production manager who can buy real estate at a 25-percent discount would be foolish not to try to substitute real estate for the inputs available only at full price. The reduced price of this one input, of course, allows more total production than if the price remained unchanged: therefore an arts institution is richer with property tax exemption than without it. The question here is the cost of giving aid by exemption: how would the institution react to the same subsidy in any other form? It seems unlikely that it would spend as much on real estate as when the aid is contingent on real property ownership. To put the importance of property tax exemption as an incentive to inefficiency in arts institutions in perspective, we might consider the impact on choices if a government made an annual grant equal to one-quarter of the payroll of a qualifying arts institution in-

stead: obviously, the institution would buy less real estate in the future and hire more people.

Many people find it hard to accept that there are substitutes for inputs. This resistance is partly due to our casual acceptance of language like "the museum needs fifty thousand more square feet of exhibition space" in discussing such problems; surely an opera company "needs" an opera house—not no houses or two—and all the scenery or violin players in the world will not be a substitute for a hall.

The conventional vocabulary is inaccurate, however, and the widespread perception that inputs cannot be substituted in arts production is wrong. When the Opera Company of Boston was ready to buy its own house in 1979, it had the opportunity to buy a large or a small hall. The president of the company, Laszlo Bonis, explained that they passed up the large house mainly because "we couldn't afford it."[2] Had it been cheaper (perhaps because of a government grant), they could have and would have bought it; instead, the company substituted more performances for a larger hall. There are minimum requirements of certain inputs (one lead tenor for *La Bohème*, and no fewer); but arts institutions face few such limits when they plan their programs. The company can scrimp on rehearsals to pay Placido Domingo, or economize with a less expensive singer and spend the money on other inputs. And the museum in the previous paragraph that "needs" another 50,000 square feet obviously can make do with less: the evidence is that it is doing without that space at the time the remark is made.

Sometimes market intervention serves to correct erroneous prices—prices that misrepresent costs—rather than distort correct ones, but no evidence exists that remission of property taxes "corrects" the price of real estate. For the property tax exemption to be a genuinely desirable form of aid for arts institutions, there should be external public benefits resulting specifically

from additional real estate investment. None is visible: why, for example, should a museum be induced to buy an expensive, highly secured building with a sophisticated electronic burglary detection system, while an art dealer achieves the same level of security more efficiently by hiring additional guards to patrol a less expensive building?

The property tax exemption's incentive to overbuild is part of a larger problem. As Vladeck and others have pointed out, charitable institutions face many pressures to operate in a capital-intensive way, though Hansmann points out that nonprofits typically have more trouble obtaining capital than firms organized for profit.[3] The property tax exemption amplifies such pressures as philanthropists' preference for bricks and mortar rather than endowments or operating costs. Also, fundraising campaigns for "building programs" that include an architect's model displayed prominently in the art institution's lobby have enjoyed wide success. Much less successful, unfortunately, are attempts to get endowment or operating expense donations to maintain these buildings. (The Lehman Pavilion at the Metropolitan Museum of Art is a notable exception, for the Lehman Foundation has endowed the pavilion's ongoing operating expenses.) Karl Meyer has noted that the Museum of Modern Art did not call its drive for a larger endowment a "building campaign" by accident.[4]

In many cases, funds cannot be obtained unless accepted as buildings. Consequently, an arts institution often will find it difficult to refuse such a gift merely because its operating costs are not covered. The tendency to condition aid on building construction or purchase extends to the federal government, which has operated programs—especially for hospitals and higher education—that pay only for capital investment.

A specific misperception contributes to overcapitalization in the arts and education, namely, the belief that buildings seem

to be a uniquely value-free, and therefore politically acceptable, type of government support. In the past, arts advocates suggested construction of arts facilities as a strategy to ease the federal government into support of the arts.[5] Although building construction or acquisition programs generally do not involve the government explicitly in arts choices, such investments in fact do imply value choices. Bigger buildings, for example, generally imply an emphasis on delivering arts institutions' programs to people who can buy a ticket and enjoy a program on the spot. Conversely, bigger operating budgets could be used for outreach and education programs in schools, on television, and elsewhere.

The professional staffs of art institutions are not immune to this "edifice complex": it is easy to sympathize with a museum director who would rather be remembered for doubling the size of the museum than for adding two new galleries and assuring their maintenance.

Overcapitalization in real estate also imposes restrictions on an institution's future. In the late 1960s, Harvard University dropped a rule that prevented its various schools and colleges from undertaking new construction until a sum equal to the new building's cost was raised for its future maintenance. The impetus behind this move was that millions of dollars in potential federal subsidies were at stake and it was unlikely that the necessary endowment funds could be raised prior to the expiration of the federal qualifying deadlines. The costs of operating the resulting new buildings almost bankrupted two Harvard graduate schools, forcing them to double their student-teacher ratios and otherwise compromise traditional standards of quality. (Harvard's maintenance-endowment rule has now been restored.)[6]

The lessons learned from this experience have commended themselves to the university's administration in connection with

an expansion plan for Harvard's Fogg Art Museum; its history highlights most of the overcapitalization problems we have mentioned. In 1977, the Fogg launched a capital fund drive, a major portion of which was to be allocated for expansion and renovation. In early 1979, an anonymous donor (widely reported to be Dr. Arthur Sackler) announced that he would contribute $6 million if the plans would be enlarged to build an entire new building. The offer was accepted, and the fundraising goals increased accordingly. The Fogg was warned by the Harvard administration in the winter of 1981–82 that it would not be permitted to build the proposed major addition because it had not raised enough money for the building and its carrying costs together. The Fogg responded by proposing to sell some redundant objects from its collection, but it decided against that move after the Association of Art Museum Directors condemned such "deaccessioning" as a violation of the association's code of ethics. Harvard's president stood firm, insisting that an additional $3 million be raised by a fairly imminent date as a condition of going forward, and the Fogg's supporters complied.[7]

What is interesting about this story is the museum's apparent wrongheadedness on two scores—a wrongheadedness closely related to the consistent pattern of overcapitalization by museums. In the first place, the Fogg was apparently willing to saddle its future with a building it could not be sure that it could operate. In the second place, the Fogg—the premier teaching institution for museum professionals in the nation and therefore a logical leader rather than a follower in such practices—acquiesced in the Association of Art Museum Directors' finger-wagging.

Why are museum directors so touchy about selling objects? The "deaccessioning issue" has arisen publicly in connection with some recent sales at bargain prices, and some allegations of sales from collections for a curator's personal gain, at three

New York museums. The issues involved in these cases are no different from the sale of a tractor to a country club chief gardener's brother-in-law for a "knock-down" price; any employee or administrator is responsible for protecting the interests of his company. But the debate expanded to encompass the idea that art objects—different from the tractor in their irreplaceability and value—once in public hands should not be "lost" to the public by sale. Even if the proposition that an object once in a museum should always be in some museum is accepted, however, the direction in which museum directors have taken the issue is not clear. There seems to be a confusion between a single museum and museums in general; why is the proposition that "museums should sell only to other museums" not put forth as an alternative?

Such a policy would not only protect the public against loss of museum objects to private ownership, but would also protect the public against the equally common loss of art objects into inaccessible museum long-term storage (the Fogg will not be able to display its entire collection even in the expanded building) and against the even more serious loss of objects to decay and damage that occurs when they are owned by museums that cannot afford to conserve their entire collections properly. Since every goal claimed by those museum professionals who oppose deaccessioning is served better by a sale-to-museums policy, we are forced to conclude tentatively that a rule of "no sales" is favored because it appears to protect curators from having to decide whether an object should be sold to another museum to allow better display and protection for the remainder of the collection. Hoarding objects that would serve the public and scholarship better in another museum is probably the best example available of the general tendency toward overcapitalization of individual institutions.

This discussion has taken us some distance from the prop-

erty tax; but federal tax policy, as we shall see below, also encourages this very inflexibility in the management of public collections. The property tax exemption is a particularly bad method of distributing aid to the arts because it amplifies an already inefficient approach to the "production" of art services to the public.

The effects of overcapitalization are easy to observe. Because of high operating costs many museums regularly resort to one- or two-day-a-week closings, admission price increases, or other economies. Thus, their art becomes less accessible because the costs of housing it are so high. Dick Netzer has detailed the year-to-year budget impact of the Metropolitan Opera's new building: its operating costs must be drawn partially from production resources. The result is less opera at higher prices than could be had in a more modest house.[8]

Other consequences of overcapitalization are more subtle but equally serious. The very permanence of buildings (or, for that matter, of art donated under "no sale" or "perpetual display" restrictions) that makes them attractive to philanthropists also restricts the ability of arts institutions to respond to evolving trends and scholarship. For example, a museum with a large building divided into traditional galleries, or a regional theater that owns a conventional proscenium building, is much less adaptable to new and different programs than arts institutions renting space under medium-term leases. The open hand of the donor soon becomes the closed hand of an outdated past. Similarly, the arts institution with a first-class building, symbolizing with marble and grandeur the respect its patrons had for art, is much more likely to compromise its future than one with more flexibly invested assets.

Surely the grand gesture has its place, and opera is often appropriately presented in stately halls—but such surroundings are difficult to convert to other purposes if they become mill-

stones around the art institution's neck. The point is not that the arts should always be displayed and performed in rented warehouses, but rather that a complex of pressures, including the property tax exemption and, to a lesser extent, the income tax deduction rules by which the government amplifies the philanthropy of the rich, pushes these nonprofit arts institutions to consistently spend more of their resources on inflexible and costly-to-maintain buildings than they should.

Capital Intensity: Works of Art

Indirect government aid to the arts also encourages the use of capital other than real estate. Museums, for example, usually have more wealth invested in art objects than in their buildings; Harvard's Fogg Museum collection has been estimated to be worth as much as the university's entire endowment.[9] It may seem contradictory to suggest that a museum can invest "too much" in art objects, since a museum is at the very least a repository: we expect it to collect and preserve art objects in perpetuity. However, the arts institution ill serves even this function if it acquires so many art objects that it cannot provide adequately for the preservation and viewing of the art works— space, security, and control of temperature and humidity. In any case, no publicly supported museum should be viewed solely as a repository. Its chief role is often educational—to inform and teach by exhibiting art objects to the public.

The importance of the latter role is well illustrated by the litigation concerning The Barnes Foundation, one of several museums that exhibit a single individual's collection, usually in a sharply restricted format.[10] The collection left by Albert Coombs Barnes (including works by Renoir, Picasso, Matisse, Seurat, Corot, Titian, and many others) was valued at from $25 million to $100 million in 1958. The trustees of The Barnes Foundation

operated the collection so as to exclude the general public, not-withstanding an earlier judicial ruling that the foundation was entitled to property tax exemption as a public charity. The Pennsylvania Supreme Court construed the trust indenture establishing The Barnes Foundation as aimed at setting up an art gallery as well as a school. The court thus required public access:

A painting has no value except the pleasure it imparts to the person who views it. A work of art entombed beyond every conceivable hope of exhumation would be as valueless as one completely consumed by fire. Thus, if the paintings here involved may not be seen, they may as well not exist.

The court emphasized the tax exemption benefits enjoyed by the foundation:

If The Barnes Art Gallery is to be open only to a selected restricted few, it is not a public institution, and if it is not a public institution, the Foundation is not entitled to tax exemption as a public charity.[11]

When a museum provides an experience of visual art for its visitors, it can devote more or less of its resources to the objects themselves. Many museums now invest so heavily in art objects that most of the collection must be stored rather than exhibited. But others have elected instead to acquire a small collection nearly all on display, or no collection at all, with extensive, temporary exhibitions, a lecture program, slide tapes, art classes, and field trips. Similarly, a museum might mount a special exhibition that depended on a few borrowed works and others from its own collection combined with an extensive catalog or lecture program, or it might borrow dozens of objects from around the world for a blockbuster exhibition.

In short, arts institutions make choices about how to serve: differing levels of investment in art objects may produce differing but equally plausible programs. But indirect aid encourages

institutions to acquire works of art. As we have seen, the federal income tax deduction for charitable contributions permits the donor to deduct the fair market value of appreciated property without including the appreciation as income (even as capital gain). These tax benefits for the appreciation in value give added encouragement to donate property in-kind rather than cash, especially to wealthy donors.

This discussion has treated the fair market value of a work of art as readily ascertainable and has assumed that donors will claim the correct value when they make contributions. In fact, however, it is difficult to value works of art, particularly of museum quality, and a range of reasonable values rather than a single value may express the monetary worth more accurately. Donors may take advantage of valuation difficulties by deducting large dollar amounts, and it may be that they systematically overstate the value of donated art works. If this is so, the foregoing understates the income tax incentive to contribute art objects.

Moreover, since the full benefit of the charitable contribution of tangible personal property (including works of art) is limited to a charitable recipient that will use the property in connection with its charitable purposes, donations of art objects are funneled to arts institutions rather than other charities. (To a lesser extent, churches and schools also benefit in this way.) These tax provisions thus create incentives for more contributions of art objects to museums. The data presented earlier (see Chapter 3) on types of indirect aid indicate that 57 percent of the total charitable contribution to culture in 1973 was in the form of property while property amounted to only 10 percent of the total contribution to all charity. (For museums alone, the property percentage is presumably higher because of the relative importance of art donations.)

The incentives from the estate tax are similar. An owner of

valuable art works can leave them to his or her family only by incurring estate taxes that will diminish the liquid assets of the estate. Moreover, the uncertainty in valuation of the art renders the amount of this liability indefinite and hard to plan for. The owner may resolve this problem by leaving the art works to charity, thereby removing from the taxable estate both the tax-incurring asset and the uncertainty.

Donor restrictions may tie gifts of cash or securities to increased museum investment in art works. Or a donor may require as a condition of giving a painting that the museum keep it, and sometimes may even specify the manner in which the work must be exhibited. Although the institution arguably does not receive the full value of the work when it obtains a restricted rather than an absolute gift, the Internal Revenue Service generally applies no reduction to the donor's charitable contribution deduction. Even a painting donated without strings may incur a "moral obligation" that pushes the museum to retain it for a certain time. In addition the arts institution generally has little incentive to turn down such gifts, as they cost the museum nothing (except for marginal increases in security and storage).

The donor's restrictions apply to two sources of enrichment for the institution from the contribution: the private contribution for which the donor pays and the tax expenditure that represents an indirect government subsidy, paid for out of general revenues. Here, we are concerned with the donor's power to restrict the latter, making the publicly supported share art-intensive. This effect generally is ignored, as when Mr. and Mrs. Sydney Lewis made a $250,000 grant to the Whitney Museum for the purchase of works by living American artists. Thomas Armstrong, the director of the Whitney, described the details of this grant:

As is the case with other donors, the arrangement has been that both the Lewises and the museum can recommend to each other works to

be acquired for the permanent collection, and each reserves the right to veto the other's choice. So, if I wanted to buy a work by an artist that they didn't like or feel was important, they could say that it wasn't appropriate; they didn't want their money spent that way.[12]

The Lewises made a generous gift for a worthy purpose, but they and the museum director treated it as if only the donors' money was involved. To the extent that this gift includes a large tax expenditure, the indirect aid system has used public money to magnify a private preference for capital- and art-intensive investment. Given the public decision to provide a particular amount of indirect government aid to the arts institution, there appears to be no benefit in denying the institution maximum flexibility in its use, nor in restricting the museum to accepting only art objects that it will retain for a certain period.

The critical link between donors and acquisitions is well documented: according to Thomas Hoving, the Metropolitan Museum of Art added 15,000 works of art to its collection between 1965 and 1975, of which 85 percent were gifts or bequests. Karl Meyer estimates the total value of these donations, including the Lehman collection and the Nelson Rockefeller collection of primitive art, to be more than $100 million.[13] Ralph Colin, then the administrative vice president of the Art Dealers Association of America, stated, "The museums of this country, with few exceptions, rely to the extent of well over 90 percent on gifts and legacies for their new acquisitions."[14] Yet Alan Shestack, Director of the Yale Art Gallery, has expressed the fear that through donor restrictions, successive generations of donors will dictate the character of museum collections.[15]

Misallocation of Artworks

There is another kind of input distortion in the indirect aid system: a work of art can be donated irretrievably to the "wrong" museum. Donors give art works to institutions for a variety of

reasons, some having at best a tenuous relation to the benefits derived from a work's presence in the collection of the recipient museum rather than the collection of any other museum. Furthermore, donors who encumber their gifts with no-sale and perpetual-display restrictions block museums from trading among themselves to improve their collections.

Consider, for example, the donor who decides to donate a painting by painter Smith to Museum A. The museum already owns several paintings by this artist and has little need for a third or fourth example. Yet the museum has little incentive to turn down the donation; it costs the museum nothing and acceptance will help maintain a good relationship with the donor. Thus Museum A might accept the painting with no intention of ever displaying it. Museum B, on the other hand, might benefit greatly from the addition of this painting to its collection because it owns no Smiths, or because it is looking for works from a particular period or genre. With no donor restrictions, Museum A would be able to sell, lend, or swap the painting to Museum B, but if the painting carries restrictions, whether express or implied, no exchange or other adjustment is possible.

Through the tax expenditure, therefore, the public has helped pay for a transaction that will not be of maximum benefit to the public. To help museums operate more in the public interest, we ought to minimize publicly funded private restrictions on their operation, possibly by limiting the donors' freedom to control the use of their gifts. J. Michael Montias has suggested an auction scheme to improve the allocation of donated art works among museums.[16] This scheme and other limits on donor restrictions are discussed further in Chapter 8. In addition, two of the present authors have argued elsewhere that museums should also consider using their expertise to speculate in art as part of their investment portfolio.[17]

Unfortunately, museum professionals seem to have little in-

terest in such a course, as evidenced by their deaccessioning policy (discussed above in connection with the Fogg Museum). Another possible reason for their desire not to accept exchanges among museums may be that the present policy makes it easier for them to reassure donors that their wishes will be respected even when they are in conflict with the institution's interests.

Other In-Kind Subsidies: The Arts and Artifacts Indemnity Bill

Governments provide in-kind subsidies for particular courses of action by arts institutions through mechanisms other than tax exemptions or deductions. In this section one interesting example of a non-tax in-kind indirect government subsidy to the arts is covered: the Arts and Artifacts Indemnity Bill. This law provides substantial incentives to offer blockbuster exhibitions rather than, say, to highlight art works already in collections with lecture or catalog programming. Passed in 1975, it provides free all-risk insurance, within certain limits ($250 million maximum outstanding at any one time, $50 million maximum per exhibition, $15,000 deductible per exhibition), for art exhibitions coming to the United States from abroad or going overseas from the United States. Only one part of an exchange can be covered, and insurance is available only for exhibitions certified by the State Department as in the "national interest."

The testimony supporting this legislation argued that important exhibitions were not being assembled and circulated because of the escalating costs of insuring the art objects:[18] two-thirds to three-quarters of the cost of mounting an exhibit was said to consist of insurance premiums. Thomas P. Hoving, then director of The Metropolitan Museum of Art, testified that the museum had spent a total of $818,000 in insurance premiums,

on nine recent exhibitions, with no losses incurred.[19] Congress responded with free insurance—which was seen as a nearly costless way to help museums broaden their education and cultural activities. But the legislation exemplifies the faults of such in-kind subsidy programs in an interesting way.[20]

The correct insurance premium is an amount, computed by actuaries, that reflects the value of the works and the likelihood that they will be damaged or lost, plus an amount for paperwork, administration, and profit. The price of insurance determined in this way provides information; it represents the approximate average value of the damage that can really be expected to occur to such exhibitions, whether by a small act of vandalism, loss of one crate among many, or foundering of the ship carrying a whole show. Even though any single exhibition is likely to come through unscathed, the premiums charged for a hundred such shows should be close to the damage or loss incurred by the curatorial policy that decided to have them.

Exactly as the cost of crating the paintings or hiring extra guards informs the decisionmaker of the labor resources society will have to give up in order to enjoy the proposed exhibition, the cost of insurance reveals, at least, the money equivalent of the probable losses of art objects the exhibition will entail. In particular, it is an estimate by experts who deal regularly with shipping valuable items. Also, most insurance companies insert into their contracts conditions such as which carriers are acceptable, how objects can be shipped, what security should be maintained and other stipulations that limit the risk.

Unfortunately, as the evidence available to Congress demonstrated, insurance companies were not very good, from a policy analyst's point of view, at pricing and selling this kind of insurance.[21] They tended neither to compete in providing innovative

services nor in supplying information about available services. The available data on museum exhibitor losses indicate that the premiums typically charged were much greater than the loss experience for this particular category of risk. Where the loss ratio (the fraction of premiums paid out in claims) on comparable insurance is about 60 percent, museum exhibitor insurance showed a loss ratio of only 5 percent, and no company apparently cared to offer more competitive rates. The commercial premiums actually exaggerated twelvefold the insurance costs of the expected exhibitor losses.

Thus the decision of the government to offer insurance was justifiable, assuming other strategies to induce competition were impractical, to correct a misleading price. But Congress' remedy overcorrects the system: reducing the price of insurance to zero skews arts decisions just as overcharging does. Free insurance for traveling exhibitions tells the curator too little about the risks involved. (An interesting feature of the Indemnity Act is that conditions are imposed neither on shipping practice nor security (except that only $7,500,000 worth of art can be shipped in a single ship, airplane, or truck without special permission). The institution must indicate its plans in its application for indemnification protection, but the Federal Council on the Arts and Humanities (which administers the act) is not empowered to refuse coverage on the basis of these conditions.)

The distortion lies in a loss whose likelihood is concealed from the curator by insurance. When insurance bears the correct premium, a museum's decision not to put on a planned exhibition because it cannot afford the insurance premiums would, in effect, be a decision that the benefits of having the exhibition would not outweigh the potential losses. If the museum did not expect admission fees to cover the premium, or could not find a donor to pay it, it would have even clearer

evidence that the particular exhibition, valuable as it might be, was not worth the costs—including the possible danger to the art objects.

When the government insures exhibitions for a no-cost premium, a curator (already dazzled by the importance of his exhibition) is induced to discount the risk to valuable objects imposed by sending them on tour. Both the discipline and the guidance of the price system are denied him, and he is left to his own devices in making a difficult allocation decision. At the same time, he confronts a subsidy (the value of the premium) that he can obtain for his museum's use only if he proceeds with the exhibition.

The argument is not merely theoretical. In 1977–78 a major international loan exhibition of Irish art provided by the Republic of Ireland toured the United States, including three-month stays in New York, Boston, Philadelphia, San Francisco, and Pittsburgh. Among the art treasures included in this exhibition were two important, yet extremely fragile, illuminated manuscripts—the Book of Kells and the Book of Durrow. The curatorial decision to include these unique, irreplaceable manuscripts in the exhibition—particularly since they would only be viewed two pages at a time anyway—was widely debated in the public media.

Did the benefits outweigh the risks? Obviously the organizers of the exhibition felt so, perhaps because the manuscripts made the show into a blockbuster. But this choice was made easier, though not necessarily more correct, by the free insurance.[22] Had the organizers been obliged to pay the correct insurance premium, they might have made the same decision, but they might not have. They certainly would have been making the choice with better information: a decision to proceed would have taken more accurate account of the real risks.

In summary, the in-kind subsidy has reversed (not elimi-

nated) a distortion of museums' use of traveling exhibitions as compared to other, less risky, means of providing art. As a test comparison, consider what museum decisionmakers might do if the government offered museum insurance at a correct premium and substituted a cash subsidy in the same amount, but not tied to traveling exhibitions. Unless (1) we are certain that every museum now considering a traveling exhibition would proceed to mount it under such circumstances, or (2) we think there are special public benefits to be obtained from museums devoting resources to traveling exhibitions rather than other activities that cost the same, the zero-price program is suspect, even though it may be more efficient than the system it replaced. It might be argued that this price distortion, in favor of blockbuster tours, offsets to some degree the capital-intensive incentives of the tax system to own a collection and exhibit it permanently. If the museum could choose only one of these two forms of exhibition, the distortions might offset one another in a rough fashion. To the extent that the museum has still other options, however, free insurance pushes the museum further away from them.

Efficient In-Kind Subsidies: The Special Theater District Law

Not all in-kind subsidies induce inefficient allocations of resources. If the factor being subsidized is one that limits outputs, assistance tied to the use of that factor can be as efficient as a cash grant. Generally, this means that the director of the arts institution would spend any additional cash on the "tied" factor. The production function for theater, for example, is inelastic with respect to theaters: one production, one theater. (A closer look complicates the issue: if theaters are made cheaper, the industry may use "more theaters": in the long run, by using

more expensive or elaborate theaters, in the short run, by in-
creasing rehearsal time.) Provision of more theaters will increase
the number of new shows if, and only if, theater production is
now limited by available performance space (theaters will be
used at the efficient rate of one per production). But if there are
more theaters than there are scripts worth producing, building
more theaters will just yield more dark houses.

One local program exemplifies in-kind subsidies with such
"all-or-nothing" efficiencies and also allows us, in a slight
digression, to consider the incidence (that is, who pays and how)
of a non-tax-supported program: New York City's "Special Thea-
ter District." Legislation creating the Special Theater District was
enacted in response to the growing likelihood that new com-
mercial office and hotel development in the Times Square area
would destroy several legitimate theater buildings.[23] The legis-
lation turns on the existence of a more general regulatory
scheme: new construction on any site in the area, as in practi-
cally all urban land covered by modern zoning laws, is limited
to a fixed multiple of a particular building lot's area. This factor
is called a "floor area ratio" or FAR.

Usually the allowable FAR on an urban site is much lower
than the FAR of the most profitable building that might be built
(otherwise there would be no need for a zoning restriction). For
example, land zoned to an FAR of 10 (a 10-story building cov-
ering the whole site or a 20-story building on half of it) can be
used much more profitably at an FAR of 20. (In some very valu-
able locations, an FAR of 60 can be justified financially.)

The Special Theater District (or STD) legislation encourages
the construction of theaters that would otherwise be financially
unattractive in one area of the city. It allows builders there to
exceed the permissible FAR if their buildings contain theaters.
(Flexibility in using FAR in other ways continues to be actively
discussed among city planners and lawyers.) As the additional

profits to be gained from five or ten extra floors of offices often exceed the losses resulting from the theater, four new theaters have been built in the Times Square area under this legislation.

Proponents of the legislation apparently anticipated that adequate performance space was about to be a critical factor on Broadway. Several theaters faced the wrecker's ball, and others were too old and inefficient to attract producers. (By 1974, however, the situation had changed substantially, and one developer, Jerome Minskoff, told a theater conference that he regretted taking advantage of the STD law.[24] At that time, no benefit at all was being obtained from the subsidy. More recently, the theater district has experienced yet another change of fortune and the STD draftsmen seem wise in retrospect. The benefits of the subsidy thus affect the theater industry favorably on an intermittent basis; any other operating costs are, of course, incurred continuously.)

At first glance, there are no costs attributable to the program, for it looks very much like a free lunch, at least when the STD theaters enjoy full houses. What is sacrificed to obtain the new theaters can be found in the rationale, or lack of it, behind the original FAR limitation. Cities are zoned to limit the density of development for several reasons, all debatable by planners and architects, but for our purposes presumably well-founded. (For example, too much construction in a given area will generate excessive loads on in-place sewer and water systems, overcrowd the transportation system, darken the streets, and interfere with ventilation. The buildings will also block light to each other's windows.) Originally zoning a site that would profitably support a FAR of 20 for a FAR of 10 means that society found the services provided by an additional ten stories of construction on that site outweighed by the social costs they would impose.

When the city allows a builder to add five stories in return

for providing a theater, the city is covering the theater's estimated losses with the difference between the builder's extra rents and the (larger) social costs of his large building.

Table 6.1 delineates the transaction. Before zoning, the developer would choose to develop at a FAR of 15 without a theater (4). The FAR limit moves him to a FAR of 10 without a theater (2); society would most like a FAR of 10 with a theater (1), but the Special Theater District device can at least allow him to achieve a FAR of 15 with a theater (3). The example in the table favors trading the additional density for theater space. Surely it would be hard to find a New Yorker who has found Times Square noticeably darker because the Minskoff building is taller than it might have been, much less one who could argue that the additional darkness is more costly than Mr. Minskoff's additional profits plus the net public benefits of the theater.

Unfortunately, if we argue that the "almost unnoticeable" increase in building density is not as bad as the theater is good, the nose of the camel will be followed by the whole beast: we find it equally hard to show that the density's social cost is greater than the profits on the additional office building alone, leaving the theater aside. And if this last is the case, the grounds for limiting Mr. Minskoff's density in the first place— "seizure" of the coin with which we bought the theater—are dubious. Conversely, if we accept that density limits are correct at about the point where they are set under current zoning laws, the argument that the theaters are free, or even cheap, to the city is weak; the benefits from low density must be compared to the benefits from theaters with great precision to justify the policy.

The program is especially interesting in the present context because its cost can be demonstrated entirely within the arena of aesthetic values: the Special Theater District legislation en-

Table 6.1
Costs and Benefits of Special Theater District
(Hypothetical)

	Benefits (Costs)	
	FAR = 10	FAR = 15
A. Office space profit	$1,000,000	$1,500,000
B. Public density cost	(300,000)	(1,300,000)
C. Public benefit from theater	800,000	800,000
D. Theater loss	(200,000)	(200,000)
Developer's profit:		
with theater (A − D)	800,000 (1)	1,300,000 (3)
without theater (A)	1,000,000 (2)	1,500,000 (4)
Total social benefits		
with theater (A − B + C − D)	1,300,000 (1)	800,000 (3)
without theater (A − B)	700,000 (2)	200,000 (4)

courages the buying of art at the expense of urban visual quality. Also, the STD encourages capital investment in an arts program and thus resembles the subsidy programs tied to capital investment that we criticized earlier. One distinction lies in whether the building is the limiting factor in production of the art. For the theater, apparently, it was and is. For museums and performing arts institutions, it is far less likely to be so.

So far, this examination of in-kind subsidies has addressed issues of cost in connection with the goods and services, the inputs, devoted to the arts. However, indirect government subsidies also can affect outputs—the kind of art we produce and enjoy. Again, we cannot demonstrate how much change the indirect government aid to the arts system produces, only that the incentives it creates push the nonprofit arts institutions in directions they would be unlikely to pursue if guided solely by the public interest.

DISTINCTIONS OF TASTE

Among the most important output distortions induced by the indirect government aid system are those that respond to the tastes of particular segments of the population. The predominant distortion of this kind is the encouragement of art that pleases rich people, a distortion fostered by the treatment of charitable contributions under the income and estate taxes.

At the outset, it is necessary to distinguish the favoritism we have in mind from the influence conferred in a free market by wealth itself. A rich man will always have more to say about what is produced than a poor man, since he has more money to spend and hence has more votes in the marketplace. Whether this should be so, and what might be done about it if it should not, is a subject of the greatest importance, but it is beyond the scope of this investigation. What concerns us here, rather, is the extent to which rich people influence the arts in addition to the market power they have because of their wealth.

Our discussion since Chapter 3 has analyzed the government supported (tax expenditure) part of giving to the arts. (In the next few pages, we will offer examples from the income tax laws using the term "donor" to cover all who give and benefit from tax incentives; the qualitative argument applies to the estate tax and "testator" as well.) For a variety of reasons contributions to nonprofit institutions usually are discussed with no reference to the government share. The annual report that lists important donors notes, "Mr. and Mrs. John Artlover . . . $2,500," and treats the checks and paintings received from the Artlovers and other donors as "private contributions." Nor does the income tax form the Artlovers fill out display the tax foregone as a result of their gift. It is in the interest of fundraisers and contributors alike to treat philanthropy as though the total contribution received from a donor—including both the cost to the donor (the private con-

tribution) and the cost to the government (the tax expenditure)—were a totally private contribution.

But whether we accept the tax expenditure analysis implicit in this discussion or not, the private donor clearly sees the price of his gift.[25] Wealthy taxpayers certainly understand that they can increase the prosperity of a museum or opera company by a dollar at a cost to them of only a fraction of that, and less fortunate givers know that making the same institution a dollar better off will cost them more nearly a whole dollar. Not surprisingly, arts institutions see the world as it is abstracted in Table 3.4: the part of their support that depends on individual choice (other than earned income like admission fees) comes mostly from the wealthy.[26]

This concentration is not surprising for three reasons. The first is the obvious one: rich people have more of their own money to give. The second is almost as obvious: it costs them less to give each dollar. (If two people of equal wealth and tastes face different prices for helping charity, we would expect the one who could provide each dollar for 30 cents to "give" more dollars than the one who had to pay full price.) The third reason is the one that most concerns us in this chapter: rich people like arts institutions' current and expected behavior relatively more than other donors do. The evidence is that they give relatively more of their aggregate private contributed dollars to the arts than others do. A fourth reason for large gifts concerns the intangible personal benefits a donor may derive from his contribution. Cachet, a reputation as a patron of the arts, and access to other large donors, are not obtained ratably for small contributions.

Donors, after all, "buy" some sort of behavior or production on the part of the charity. If a museum, or the Red Cross, simply put contributions in a bank and let the interest accumulate, gifts from all but a few insiders would certainly dry up as they do

for "charities" that are found to use most of their income for further fundraising. The philanthropist parts with his resources to enable, or encourage, the charity to do something he would like done, and he gives them to the organization that will do with his gift the thing he most desires.

It is useful to compare the relative importance of these reasons for disproportionate giving to arts institutions by the rich. To do so involves an investigation of what economists call "elasticities"—the proportional change in some behavior in response to a change in some economic incentive. In particular, it concerns the income elasticity of giving, which measures the extent to which people give more as they have more income; the price elasticity of giving, which measures the extent to which people give more as giving becomes cheaper; and the differences between these two elasticities for arts institutions and other kinds of charity. Martin Feldstein has performed the most recent investigation of these, and confirmed that they are less than plus one and less than minus one, respectively. This means that as income increases by 1 percent, people increase giving, but by less than 1 percent, and as price decreases by 1 percent, people increase giving by more than 1 percent.[27]

Feldstein's research and our analysis of the National Study of Philanthropy data also confirm that different kinds of charity are treated very differently by people of different incomes, and the income elasticities of giving to different causes are different.[28] Generally speaking, religious charities are favored by low-income givers while educational and cultural charities appeal to higher-income givers (see Tables 3.4 and 3.5). Cultural institutions receive 1 percent of the total private contribution to all charity but 4 percent of the total tax expenditure; educational institutions receive 5 percent of private contributions but 13 percent of the tax expenditure; while religious institutions receive 78 percent of private contributions, but only 59 percent of

the tax expenditure. Wealthy donors take advantage of the incentives provided by the charitable contribution deduction and use the tax expenditure to channel additional money to their preferred charities.

But donors do not make these gifts to arts institutions in general; they give to particular institutions for particular purposes. The appeals of charities anxious for gifts generally exceed the funds to be given. Donors choose among charities to encourage and reward those doing, or promising to do, what the donors want. Some donors' preferences are altruistic: they support the dance company that performs in schools in poor neighborhoods or the museum that promotes the work of artists they think talented. But even with the best of donor motives, fundamental questions remain: why should the tastes of the rich determine the expenditure of government support for charities? Do arts institutions change their behavior to correspond to the desires of these wealthy donors? If so, why?

Many goods and services will be misallocated through a free market either because they are public goods, like defense and public health, or because of externalities, or because it requries a great deal of technical expertise to choose wisely among them.[29] In such cases, society delegates the choice to government or to experts. The FDA and licensed physicians decide what drugs to dispense precisely because the choices will be different from the drugs individuals would choose in a free market. If people agreed that a free market would misallocate art for lack of expertise, it might be appropriate for the government not only to subsidize it as it does the army, but to delegate decisionmaking power over the use of the subsidy to experts who will spend it wisely.

How can the expertise of the philanthropists entrusted with the lion's share of the tax deduction subsidy be established? To believe that the rich exert this control in a way appropriate for

public funds, one or more of the following propositions—none of which is easily tenable, though all are possible—must be accepted:

1. What the wealthy want arts institutions to do is by definition what the institutions ought to do: a museum or symphony should satisfy the tastes of the wealthy with public support.

2. (a) What wealthy people permit or encourage is exactly what arts professionals want to do anyway, either by coincidence or because patrons always defer to the will of the professionals; and

 (b) What arts professionals want to do is what ought to be done.

3. What the wealthy want from arts institutions is exactly what the public wants, perhaps because very rich people are not "different from you and me."

4. What wealthy people support with their own funds represents at least a plausible target of public aid. Since no delegation of decisionmaking authority is certain to meet the threefold criteria of expertise, diversity, and resistance to malign influence, the least costly delegation follows the use to which private donors, predominantly the wealthy, put their own funds.

Proposition 1 will not support an argument either way; either you believe it or you do not. We do not. Proposition 2 is contradicted by many stories that leak out from time to time. It is interesting, incidentally, that the tax law subsidy mechanism gives none of the parties involved any incentive to divulge data that would allow us to test the hypothesis. A new program or a change in plans occasioned by a donor's explicit or perceived desires will always be described as the result of a professional analysis; an innovation foregone in fear of donor retribution—

whether explicitly threatened or perceived—will never be heard of at all.

It is important to remember, with respect to Proposition 3, that there are several reasons why the wealthy might want an arts institution to function differently from the way the rest of the public wants. For one thing, rich people generally are well educated and often receive at least an introduction to the fine arts. They may have less desire or need for educational programs. In matters of connoisseurship, they may be less in awe of a curator's or director's critical judgment and more likely to rely on their own. Also, the wealthy are much more likely to have taken an investment position in the work of a given artist or school—at least in the plastic arts—as collectors, and may have much at stake in the reputation of their favorite painter— a reputation that the museum curator can affect substantially. The wealthy are, on the average, older than the population as a whole; they may be less flexible and less open to innovation in art than the rest of society might like. Wealthy people may be more interested in maintaining arts institutions as restricted clubs; if so, they may be less pleased by a substantial increase in attendance by the poor and middle classes. Such exclusivity is evidenced directly in Arian's discussion of the Philadelphia Orchestra's Ladies Committees, which functioned as exclusive social clubs by invitation only—despite their charitable outreach functions like managing youth concerts.[30]

Some of these tendencies may push in opposite directions. Thus education and the desire for social distinction may accommodate innovation even if the others favor the status quo. In other cases, these biases may reinforce each other. Admiration for late eighteenth-century American portraits may be greater when one of Great-Grandpa already hangs over the fireplace and only a few are available at any price. In any event, these factors make it difficult for us to conclude that the tastes of the rich and the desires of society in general are congruent.

For example, the Philadelphia Orchestra twice turned down financial assistance so as to avoid a small measure of public governance. In 1963 and again in 1968 the orchestra's board of trustees refused seats to a labor union and to the city of Philadelphia despite significant conditional contributions. In this case, the trustees were not refusing support that might compromise their standards; they gave up resources to avoid having their standards set in a slightly more democratic way.[31]

At this point, two seemingly banal observations must be stated. First, rich people have as much right to pursue what they enjoy as everyone else does. Indeed, there is no prior reason, in the absence of a general condemnation of high income or wealth per se, that the wealthy should not organize arts institutions which avowedly serve their own interests, including such narrow interests as speculation in art. Second, nothing that has been said above is meant to imply that the wealthy are malicious in their manipulation of the indirect government aid system. They merely take full advantage of the legal opportunity available to them through the tax expenditure structure.

Proposition 4 implies a rejection of government control in favor of private decisions, even if they are wealth-dominated, and to that extent responds to the siren call of decentralization. It offers no support, however, for discriminating among private donors by their wealth. The subsidy to giving that favors the rich (created through the income tax deduction and the progressivity of the rate structure) cannot be justified on these grounds. The question with which we began remains: why should the wealthy determine how the government portion of the aid gets spent?

Monroe Price has argued that public support of culture should not be determined by wealth:

The present condition is that museums characteristically represent a context in which a public trust, largely publicly supported, is vested in

individuals over whom the public has virtually no control. Wealth and status, independent of other characteristics, can find their place. While there is nothing wrong with those characteristics, it is wrong to have a system of museums dependent on wealth, just as it would be wrong to have a system of public education dependent on wealth. The critical point is to develop a tradition in which collection and donation of gifts to museums are not accompanied by expectations of control. . . . By relying on tax-induced contributions, we place the center of strength for our arts institutions with the rich. It is their taste that becomes the museum's taste, and thence the community's. As a nation we have always depended on the bounty of the rich and the powerful to build our cultural institutions, but in this century, we have rewarded such gifts with generous tax savings. Perhaps it is time that we review our method of building public collections to determine whether more democratic means would yield institutions that are freer of idiosyncratic and individual taste.[32]

We now can turn our attention to the second fundamental question concerning taste: do arts institutions change their behavior to correspond to the desires of these wealthy donors, and, if so, to what extent?

There is no question that expert judgment affects donors. Often a philanthropist will ask a museum director, "What do you need?" and will respond accordingly. (This philanthropist, of course, has already made two preliminary decisions: selection of the arts as the recipient of his largess and selection of the arts professional whose judgment he consults.) Not surprisingly, arts managers are quick to assure the curious that they never compromise their professional standards to obtain funds, and they have so assured us. But the decisionmaking environment in which arts institutions' managers operate is not conducive to such independence. First, the director serves at the pleasure of a board of trustees overwhelmingly dominated by the wealthy patrons of the institution (a point considered earlier in Chapter 5); some boards of trustees have appointed "public interest," "community," or "professional" trustees, but these

token members cannot sustain a director whose interests diverge from those of his board.

Richard Brown found that in the six years prior to 1975, the 90 largest American museums dismissed 38 directors.[33] The war between trustees and professionals (settled long ago, for example, in favor of the professionals in universities and hospitals) still continues in arts institutions and the trustee side is doing very well. Each art purchase by a museum is considered by an acquisition committee of the board of trustees and such approval usually is not perfunctory. (What first-rate university submits a faculty tenure decision to its trustees except as a formality?)

To what extent can donors and trustees' wishes affect the operation of arts institutions? The director of the Metropolitan Opera, Anthony Bliss, flatly denies that philanthropy affects artistic decisionmaking.[34] He receives offers from donors to finance specific new productions, and only when his artistic judgment concurs, does he accept such donations. Yet while Bliss considers himself quite independent of financial persuasion, he operates an institution that canceled part of two seasons for lack of funds. Moreover, Bliss decided to treat the costs of new productions as capital investments and finance them as much as possible from contributions by the Opera Guild, the National Council (an outside-New York City group of large contributors), or any other individuals or corporations willing to make gifts for this purpose.

Numerous Metropolitan Opera productions have been financed in this way, some for surprising reasons. Cornelius Starr, a New York insurance executive, commissioned a new production of *Madame Butterfly*, citing his impatience with the old production's unforgivable anachronism: cherry blossoms (a spring flower) and chrysanthemums (an autumn flower) side by side on the stage. (The Met does turn down some gifts: the be-

quest of McNair Ilgenfritz, a Metropolitan Opera box-holder and amateur composer, which was to be used in part to produce one of his own one-act operas, was refused.)[35]

Even Bliss can't present an opera for which he lacks the resources. If of the many operas that Bliss would be willing to produce, his donors will only underwrite a selected few, then donor selection precludes production of those approved but unproduced—whether Bliss thinks so or not.

More generally, can an institution dependent on the charity of a few wealthy patrons afford to consider general policies that might alienate this support? (As arts institutions go, the Met's charitable support is broadly based thanks to its tradition of broadcasting nationally.) If Mr. Bliss and his staff never want to mount an opera that the patrons dislike, and always really desire to produce operas the patrons happen to like, the donors' control of government funds has no untoward consequences. But if artistic judgment indicated a shift in policy that Bliss could reasonably expect would offend his patrons—say, a large diversion of resources into newly commissioned avant-garde works—what could he expect to gain from this seeming foolhardiness? An artistic director often gets but one chance to take such a stand on principle; it usually turns out to be at the end of his tenure and subsequently the policy is overturned anyway. Clearly, the existence of implicit or anticipated donor influence cannot be ignored.

The Metropolitan Museum of Art, which should be in an excellent position to ignore the untoward pressures of self-serving philanthropists, not only enjoys high international reputation and intense public scrutiny, but also a municipal subsidy covering nearly all its costs outside of professional staff, special exhibitions, research, and acquisitions. Nevertheless, it illustrates dramatically the possibilities of direct philanthropic control.

The conditions museum donors attach to their gifts range from

the relatively innocuous (such as placement of the donor's name on a brochure, next to illustrations of the donated works of art, or on a plaque hung in the lobby of the institution) to complicated instructions dictating the gift's use in perpetuity. Museums have been the grateful recipients of numerous collections donated with the understanding that the collections were to be kept intact and on display in the recipient museum. Eventually, initial gratitude has been tempered by the realization that these restrictions prove burdensome and inappropriate as styles, tastes, and knowledge change. For many years the Metropolitan Museum of Art exhibited the Altman, Friedsam, and Bache collections in a suite of collectors' memorial rooms. Recently, they have been redistributed throughout the museum;[36] the Metropolitan's curators obviously now prefer the freedom to display the works as they choose—by period, by school, or not at all. In the light of their preference, the story of the Lehman Collection seems particularly interesting.

In the 1960s Robert Lehman, long a generous supporter of the Metropolitan Museum, opened negotiations with museum officials regarding the disposal of his extensive art collection, part of a multi-million-dollar estate. His intentions were to give it to the Met, if the Met would agree to certain conditions. In particular, he wanted his home, a Manhattan townhouse, moved to a location adjacent to the Met's buildings and his art collection displayed in the house exactly as it was when he lived there. Lehman's intentions challenged every accepted standard of professional museum practice. For example, the Association of Art Museums strongly advises in its members' handbook that "gifts and bequests be of a clear and unrestricted nature and no work should be accepted with an attribution or circumstances of exhibition guaranteed in perpetuity." (Thomas Hoving, former director of the Metropolitan who participated in negotiations with Lehman, was a member of the committee that wrote this report.)[37]

The result of the complicated negotiations was that the museum avoided the embarrassment of having Lehman's townhouse on the museum grounds only by agreeing to build a sort of concrete tent containing one of the highest ratios of empty space to art in museum history. It is dedicated exclusively to the Lehman collection, and contains seven rooms reproduced exactly from his home to display much of the collection just as it was displayed there (including stairways that lead to nonexistent upper floors, paintings installed in curious nooks and crannies, and windows with no views). The museum is committed to this rather bizarre arrangement forever.

The experience may have taught the Met a lesson about how museums should be run, despite the disclaimer by the secretary of the museum that if the Met had had the monetary equivalent of the Lehman bequest to spend, and the Lehman collection had been on the block, "We would have bought it all and installed it exactly as we did."[38] We remain skeptical, however, especially since we have discerned no movement in the museum fraternity to revise its views about accepting gifts with strings attached.

Given the peculiar circumstances it faced, the Metropolitan may have been well advised to compromise its principles to obtain a very important collection. But Lehman's power to control an arts institution as he did resulted in large part from the fact that the government allowed him to channel millions of dollars in foregone estate taxes to the museum of his choice. If this enormous subsidy had been granted directly to the Met—or to museums in general—by the government to spend according to the best professional judgments, then the Lehman collection might well have gone on the block (though not necessarily all at once). Museums (and others) then would have been able to bid for the works of art they felt appropriate to their collections, installing them to best advantage.

Of course individual donors are not alone in attempting to

take advantage of an opportunity to restrict the use of their do-
nations, thus dictating museum policy. As corporate donations
to the arts have increased, arts professionals have expressed
concern about the influence these donors try to exert. In fact,
Lee Rosenbaum, the editor of *Art Letter*, has suggested that the
corporation may be the most restrictive sponsor of all.[39] Cor-
porations tend to be conservative in their tastes. Walter Pole-
shuck, when development officer of the Whitney Museum, said:

Corporations are primarily interested in representational art; the masses
of people relate to it more surely. The masses do *not* relate to abstract
art. Corporations are interested in improving their image, and if they
spent money on an exhibition which the bulk of people do not relate
to, they would, in their view, be doing themselves more harm than
good.[40]

Corporations have also been involved in sponsor-initiated
shows, packaging and assembling the shows without assis-
tance from the museums where they are scheduled to appear.
They have political interests: one of public television's most im-
portant sponsors, the Mobil Oil Company, set many teeth on
edge when it publicly attempted to have a program likely to
offend the Saudi Arabian government canceled.

Even foundations may exert undue influence on the art they
support. For example, the Joffrey Ballet cut its ties with the
Rebekah Harkness Foundation, a source of considerable support,
when the foundation requested that the ballet change its name
to the Harkness Ballet and allow the foundation officers an un-
specified amount of control over the artistic decisions of the
company.[41] W. McNeil Lowry, former vice president of the Ford
Foundation and the architect of that foundation's support of
the arts, does not think of even broadly controlled foundations
as passive supports:

We are catalysts rather than reformers, participants rather than back-
ers, communicants rather than critics . . . Our investments in the arts
are not so much subsidies as they are levers.[42]

Thus, arts institutions are affected in numerous, and often less-than-obvious, ways by the influence donors wield over the distribution of tax expenditures. Donor tastes play a very important role in allocating indirect government aid to the arts.

PROFESSIONAL AND ETHICAL COMPROMISE

Recently, the operation of tax-exempt charities has come under increased scrutiny. State attorneys general have intervened in the operation of a number of arts institutions. Arts service organizations have expended considerable effort compiling codes of behavior for trustees, curators, managers, and other arts professionals.[43] Journalists have been quick to draw public attention to conflicts of interest in the operation of arts institutions. Thus the trend is toward greater accountability.

Two issues, professional and ethical compromise, are at the center of this reexamination, and, not surprisingly, the indirect government aid system touches them in important ways. In addition, as we have noted, the aid system abets the view that the institutions receiving the aid are private in nature and hence immune to public scrutiny. An arbitrary distinction between professional compromise and ethical compromise is helpful in comparing the incentives provided for each under the indirect government aid system: professional compromise involves matters of taste or quality—violations of professional standards— while ethical compromise entails one person's gain at another's expense, perhaps illegally. The latter involves violation of broader norms.

Professional compromise is common. Arts administrators often modify their programs in the presence or absence of financial support. Generally, any input or output distortion will affect arts administrators' plans and may leave them with a sense of having made a professional compromise. Direct government grants

also can result in professional compromise as their conditions affect the behavior of arts institutions vying for the grants. Presumably, if direct aid programs were well formulated and efficiently administered, changes in the operation of arts institutions would be applauded as working in the public interest even though arts professionals might have been forced to change their plans, "lower" their standards, or aim toward a different audience.

The arts market itself, comprised of millions of individual consumers, has a similar effect on artistic production. Many plays fold annually despite critical approval; some deplorable films are financial successes and some excellent ones are box-office failures; some opera or symphony orchestra programs are less well attended than others. All of these examples represent market restrictions on arts institutions. Programs have to be designed carefully to attract an audience, and, by extension, this adaptation to popular tastes could be considered a professional compromise.

Ethical compromise is a more serious matter, at least in the visual arts. If anything, the indirect government aid system encourages, rather than minimizes, ethical compromise. The arts transaction most vulnerable to compromise is the gift of art works to museums. In such a transaction, the donor and the institution may seek to gain at the government's expense. When the donor claims a tax deduction, he or she makes an estimate of the market value of the donated property. However, the actual market value of appreciated property, such as unique works of art, is difficult to assess. A higher estimate of market value means, of course, a larger deduction, greater tax savings—and an equivalently greater tax expenditure. If the deducted valuation is high enough, the financial advantage of a donation may surpass the potential after-tax profits from the sale of the property. Thus financial considerations may outweigh philanthropic

motives. The system tempts donors to claim deductions that exceed the legal limit (that is, the market value of the art work). A donor who might blanch at suggesting to a charity that its receipt for his $1,000 cash contribution instead show $5,000 may have no compunctions about claiming, for tax purposes, a market value of $5,000 for a $1,000 work. Such exaggeration apparently is a frequent occurrence.[44]

The donor and the arts administrator receiving the gift at an inflated value in effect are partners in an exchange paid for in large measure by unknowing taxpayers. This transaction is like so-called victimless crimes in that no one involved has anything to gain by enforcing the law or "blowing the whistle." There is a victim, of course: the more the donor cheats by inflating his deduction, the more all taxpayers pay.

The Internal Revenue Service monitors the deduction of gifts of appreciated property, auditing tax returns with unusually large deductions. The IRS urges that the donor have the art work appraised by a disinterested third party, but even this process is not free of compromise; it has been suggested that the use of certain appraisers virtually guarantees a tax audit.[45] Valuation questions for works of substantial value are referred to an IRS Art Advisory Panel comprised of collectors, artists, and other knowledgeable individuals. (The panel also considers the valuation of art works for estate and gift tax purposes; in these cases a donor can cheat by underestimating the art's value to lower his tax bill.) The experience of the panel indicates clearly that misvaluation is attempted. In March 1974, the panel met to consider 92 items with an aggregate claimed valuation of $5,875,000. The panel recommended adjustments of approximately $2,697,000—a 28-percent net reduction in claimed charitable contributions and a 110-percent increase in claimed estate and gift tax appraisals. Only 34 percent of the item valuations considered were accepted.[46] In 1972 the panel met three times

and reviewed 711 works valued by donors at more than $18 million. The panel recommended a 30-percent net reduction in the values claimed for estate and gift tax purposes.[47] Donors apparently have become more honest or more realistic: In its April 1978 meeting, the panel reduced charitable valuations only by 19 percent on an average and increased estate and gift tax valuation by 15 percent.[48]

Occasionally, the donor may even ask, or expect, the curator to become a party to this deception. In other words, the donor asks, will the curator substantiate, or at least not quarrel with, the inflated valuation which the donor intends to claim? The curator is not anxious to establish an inflated value for a painting (which might even be of questionable provenance), yet he or she may be torn by a desire to have it, cost-free, in the museum's collection or at least not to scare away the donor by a seeming lack of gratitude.

A more elaborate scheme—in which the government is defrauded while the museum, the donor, and an art dealer profit—follows: The donor donates $100,000 in cash to a museum with the stipulation that the museum use it to buy a specific painting owned by an art gallery. The director of the museum goes to the gallery and buys the painting for $100,000. The collector has a canceled check supporting a tax deductible contribution in that amount to the museum; the director has a new painting, which cost the museum nothing. All perfectly innocent, except that the donor was also the previous owner of the painting. He took this $50,000 painting to the art gallery and sold it for $95,000, an inflated price, by guaranteeing that in several days a museum would pay $100,000 for it. The dealer makes a quick $5000, the collector has created a large tax break for himself, the museum has its painting, and it is nearly impossible for the IRS to untangle this web.[49]

Another tax dodge involves back-dating donations. A donor

discovers that the tax advantages of a gift would have been greater in the previous taxable year, so he asks the museum to back-date the receipt for the gift. (In early 1970 back-dating was particularly tempting to artists, authors, composers, and other public figures who realized the Tax Reform Act of 1969 had severely limited the deductions they could claim for donations of their own art works or personal papers.) It costs the museum nothing to back-date the receipt, but the practice will cost the government and other taxpayers. Alan Shestack, director of the Yale Art Gallery, turned down such a gift only to discover its photograph one month later on the cover of another museum's bulletin as one of the major acquisitions of the previous year! Refusal was the ethical (and legal) action, but as Shestack recognized, museum trustees expect their administrators to do everything in their power to improve the collection and attract gifts.[50]

Several other problems in museum operations can also be traced to the deductibility of appreciated property: is there a compromise involved in the acceptance of a donated painting that the curator expects will never be displayed? (Whether or not the painting is displayed, of course, a tax expenditure occurs upon the transfer.) Should artists' gifts of their own work be accepted at all? If such a work is displayed, has the museum's inevitable contribution to the appreciation of the artist's present and future work been compromised by the artist's inevitable self-interest? Similarly, should a museum display gifts from a trustee when such display will cause the remainder of the trustee's collection to appreciate? We think the indirect government aid system makes donations of art works so enticing for a museum that the consequences of acceptance are inadequately examined.

One of the ugliest manifestations of the tax code's influence on the arts is detailed in articles by Lee Rosenbaum about the

New York State attorney general's investigation of the Metropolitan Museum's storage of a private collection (beginning in 1966) in the hope that the collection would be donated to the museum.[51] Museum directors and curators conventionally provide a variety of services to important collectors who then might be induced to give or bequeath their collection to the museum. These services include storage, advice on purchases, free or cut-rate conservation, even brokerage.

The museum directors and curators Rosenbaum quotes universally regard the hoped-for donations as private gifts. In this light, the practice may be justified as a risky but reasonable investment of museum resources in collection-building. If the value of the time and expertise so committed could not obtain art of greater worth elsewhere, it would seem the best use of resources from the institution's point of view. The danger would merely be that, in some cases, curatorial advice or assistance builds a collection that is later sold for private gain. (From an individual museum's point of view, of course, there is the further risk that the collector will donate his work to another museum.)

But the donations are never private; the government, as we have seen, is a principal partner in contributions by the wealthy. When a top-bracket collector gives a work he obtained (with a clever curator's advice) before substantial appreciation, the government can find itself making most of the gift. The deduction system has turned museum curators who advise collectors (and their museums) into accomplices in a lamentable practice of allowing collectors to enjoy art at public expense.

To see why this is so, consider a painting available for purchase at $100. A curator believes it likely to appreciate greatly, so he recommends its purchase to a wealthy (top-bracket) collector who is a friend of the museum. After, say, ten years the collector contributes it to the museum; it has appreciated to

$1,000. The collector is out of pocket the $100 originally paid; on the other hand, the deduction insulates 50 percent × $1,000, or $500, from his income taxes. He has enjoyed owning the work of art for a decade; he may even have arranged to rent it or sell reproductions of it while he held it.

Consider now an alternative system of government subsidy that would also leave the museum in possession of the painting after ten years, with no change in its cash position. If the government gives the museum $100 in direct aid when the painting is first discovered, and allows no deduction for contributions, the sharp-eyed curator will buy the painting. Ten years later, the collector will neither make a charitable contribution nor claim a deduction to offset other income. The government would then collect $500 in income tax, leaving the taxpayers $400 ahead. (The taxpayers are ahead only $241 if we take account of interest [at 10 percent per year compounded] on the original $100 grant. Moreover, the collector might pursue some other tax-sheltering strategy; the fisc would then show no improvement, but the public benefits from the alternate investment would have been gained.)

At this point, the museum not only has the painting, but has had it for the ten years between its discovery and the time it would have been donated. The collector is not so well off in this version, however. He saves his initial $100, plus interest on it, but does without the painting for ten years and then pays $500 in income tax on his other income.

In summary, the use of tax deductibility of charitable contributions of property rather than a direct system of subsidizing museum acquisition has:

1. Transferred the use of the painting for ten years from the public to the collector;
2. transferred $241 from the taxpayers to the collector;

3. given the collector credit for the curator's perspicacity;

4. given the collector acclaim for a donation of government funds.

If the donor is in a lower tax bracket, or the appreciation less spectacular, he will make out less well in the current-practice version. But the numbers in the example are not out of the ordinary for serious art collectors and art works by rising artists. Even if the collector suffers some real cost, he still enjoyed ownership of the work while he held it—as well as the option of not contributing it if he can do better by selling it, leaving the museum with nothing for its investment of expertise.

The glaring inefficiency is evident, but even more dismaying are the consequences of the deduction system on the morale of museum professionals. Not one of Lee Rosenbaum's sources is quoted as challenging the tax deduction itself, nor does Rosenbaum—an acute and principled observer of the art scene—suggest that the rules of the game should be rewritten. The tradition of public philanthropy disguised in private garments has produced a generation of art museum professionals so conditioned to play the roles of courtiers and toadies in their relationships with wealthy donors that they apparently have lost hope for any other possibility. The picture is distasteful in almost every way. Private collectors, whose wealth is their only qualification to participate, enjoy private use of art that might instead be in public hands. In addition, they gain credit for taste and perception that rightfully belongs to the curator who advised them, and enjoy reputations as philanthropists by giving away public money. At the same time the professionals, who display merit through their expertise and connoisseurship, divert their professional education and abilities by spending time buttering up collectors so they will in the end make the contributions the museum has banked on—but cannot require.

Several of Rosenbaum's sources note that most museum collections come from private gifts. This is not only incorrect, but irrelevant. First, the gifts are, in reality, largely public, not private, as we have seen. Second, if the same government aid were provided directly, most museum growth could have occurred through purchase—of exactly what the museums needed most and at prices that maximized the market advantage of the museum professionals' judgment. In contributions of art to museums, the system has institutionalized practices with almost no redeeming qualities. Acquisition decisions often are made by the same curators who would make them if aid were given directly. The contributions of substantial art collections in the early years of the century (before income tax rates were high enough to provide a significant incentive) suggest that significant gifts or bequests of art objects will continue to be made even in the absence of deductibility.

CONCLUSIONS

Measured by the dimensions discussed in this chapter, the indirect aid system does much worse compared to alternative ways of distributing funds than it did by the measures applied earlier in this study. Indirect assistance tied by statute to particular economic inputs to art production, such as the property tax exemption for nonprofits, induces inefficient production of art; either less art is produced, or more is paid for it, than would be true if that aid were distributed without requiring its expenditure on real estate ownership. Two kinds of inefficiency are especially important in this context. First, property tax exemption gives institutions that own real estate an advantage over institutions that rent space, which is justified neither by efficiency nor fairness. Second, it induces overuse of real estate relative to

other, nonsubsidized, inputs, and this incentive to overcapitalization is the more serious because it acts in tandem with other incentives to the same kind of inefficiency.

The charitable contribution deduction places control of public funds in the hands of a group of people that is not only small in number compared with the population that pays for government aid, but is also demographically distinct—especially as regards income and education—from most of those who pay the bill. Whether these decisionmakers frequently use this power over public money to control the institutions to which they donate against the public interest, or do it only rarely, cannot be determined. But their control, and the deduction rules pertaining to gifts of art objects, consistently face the administrators of tax-exempt arts institutions with the obligation either to please influential donors, or to serve their institutions' and the public's goals, but not both. Furthermore, the rules relating to gifts of art are easily perverted into expensive subsidies to wealthy collectors with only minuscule public benefits.

To replace all indirect assistance with direct aid would be an unnecessarily drastic response to these criticisms. The property tax exemption could, and should, be so replaced, and we will suggest a way to do this in Chapter 8. But diffusion of control over some public support of the arts, such as the existing deduction rules imperfectly achieve, is a worthy goal. Rather than eliminate tax expenditures for the arts, we would transform the deduction into a tax credit; again, Chapter 8 presents several ways this might be accomplished. Also, the rules relating to gifts of property should be tightened so as to diminish the existing incentives to pervert the system for private gain.

7

TAX LAW CHANGES: CONSEQUENCES
FOR ARTS INSTITUTIONS

Advocates of indirect government aid to nonprofit arts institutions commonly single out two noneconomic characteristics to further support their contention that the indirect aid system is desirable public policy. The first of these characteristics, diffusion of decisionmakers, was discussed in Chapter 5; the security of the financial support system from the whims of government policymakers is the other.

Many artists and arts institution administrators, as well as donors and members of the general public, think that insulating government financial support from political change is necessary to safeguard artists, their works, and arts programs from intervention and intimidation. Many arts professionals believe that the indirect government aid system ensures that bumptious lawmakers and bureaucrats can neither dictate art institutions' policies nor impose artistic views on them. Unfortunately, the security of indirect government aid is not as dependable as many of its proponents seem to believe. Unlike direct grant assistance, indirect aid is vulnerable to modifications in the tax code that sometimes are related only peripherally to arts and others char-

itable institutions. The Economic Recovery Tax Act of 1981 presents a recent example of tax legislation that carries major implications for arts institutions without referring to them directly.

Moreover, a covert system of aid does not seem a sound public policy. Specifically, why should aid to the arts be shielded from the legislative review to which the food stamp program or national defense are subjected?

THE APPEARANCE OF SECURITY

Critics of indirect government aid point out that tax expenditures are usually not subject to the normal constraints of the budget review process. (The Congressional Budget and Impoundment Control Act of 1974, P.L. 93–334, introduced federal budget reports of tax expenditures, but does not require periodic legislative approval.) Unlike direct appropriations, which must undergo formal congressional review every year, tax subsidies are part of the framework of the existing tax law and are rarely scrutinized independently. Moreover, the congressional committees that create and oversee tax subsidies are the tax-law-writing ones—the House Ways and Means Committee and the Senate Finance Committee—not the ones responsible for arts policy such as the House Committee on Education and Labor or the Senate Committee on Labor and Public Welfare. But arts advocates often applaud the low visibility and infrequent review on the theory that obscurity helps to protect indirect aid.

Nevertheless, inclusion of arts aid in tax laws involves some risks. Legislatures periodically revise and restructure tax laws, thus modifying the indirect aid mechanisms. These alterations generally affect other interests far more than the arts, so the legislative process tends to ignore the needs of cultural activities even though changes that are not labeled "arts-related" or

"charity-related" can affect the finances of arts institutions as much as bills aimed at implementing an arts program. Precisely because tax expenditures are part of the general tax structure, changes in the tax law may affect arts institutions as taxpayers alter their patterns of charitable giving. The impact on arts institutions is frequently hard to clarify, leaving arts institutions' decisionmakers in doubt about the appropriate response to such a change.

The analytic difficulty is threefold.[1] First, the arts institution must learn to examine tax legislation, even changes in apparently unrelated provisions, as affecting them. Second, once the relevant changes are identified, the institutions need a framework from which potential effects can be predicted. Third, the institutions may have to cope with new ground rules for carrying on their activities. A practical difficulty also may assert itself: the arts institution's interests concerning a proposed change in the tax law may differ from, and even oppose, those of its major donors.

A prime example concerns changes in tax rates, which can substantially alter the flow of indirect aid to arts institutions. In general, a rate increase raises the incentives for charitable giving. As an individual's tax rate rises, the price of giving falls, and a charitable donation becomes a relatively cheaper alternative use of money. Similar effects will occur for some taxpayers if the government reduces the zero-bracket amount (formerly the standard deduction) or removes tax benefits by tightening loopholes. On the other hand, rate reductions and enlargement of deduction or exemption provisions generally weaken the incentives for charitable giving. Tax changes that work to the advantage of taxpayers by decreasing their taxes work to the disadvantage of charitable institutions.[2]

Such changes probably affect arts institutions more than other charities. Donors to cultural institutions display two character-

istics likely to increase sensitivity to alterations in the tax environment. On average, donors to cultural institutions are wealthier than the general population and wealthier than donors to any other charitable sector except education (see Chapters 4 and 6 and Tables 3.3, 3.4, and 3.5). As a result, tax changes aimed particularly at wealthier individuals, such as limitations on tax shelters, affect arts institutions proportionately more than other charitable institutions as taxpayers adjust their charitable giving to the tax law revisions.

The second characteristic concerns the relative priority of charitable donations to different charitable sectors. The National Study of Philanthropy[3] asked each interviewee to name the sectors to which he made his four largest charitable gifts. (The interviewees were asked to name the organization receiving the most and three organizations receiving other large portions of his total gifts. The second, third, and fourth mentions probably reflect declining relative importance to the donor.) Tables 7.1 and 7.2 summarize the responses by the percentage of gifts and of dollars given to each sector. Relatively few donations to cultural institutions were first gifts, only 19 percent; in contrast, cultural institutions received 53 percent of the third or fourth gifts. Only health institutions suffered from a similarly low relative priority. The percentage of the total dollars received by cultural institutions in first gifts formed a larger proportion— 41 percent. Again, this was a smaller percentage than for any other charitable sector.

The lower donor priority for cultural institutions need not imply that they are considered unimportant. Rather, it may reflect donor decisions to fulfill what are seen as obligations to church or alma mater before turning to support of cultural activities. Also, religious and educational charities more readily lend themselves to single institution loyalty; a donor may favor one church or college, but several cultural institutions, with his donations.

Table 7.1
Precedence of Charitable Giving, Charitable Gifts by Sector, 1973

Charitable sector	Percentage of gifts given to each charitable sector by order of gift				Total number of gifts (millions)
	First mention	Second mention	Third mention	Fourth mention	
Culture	19%	28%	18%	35%	.43
Religion	89	6	3	2	32.02
Education	24	41	24	11	2.59
Health	15	33	32	20	10.05
Other social welfare	23	44	20	12	18.53
Other charitable	23	63	14	0	.13
Aggregate	55%	23%	14%	8%	63.75

Source: The Commission on Private Philanthropy and Public Needs. National Study of Philanthropy, 1974.

Note: Not all rows add to 100% because of rounding errors.

Table 7.2
Precedence of Charitable Giving, Total Charitable Contributions by Sector, 1973

Charitable sector	Percentage of total dollars given to each charitable sector by order of gift			
	First mention	Second mention	Third mention	Fourth mention
Culture	41%	16%	33%	9%
Religion	95	3	1	1
Education	62	28	7	4
Health	49	26	16	9
Other social welfare	44	37	13	6
Other charitable	98	2	1	0
Aggregate	84%	10%	4%	2%

Source: The Commission on Private Philanthropy and Public Needs, National Study of Philanthropy, 1974.

Note: Not all rows add to 100% because of rounding errors.

Whatever the cause, the implications for cultural institutions are important in gauging donor reactions to any changes in tax rules that reduce incentives for charitable giving. When the donor reduces his total giving, which charities will lose? He might reduce all his gifts proportionately, but more likely he reduces giving more drastically to later-choice charities. For these reasons, arts institutions suffer a more than proportional impact from across-the-board changes in tax law. For a small arts institution, heavily dependent on charitable contributions from one or a few donors, a marginal change in the tax law might have a large, perhaps disastrous effect.

FEDERAL TAXES

Three major revisions of the Internal Revenue Code—in 1969, 1976, and 1981—provide many examples of the link between the federal income tax law and charitable giving to arts institutions. The first illustrates direct federal tax actions bearing on charity; the latter two show indirect effects. (Changes in state law also are important, although harder to pinpoint because there are so many.)

The Tax Reform Act of 1969

Private foundations. The Tax Reform Act of 1969 (TRA) dealt at length with charities. Many of its provisions were aimed at abuses—both real and imagined—in the operation of foundations controlled primarily by a small number of individuals. The TRA defined a new subclass of tax-exempt charities, *private foundations*, that neither derive substantial support from the general public or the government, nor operate as churches, schools, or hospitals. The TRA of 1969 also defined subclasses

of private foundations of which the private operating foundation is the most significant. The TRA of 1969 imposed new reporting requirements on these private foundations, as well as special excise taxes and other constraints designed primarily to prevent self-dealing, undue control over business enterprises, excessive accumulation of tax-free income, and expenditures for inappropriate purposes.[4]

These tighter rules for private foundations affected the arts in at least two ways. First, they applied directly to some arts institutions, often with perverse results. Second, to the extent that private foundations themselves provide aid to the arts, disincentives to the growth and operation of private foundations may have affected the flow of funds to the arts.

The act excludes most arts institutions from the private foundation definition in that the diversity of their sources of income classifies them as public charities. However, some arts institutions failed to meet this test. In congressional testimony given in 1973, Kyran McGrath, director of the American Association of Museums, estimated that fifteen museums were classified as private foundations.[5] Later estimates increased this figure to about two dozen. The museum may have insufficient public support under the tax code when it enjoys so large an endowment that its investment income dwarfs public support. Often one individual created and heavily endowed the museum, and he also may have given the collection. Prominent examples include the Frick Collection, the Currier Gallery of Art, the Corning Museum of Glass, the Winterthur Museum, and the Adirondack Museum.

Apart from costs of reporting and record-keeping, private foundation status imposed two significant financial liabilities. First, the charity incurred an annual 4-percent excise tax on endowment income putatively to reimburse the Internal Revenue Service for the costs of auditing private foundations.[6] Sec-

ond, it became a less attractive recipient of grants from other private foundations. Private foundations must exercise "expenditure responsibility" when making grants to other private foundations, entailing detailed record-keeping and reports; many private foundations therefore became less willing to make grants to other private foundations.[7] Furthermore, if a private foundation is the primary source of funds for a charitable institution, that support may cause the charitable recipient itself to be reclassified as a private foundation.

Karl Meyer reports an ironical instance in which the private foundation rules apparently restricted public access to a museum rather than making the museum's collection more public. The Frick Collection in New York found itself liable for between $55,000 and $75,000 annually of excise tax on investment income. To remove itself from private foundation status, the Frick Museum ended its free admission policy and introduced a $1 admission charge; the new income reduced the proportion of total income attributable to the endowment so as to reclassify the Frick as a public charity.[8] The tax rules induced the Frick to make its base of support more public, but paradoxically, only by restricting public access to the collection through a new admission charge the Frick never before thought it needed.

Unfortunately, we do not know whether the TRA of 1969 has reduced the aggregate support for public cultural institutions that otherwise would have been contributed by foundations. It certainly slowed the growth of private foundations, but even if the tax laws had entirely eliminated favorable treatment for private foundations, philanthropy would not have ceased: the donations and bequests that formerly went to foundations as charitable contributions may have been redirected to museums and other operating charities. The net effect on arts institutions of the specific excises and other limitations on private foundations similarly defies easy conclusions. The tax on investment

income decreases the amount a private foundation has available for distribution. But the minimum payout rules require private nonoperating foundations to expend their income for charitable purposes and not accumulate it. (The 1969 act required payout of adjusted net income or, if greater, a stated percentage of non-operating assets. The Economic Recovery Tax Act of 1981 changed the payout requirement to 5 percent of the foundation's assets not used directly in carrying out its exempt purposes. See Code Section 4942.) The latter requirement in fact may have resulted in more money flowing to arts institutions as foundations increased their spending to comply with these provisions. Whatever the aggregate aid level effects of the private foundation rules, arts institutions have coped with conditions and requirements unrelated to any specific public policy directed at them.

Charitable contributions. The TRA of 1969 dealt with other aspects of charitable contributions. For example, it liberalized the annual individual income tax deduction by increasing the general limitation for donations to public charities from 30 percent to 50 percent of the donor's "contribution base" (roughly equivalent to the donor's adjusted gross income). The additional 20 percent cannot, however, be in the form of appreciated property. This increase in percentage primarily affects large donations by presumably wealthy donors. But arts institutions depend on wealthy donors for much of their support, and these donors contribute substantial sums at one time. Arts institutions thus benefit from the new limits more than other charities.

As mentioned earlier, the act limited the deduction for gifts of appreciated inventory and other ordinary income property, including artists' works, to the donor's basis in the property. The act also limited the deduction for gifts of appreciated tan-

gible personal property (e.g., paintings but not stocks) to the donor's basis plus half of the appreciation when the property is unrelated to the exempt function of the charitable recipient. (The Revenue Act of 1978 changed the one-half to 60 percent to conform to a similar change in the capital gains rules.)

The Tax Reform Act of 1969 applied a similar limitation to donations of all appreciated property to private nonoperating foundations. Individual gifts to such charities may not exceed 20 percent of the contribution base, and the excess may not be carried forward to other taxable years. The more favorable limits for donations to public charities undoubtedly help funnel donations to these public charities—including most arts institutions. More specifically, the tangible personal property rule probably encourages donors to give paintings and books to cultural and educational institutions with a net benefit for arts institutions.

The Tax Reform Act of 1969 also made a number of changes in the provisions governing the donation of split-interest gifts, that is, gifts in which charities receive less than complete ownership of property.[9] "Bargain sales" of appreciated property were made less attractive.[10] Deductions for the right to use property were eliminated: a portion of a building used rent-free by a charity no longer can be deducted as a gift.[11] These changes continue to allow deduction for a narrow class of split-interest gifts in property. A donor may give undivided fractional interests in a painting to a museum over several years, with the successive portions deductible,[12] as long as the museum possesses the painting for a part of the year proportional to its ownership interest.[13] This rule links public availability and exhibition to the tax benefit.

An analogous link to the public, charitable use of artistic property exists in California property tax law, which exempts from the personal property tax works of art made available to a

publicly owned art gallery or museum for at least ninety days during the preceding year.[14] In a similar vein, Hugh Jenkins, the former British Minister for the Arts, proposing that the British wealth tax on assets worth more than $250,000 be applied to works of art as well, would have exempted works on loan to public collections. Such discussion of how tax laws can encourage the public exhibition of privately held art works has led Monroe Price, Professor of Law at the University of California, Los Angeles, to suggest—only partially in jest—turning the whole system on its head by the payment of a tax to avoid exhibition.[15]

In summary, then, the Tax Reform Act of 1969 altered substantially the ground rules applicable to charities, including arts institutions. The effect of any particular change has not been quantified, and to some extent the changes have offsetting effects. What is important is the implication of Congress' willingness to revise the tax laws related to public and private charities: the indirect government aid system may be less secure than frequently supposed.

The Tax Reform Act of 1976

The Tax Reform Act of 1976 demonstrated the possibility of change in more subtle ways, since the act did not affect charities directly. The act dealt chiefly with estate and gift taxation, curtailment of the use of certain tax shelters, and taxation of foreign income. Yet these and other provisions in the act significantly affect contributions to arts institutions and their operations.

Estate and gift taxes. In the TRA of 1976, Congress enacted the first major revisions of estate and gift taxes since the 1940s, including:

1. the partial consolidation of the estate and gift taxes into a "unified transfer tax" with increased exemption limits and reductions in the top estate tax rates;
2. an increase in the marital deduction;
3. the introduction of a "carryover basis" for calculating capital gains taxes on inherited property.

The last change was short-lived: Congress first deferred the effective date for the carryover basis and then repealed it altogether.[16]

Under these rules, a substantial number of estates became tax-exempt; the act thus eliminated the tax incentives for charitable bequests from the newly tax-exempt estates.[17] Some estates in the $1 million to $9 million range, however, probably incurred somewhat larger estate and gift tax obligations, and the incentives for charitable bequests increased accordingly. The small number of estates over $9 million were taxed at a slightly lower rate and therefore these testators had less encouragement to make charitable bequests.

Arts institutions will probably receive fewer bequests of art objects as a result of another provision (written, ironically, with farmers in mind) that allows an estate comprised mostly of an interest in a closely held business—including that of a successful artist—to pay estate taxes over fifteen years, starting five years after death, with interest accruing on part of the tax at the very generous rate of 4 percent per year.[18] An artist who leaves a substantial estate thus can pass his work to his family at a lower net cost in taxes and with less liquidity pressure; as a consequence, presumably, less art will be bequeathed to museums.

Tax shelters. Other major provisions of the Tax Reform Act of 1976 dealt with tax shelters. Typically, tax shelter investments generate tax benefits disproportionate to the out-of-pocket costs

to the investor, often in the form of paper losses in the beginning years that can be deducted from, and thereby reduce tax liability on, regular income. Hence the income is "sheltered" from taxation. An industry that incurs large front-end capital costs and realizes proceeds over a period of years can generally support such a shelter. The act imposed certain new restrictions on tax shelters. It imposed "at-risk" rules for certain investments (Code Section 465), restricted the use of cash-basis accounting advantages in certain instances (Code Section 464); required proration for production costs for films, books, and sound recordings deducted by individuals (Code Section 280); included intangible drilling costs and adjusted itemized deductions in the minimum tax base (Code Section 57); increased the minimum tax rate; and tightened partnership tax rules. Subsequent legislation made some changes: the at-risk rules were later expanded and the effect of the minimum tax was reduced considerably.

The changes in tax shelter rules affected arts institutions in two significant ways. First, as discussed previously, to the extent the amendments eliminated tax-saving possibilities, charitable contributions became proportionately more attractive. Second, certain changes limited capital-raising devices in the motion picture industry. They affected the acceleration of deductions to be used as a setoff against other income. However, the TRA did contain a silver lining for cinema: it confirmed the previously disputed availability of the investment tax credit for movies. The net effect of the act is to make capital more expensive to moviemakers by eliminating a source of tax-expenditure-supported capital investment.

The at-risk rules of the TRA of 1976 limited the extent to which the investor could obtain leverage for his deductible investment without personal liability. It also altered the current deductibility of the costs of producing and distributing movies (and video

tapes, sound recordings, books, and plays); these costs must now be capitalized and deducted by using the income-forecast method. It is said that some congressmen supported these limitations in order to stop the flow of capital into pornographic movies. Cinema as an art form may have lost out because of its lesser bedfellows.

After 1976, investors turned to other arts areas for tax shelters, such as original print publishing, rare books, and lithographs.[19] The Revenue Act of 1978 extended the at-risk rules; together with vigorous administrative action, it has chilled initial tax shelter enthusiasms.[20] Note that these tax law changes affected profitmaking arts institutions, just as earlier ones had affected nonprofit arts institutions.

The standard deduction (zero-bracket amount). The Tax Reform Act of 1976 aimed at simplifying and reducing individual income taxes in part through an increase in the standard deduction. The 1977 Tax Reduction and Simplification Act further revised and enlarged the deduction and renamed it the zero-bracket amount (ZBA). Taxpayers claim the ZBA in lieu of itemized deductions, so that increases in the ZBA reduced the number of taxpayers who benefit from itemized deductions, including charitable contributions. For the 1976 act, the House Ways and Means Committee estimated that seven million tax returns would be switched from itemized deductions to the standard deductions.[21]

For these taxpayers, the income tax laws no longer provided an incentive to give. Martin Feldstein estimated that the deductions change in the 1976 act would cost charities approximately $300 million per year in foregone contributions and that similar changes in the 1969 act had cost them $700 million.[22] Arts institutions probably suffer proportionately less than other charities from such a change, since the taxpayers who shift from

itemizing are in lower tax brackets and, therefore, tend to contribute to religious or health and welfare organizations rather than to educational or cultural institutions. Nevertheless, the change tends to inhibit any effort to expand the arts contribution constituency to low- and moderate-income taxpayers. Thus, to an extent the changes may affect not only current giving, but also future expansion of public support.

To counteract the effects of an enlarged ZBA, spokesmen for charities proposed that taxpayers be permitted to deduct both the ZBA and their charitable contributions. The Economic Recovery Tax Act of 1981, as we shall see, embodies such a proposal.

In addition, the Tax Reform Act of 1976 may have given new vigor to legislative lobbying on behalf of arts institutions, for new rules in the act made lobbying easier for charities.[23] As arts organizations become more aware of the impact of proposed legislation, particularly in the previously murky area of indirect government aid, they will be better able to influence that legislation.

Economic Recovery Tax Act of 1981

In 1981, the Reagan administration's proposals for curtailing direct federal support for the arts provoked fierce debate. The administration tax plan, enacted as the Economic Recovery Tax Act of 1981, drew far less arts-related concern. Yet the tax changes will probably affect the arts more than changes in the direct aid package. The principal effects on arts institutions of the 1981 act derive from five sets of changes in the tax law, only two of which deal directly with charitable giving; but the noncharitable provisions of the act can be of far greater significance for the arts than those that deal explicitly with charity. The five changes are:

Reduction in income tax rates. The 1981 act reduced income tax rates for individuals by an average 23 percent over three years, and cut the top bracket immediately from 70 percent to 50 percent. Since a reduction in tax rates increases the price of charitable giving, it reduces the incentive to give. This reduced incentive applies for all charities, but the effect will probably be most severe for arts institutions, which depend more heavily on donors in high tax brackets, where the rate changes have their most pronounced price effect. A change in rate from 70 percent to 50 percent increases the price of giving $100 to $50 from $30, a percentage increase of 66.7 percent from the old level. A comparable cut in tax rate at lower levels, from 35 percent to 25 percent, increases the price of giving $100 to $75 from $65, a percentage increase from the old level of 15.4 percent. Taken together with the order of donor preferences (arts institutions tend to be a third or fourth gift rather than a first gift), the likelihood becomes greater that these reduced tax incentives will affect arts institutions more than others.

The general reduction in individual income taxes will have another effect besides the "price" effect just mentioned. By reducing the tax on all income, it will increase the after-tax income available to potential donors. Donors may decide to use part of this net increase to contribute additional amounts to charity, perhaps enough to offset the negative incentive effects of the price change. Whether they will do so depends on relative elasticities of giving. Estimates of such elasticity vary widely. Our best guess (and it is little more than a guess—see Chapter 6) is that the price effect will be stronger than the income effect, reducing donations to the arts institutions.

Reductions in estate and gift taxation. The 1981 act continued to remove smaller estates from the tax rolls. When fully phased in, its provisions will exempt estates below $600,000 in value

from tax. For these estates, the transfer taxes will cease to induce charitable gifts. In addition, the top estate tax rate drops from 70 percent to 50 percent in 1985. These changes, which parallel those in the income tax, reduce the tax incentives for charitable gifts in very large estates.

Furthermore, the act increased the maximum marital deductions allowed for estate tax purposes to 100 percent. A decedent now may leave his entire estate to his spouse, without federal estate tax, regardless of the size of the estate. Where a married couple contemplates substantial gifts to charity on death, the old rule of a limited marital deduction encouraged some gifts to charity in the estate of the first spouse to die; this reduced or deferred the estate tax. Under the new rule, however, the charitable estate tax deduction probably produces a maximum tax reduction effect in the estate of the last to die. Revised estate plans are likely to shift to greater marital deductions and to deferral of charitable giving until the death of the remaining spouse.

The combined effect of these provisions will probably first reduce the number and amount of bequests to arts institutions. Second, those received may be delayed more than under the prior law.

Business incentive provisions. The 1981 act radically altered the provisions for capital cost recovery. It replaced conventional depreciation of machinery, equipment, and improved real estate with an accelerated cost recovery system that will reduce corporate tax liability by more than $50 billion annually when fully phased in. The effect for many firms will be to eliminate federal income tax liability. As a result, the corporate charitable contribution deduction will present no incentive for donations. Provisions in the act that liberalized leasing transactions in effect allowed relatively free transferability of these new benefits,

so that the reduced incentive for charitable giving would not be confined to capital-intensive firms. The leasing provisions, however, were sharply limited in 1982.

As against these substantial disincentives to giving, the act provides specific liberalization of charitable gift rules in certain categories. These will not overcome the negatives created for arts institutions, however.

"Above-the-line" deduction. The 1981 act phases in a change in the charitable contribution deduction from an itemized deduction which may be claimed only above the zero-bracket amount—and is thus limited to roughly the top three-eighths of taxpayers—to one that may be claimed by all taxpayers. One of the arguments urged in support of this provision was that it provided an incentive to taxpayers who now claim the ZBA to enlarge their charitable giving.

Arts institutions, however, should not look for a sudden increase in giving from these individuals. First, the new provision will alter donor behavior only if potential donors understand that their tax liability will fall when they make charitable gifts. This will not occur if the Internal Revenue Service does not verify actual giving. Rather than audit relatively small amounts of claimed charitable giving on some 40 million ZBA returns, the IRS will likely develop rules that allow deductions within certain dollar limits. During the first two years of the new system, when the maximum allowable deduction is $25, the IRS will simply concede the deduction to anyone who claims it. A knowledgeable taxpayer may simply deduct the guideline amount without altering actual giving, and the Treasury will be poorer by the tax deductions without charities being better off.

Second, few donors among ZBA-claiming taxpayers will choose to give their increase in charitable giving to arts institutions. These donors consist of low- and middle-income individuals,

whose preferences among charities run overwhelmingly to religious, not cultural institutions. Arts institutions should receive a less-than-proportional share of any increase in charitable gifts from donors claiming the ZBA.

Increase in corporate limit. The 1981 act increased the permissible charitable contribution for corporations from 5 percent to 10 percent of taxable income (as adjusted). There is no evidence that corporate giving to the arts had suffered constraint under the old 5-percent limit. Indeed, corporate giving to all charities has averaged about 1 percent of taxable income. Moreover, the reduction in taxable income that is likely to result from accelerated cost recovery probably overwhelms any incentive produced here.[24]

The effect of these tax changes together will probably reduce charitable giving from the levels it otherwise would have attained. The Urban Institute estimated in August 1981 that by 1984 all charitable giving will run about $9 billion under the level it would have reached under the prior tax law.[25] The decline will vary among charitable sectors; the study does not list cultural institutions separately, but if their experience follows that of educational institutions, they will suffer a greater-than-average decline.

Flat Tax Proposals

A major proposed income tax reform has centered on a "flat tax." Generally, proposals for a flat tax would substitute a single relatively low tax rate or a small number of rate gradations for the present graduated rate schedule, making up the lost revenue by eliminating most deductions and exemptions not related to the cost of earning income. The tax, it is argued, would

become simpler and less amenable to covert use for subsidy purposes. Mainly for this reason, the flat tax has attracted widespread interest from both conservatives and liberals.

How would arts institutions fare under a flat tax plan? As the breadth of support for the concept implies, the precise content of *the* flat tax has yet to be specified: only a general concept, of course, could command such wide agreement. But even at this preliminary stage, three likely results should be noted, with the net effect of reducing indirect tax aid to arts institutions. First, in some versions the charitable contribution deduction would be discarded entirely; in such a situation, the best that arts institutions could hope for—the preservation of the deduction—would tend to undercut the simplification purpose behind the flat tax. Second, even if the deduction is untouched, the tax saving to a wealthy donor by reason of a charitable contribution would fall sharply. The central element of the flat tax consists of tax rate reduction. For wealthy individuals at the top rate of 28 percent, as under one proposal, the cost of a dollar of charitable giving rises from a net of 50 cents to 72 cents, an increase of close to 50 percent. A third effect pushes in the contrary direction. Preliminary estimates show that a flat tax would reduce somewhat the total tax burden on wealthy individuals. If this income effect survives, it means that potential donors will have more net income available for giving. As in the case of the 1981 act, however, we do not believe it will offset the negative incentives discussed above.

Summary

In summary, three major pieces of tax legislation, the Tax Reform Acts of 1969 and 1976 and the Economic Recovery Tax Act of 1981, call into question the assumption that indirect aid to arts institutions is secure when hidden in the Internal Revenue

Code. The 1969 act confronted charities head-on, the 1976 act dealt with them peripherally, and the 1981 act affected charities both directly and indirectly. Yet all had important effects on the flow of support to arts institutions and artists. Some of the changes were inadvertently harmful to arts institutions. Given the adverse effects of parts of the tax legislation discussed here, the notion that indirect government aid to arts institutions is necessarily secure compared with direct aid becomes harder to sustain.

The tax laws are subject to periodic alteration and, while the money generated by the indirect government aid system is unlikely to dry up overnight, significant changes do occur. Many of these changes affect arts institutions disproportionately because of their dependence on gifts of property or bequests and their relative prominence in the philanthropy of the rich.

The nonprofit arts community would be well advised to develop an enhanced appreciation of how tax law changes can affect charitable contributions. To protect their own interests, arts institutions must take a more active role in public debate on proposed changes. It would be folly to assume that the various categories of charitable institutions will agree on proposed changes, for the consequences of a change are not always identical in each charitable sector. Replacing the income tax deduction with a tax credit, for example, might work to the advantage of religious institutions and to the disadvantage of arts and education institutions.

STATE AND LOCAL TAXES

The state and local share of indirect government aid might seem more secure than the federal; certainly, concerted action in all fifty states on any issue is unlikely. Yet the high concentration

of arts institutions in certain states means that action by a few states could have serious effects. Nor does the form of indirect aid add much assurance. The most important source of aid at this level, exemption of arts institutions from property taxes, is apparently less subject to adjustment than federal tax provisions. On closer inspection, however, it is apparent that this is not a subsidy that can be taken for granted.[26]

Wholesale abolition of the property tax exemption is unlikely. Property taxation of government and religious institutions seems improbable, and the other charity categories would resist taxation as discriminatory.[27] But erosion and even elimination of the exemption can proceed in many ways, some not requiring legislation.

The most striking evidence of this is the variation in exemption practices from state to state: what state A taxes this year, state B can tax next. A study conducted in 1973 by Rountrey and Associates for the Commonwealth of Virginia reported the following:

> Houses of worship and certain other charitable organizations were exempt in all fifty states plus the District of Columbia.
>
> Parsonages were exempt in forty states plus the District of Columbia, partially exempt in one state and fully taxable in the rest.
>
> Fraternal organizations were exempt in twenty states.
>
> Labor and professional associations were exempt in only ten.[28]

Exemptions for arts institutions, though widely accepted, are by no means universal (see Chapter 3). Wide variations among states emphasize the fact that there is not a firm theoretical base for property tax exemption, nor even a single rule like that in federal Code section 501(c)(3). While general conventions exist, fiscal pressures force localities and states to reexamine their methods of raising revenues. The removal of property tax ex-

emptions will be perceived as an attractive alternative to politically costly belt-tightening.

In 1971 New York State narrowed the class of property that was, by law, tax-exempt.[29] The new rule gave cities the option of ending exemption for certain types of property, an option that New York City exercised. (Arts institutions generally retained their tax-exempt status.) The initial expectation of $70 million in added assessed valuation, yielding a $4.5 million increase in tax revenues, was reduced after court challenges to $17 million, increasing revenues only $1.5 million.[30] But some exemptions were revoked, especially for those charities thought to be of marginal public importance.

As exemptions are more closely monitored and restricted, nongovernment arts institutions may be vulnerable because of vagueness of the statutory source of their exemptions. They are treated variously as educational, charitable, or simply nonprofit.[31] In most states the exemptions arise out of very general classifications, but in some cases the statutes do contain explicit conditions for exemption, sometimes even specifying individual institutions in the legislation.[32] In such cases, preserving the exemptions may require continual lobbying. The most persuasive case may consist of a demonstration of the public benefits of the institution; but many arts institutions find it difficult to justify any special immunity as property tax exemptions in general are eroded.

Charges for municipal services, becoming more widespread, are an implicit, as opposed to direct, erosion of tax exemption.[33] Under such plans, the exempt institutions wind up paying part of the property tax for which they would be liable if taxable. In theory, the institution pays for services related to the enhancement and protection of its property such as waste disposal, water supply, police and fire protection, street maintenance, transportation services, and the like. Exempt institutions, along with other

landowners, are assessed according to the demand they generate for each of these services. (Various cost allocation schemes have been proposed to calculate the appropriate charge for nonprofit institutions.) The property tax frequently includes the charge for these services, so separate liability for service charges increases the cost of operating charitable institutions and recaptures for the locality some of the revenue foregone through property tax exemption. The institutions affected doubtless would pass on some of the added costs to their supporters and audience. In the first instance, the result is probably fairer, since those who enjoy the service should pay for it rather than those who reside in the city where the institution is located. But if the institution enhances the value of neighboring property, for example, by drawing tourists to retail stores, the issue of fairness becomes considerably more complex.

Tax-exempt institutions pay service charges in many jurisdictions: Denver, Colorado Springs, and Nashville charge all property owners a water and sewerage charge. In 1969 Milwaukee adopted a sewer service charge for all exempt institutions except public and parochial schools.[34] The Guthrie Theater, even though it successfully defended its property tax exemption in court, pays this sewer charge and similar charges for police and fire protection, snow removal, and the like.[35] In 1970 Virginia voters passed a state constitutional amendment that allows localities the option of imposing service charges on otherwise tax-exempt organizations.

In New York, however, service charges long remained in limbo. In 1971 the state legislature authorized service charges on certain tax-exempt properties (not including most art institutions) at the percentage of the real estate tax rate that the specified services represented in the city's expense budget.[36] The law chiefly affected state-owned property and involved a cost to the state estimated at $26.4 million.[37] Even this limited program re-

peatedly was deferred—each year the legislature postponed the effective date.[38] The legislature finally repealed the service charge in 1981.[39]

Even without formal changes in the exemption, local governments have used informal pressures to encourage "voluntary" payments by exempt institutions in lieu of property taxes or charges for city services.[40] In 1974 the mayor of Boston, Kevin White, issued a "Policy Statement on Tax-Exempt Property and Institutional Growth" to call attention to the city's disproportionately large number of tax-exempt properties. The statement observed that 58 percent of the total property base was property tax-exempt. In addition, it called for state aid to minimize the unequal distribution of exempt institutions among the state's cities. Note that such state aid is raised by taxes, such as personal income taxes and sales taxes from which property-tax-exempt institutions may enjoy formal relief, but which affect the institutions indirectly by driving up the cost of wages they pay. This point is discussed further below.

The mayor listed a series of short-term policies designed to control erosion of the Boston tax base. It made city cooperation with institutional expansion conditional on written agreements for payments in lieu of taxes and sought to take into account collateral benefits from the institutions such as sharing of facilities and creation of jobs. The mayor's office also distributed a brochure that focused on the tax-exempt status enjoyed by Boston's nonprofit institutions, emphasizing the mayor's view of the city's fiscal problems (Figure 7.1). Such a strategy is not without teeth: a city can influence institutional expansion through its control over various permits and licenses including zoning variances, building permits, parking requirements, health inspections, food-service permits, and liquor licenses.

Tax negotiations with the New Haven city government preceded construction of the Yale Center for British Art. As one

Figure 7.1
City of Boston Brochure Explaining Effects of Property Tax Exemption, 1976

Why don't we change the tax system?
I'd like to, but I can't. Only the State Legislature and the Governor can. And they've got to do it this year.

If you believe Boston residents need and deserve a property tax reduction, tell the Governor.

Return the enclosed card asking him to call the Legislature back into special session to reduce property taxes this year.

Let him know that we know we cannot bear this burden any longer.
Our city deserves better.

Sincerely

Kevin H. White
Mayor of Boston

Boston's residents pay for the finest educational, medical, and cultural institutions in this country.

But who benefits?

61% of the patients admitted to Boston's hospitals live outside the city.

Less than 1% of the freshman students at Boston's private colleges and universities come from our high schools.

Two out of every three jobs created in Boston's new office towers are held by suburbanites.

And that's not all...
The State has declared colleges, hospitals and museums tax-exempt. That means they pay no property taxes to the City.
58% of Boston's property is occupied by these and other tax-exempt institutions. The remaining 42% pays the whole tab. That's you. You are forced to make up for the 58% getting a free ride.

That's unfair.
If these institutions paid taxes like the rest of us, our tax rate would be $95 less.

condition for approval, city officials insisted that the museum building include taxable ground-floor commercial shops to compensate for the loss of tax-producing land. As a result, the Yale Center is an integral part of urban New Haven, an interesting departure from the cloistered architecture of most arts institutions.

Art critic Alfred Frankenstein has offered a harsher view of the Center:

From the outside, the building, designed by the late Louis Kahn, looks a bit like an abandoned, lower-priced department store: it is the only building I have ever seen in America, Europe or the Orient constructed as an art museum to fill an entire block front with a row of shops—the result of an agreement with the city of New Haven, which was unwilling to lose the tax revenues generated by commercial enterprises.[41]

Whether his disapproval reflects a sound or benighted philosophy of urban design, it ignores the institutional environment of the museum in a way that cannot help in negotiations with local governments.

Local pressure frequently causes the exempt institution to agree to make payments in lieu of taxes to the city. The negotiated amounts probably are less than a legislated service charge would be. Many colleges and universities have entered into such agreements; it is, so far, less common for other types of institutions—although the Boston Symphony provides free outdoor concerts as the *quid* in an informal deal for the *quo* of tax exemption for Symphony Hall.[42]

Most such agreements are informal, although certain universities, including MIT and Harvard, have from time to time signed formal statements of intent with their host cities.[43] As yet there is no typical agreement: length of time, amount of money paid, method of calculation, types of property included, and methods of assessment all differ. Even token in-lieu-of-tax payments have proved politically valuable to nonprofit institutions in defusing public resentment of the expansion of tax-exempt institutions.

Pressure for payments in lieu of taxes is likely to continue and perhaps to become more widespread. Certainly, cities will not fail to identify tax-exempt property as part of the cause for their fiscal woes. For example, in 1972 the city of Cambridge, Massachusetts, began sending suggested tax bills to every property-owning nonprofit institution within the city limits except churches.[44] The city's total property tax revenue in the previous year, $9 million, was divided by the city's total land area, 174 million square feet, and every nonprofit institution was "billed" at the rate of $.0521 per square foot.

Mayor Edward Koch of New York City tried a similar tactic in 1978. He announced that he had sent letters to the owners of approximately 2,300 selected tax-exempt parcels indicating what their property taxes would be if they were not exempt and requesting voluntary payments in lieu of taxes. The foregone taxes for all of these parcels were estimated at $180 million per year. One year later, Koch's program had yielded an insignificant $78,500, $45,500 of which came from a foundation that had previously made it its policy to pay that amount every year.[45]

Payments from one level of government to another are also becoming more common. These payments are particularly important at the state level because state legislation authorizes property taxation and specifies tax exemption. Two types of state payments to localities in lieu of taxes have been implemented: payments to localities in which construction of state facilities has removed property from the tax base, and payments to localities to distribute the burden of state-mandated exemptions to all taxpayers instead of just those in whose localities the tax-exempt institutions happen to congregate.[46] The Connecticut legislature, for example, gave a partial rebate to communities with high concentrations of property-tax-exempt education and health institutions.[47]

The federal government also has a variety of revenue-sharing

and in-lieu-of-tax programs in force, each designed to minimize the impact on local tax bases of federal facilities or land ownership.[48] These programs are designed to distribute the costs of granting tax exemptions more evenly among taxpayers, rather than imposing them on the consumers of the particular services.

In the long run, the future of the property-tax-exemption subsidy may be more dependent on the future of the property tax itself than on opposition to, or amelioration of, exemptions. Any replacement of property tax revenues with an entirely different, more broadly based, local or state tax would reduce, or even eliminate, the value of the property tax exemption. Thus, arts institutions might lose an important subsidy with no replacement.

Compared with other revenue-raisers, the property tax wins few popularity polls.[49] Three surveys conducted for the Advisory Commission on Intergovernmental Relations discovered that the local property tax is generally considered the "worst" tax and always one of the two "least fair" (the federal income tax has been gaining on it in the latter category). A 1973 Louis Harris survey estimated that 68 percent of the people felt property taxes were too high. The Urban Observatory also conducted a survey in which it asked citizens of ten large cities, "If more tax money is needed, which do you think is the best way to raise it?" The local sales tax was clearly the first choice with a local income tax generally second. The property tax was always at or near the bottom of the list. The recent success of popular-initiative referenda limiting the revenue-raising capabilities of the property tax has accelerated a move away from property taxation.

Even as its political support weakens, the property tax is becoming vulnerable to court decisions invalidating different assessment procedures and school financing keyed to property

tax receipts. Educational financing systems based on the property tax have been found to violate state constitutional guarantees.[50] In most systems they favor communities with high per-capita property values. Such decisions may force states to impose a statewide tax and redistribute the revenues on a per-capita basis for education. This tax might be a property tax with the full range of exemptions, but more likely some other type of tax without such exemptions, such as income or payroll taxes, will provide the needed revenue.

Under such taxes, currently exempt institutions would continue to pay no property tax, but their employees would be treated the same as those employed in other sectors of the economy. Depending upon how the labor supply responds to this increased taxation, some of the burden of income taxation will be shifted onto the charitable institution itself.

To illustrate this proposition, consider a town with a museum and a factory, each with one employee. The factory and the employees pay property tax of $10, $1 and $1 each, respectively, while the museum pays nothing; the employees' salaries have equilibrated at $25 ($24 after taxes). If the property tax is replaced at the same revenue level by an income tax, the employees each will be liable for $6 in income tax and relieved of $1 in property tax, while the factory will be $10 richer. The factory employee will bargain hard for a $5 raise, which the factory owner will find easy to grant out of his $10 windfall. In fact, he will be able to expand production and offer the museum employee a job at $30 as well. To stay at the museum the employee will demand a $5 raise—but his employer will have no surplus to draw it from. Unless the employee (a janitor, say) would rather sweep marble than concrete *and* absorb a pay cut of $5 to do so, the museum will see the tax charge as a new cost of $5 per year. Thus, the hidden subsidy will be revealed dramatically

when it is replaced along with the tax in which it was embedded.

California has passed a property tax limit for all communities by referendum (the famous Proposition 13).[51] Massachusetts, also by referendum, limits the property tax to 2½ percent of value and imposes other restrictions on appropriations by localities.[52] Such caps operate as gradual-repeal measures. In fact, the Massachusetts measure, by limiting property tax total revenues to 2½ percent per year growth, repeals property taxes by the difference between 2½ percent and the inflation rate. Already every state but one has a broad-based tax (sales or income or both) whose growth has replaced property tax increases—at the expense of property-tax-exempt institutions.

Recent debate at the national level has favored replacing the locally based property tax with a nationally administered tax, such as a value-added tax, accompanied by a revenue-sharing plan, which would redistribute the funds to localities. This proposal has the attraction of avoiding interjurisdictional competition for industrial growth between neighboring taxing authorities, which competitively bid down their effective tax rates. Like the alternative municipal tax proposals, this plan would reduce the value of the property tax exemption and would not automatically substitute a compensating subsidy for nonprofit institutions.

A number of states and cities have already implemented versions of these proposals. As more states review the administration of property taxation, attention will turn to property tax exemption and to its costs to taxpayers in general. Charitable institutions doubtless will be called upon to defend their tax-exempt status, and as the trends we have described above continue, the institutions may well lose part or all of those exemptions or see them rendered ineffectual with the growth of new

local taxes. Such erosion, it bears repeating, will occur without any explicit tampering with the property-tax-exempt status of the institutions themselves.

CONCLUSIONS

The important sources of indirect government aid to arts institutions are not as secure as they look. Since 1969, income, estate, and gift taxes have undergone major revisions that will have lasting effects on donations to and operations of charitable institutions. More such changes are being considered, and even though we know that they too will influence arts institutions, it is difficult to measure the net effect of these proposals before they have been implemented. Similarly, the value of property tax exemptions is subject to modification.

The dynamics of the tax code framework that generates indirect government aid have seldom been scrutinized by arts institutions. Indeed, arts institutions have typically exhibited blind, or at least myopic, faith in the continuation and accretion of favorable tax preferences. We know of no arts institution opposition to the gradual substitution of broad-based taxes for property taxes, or advocacy of the exemption of charitable institutions' employees under these new taxes. The need for ongoing monitoring of tax laws by nonprofit arts institutions is clear, but we question whether even a broad-based coalition of nonprofit organizations could deal successfully with these problems. Recall that the interests of one sector—churches, for example—do not necessarily coincide with the interests of other sectors.

The hidden character of the indirect government aid system may even be a liability, for the effects of indirect government aid are difficult to identify, rendering the system less susceptible to influence than a direct system. Arts institutions have often had

to resort to *ex post facto* complaints about injurious tax re-
forms: when tax law changes are being considered, arts institu-
tions do not receive polite letters—much less Arts Impact State-
ments—evaluating the proposed changes. Often the impact on
the arts is inadvertent or believed to be minor. True, perhaps,
when weighed on the scale of federal expenditures, but dis-
hearteningly false on the scale of individual arts institutions'
budgets.

8

CONCLUSIONS AND
RECOMMENDATIONS

The financial support to arts institutions from the complicated system of indirect government aid clearly exceeds—and by a far larger amount than anyone appears to have realized—the amount given in direct aid to arts institutions. In 1973, the year on which our financial estimates are based—and unfortunately the last year for which complete data are available—indirect government aid totaled about $460 million, drawn primarily from federal income tax deductions and property tax exemptions. In contrast, direct aid from government and private sources in 1973 totaled approximately $200 million.

Indirect government aid to arts institutions does far more than merely provide money. Gifts given to take advantage of tax deductions affect arts institutions by reinforcing the decisionmaking power the rich wield through their direct donations of money and property. When a wealthy donor gives a $500,000 painting to a museum, the donation usually is preceded by negotiations between the museum administration and the donor and his representatives. During these negotiations the terms of the gift

are spelled out: Where will the painting hang? Can the museum put it in storage? Can the painting be sold in the future by the museum? The museum may not want the painting very much, but its administration may wish to cultivate the donor; and in any event, it has little reason to turn down a gift with little cost to the museum. Perhaps the donor has hinted at further gifts that the museum wants or perhaps the donor and his gift are being championed by an important museum trustee; the reasons why the gift is given and the reasons for its acceptance do not affect the financial benefit to the donor. Once the gift is accepted, the donor takes a tax deduction on his personal income tax return. Thus, the decisionmaking process and incentives fostered by indirect government aid do have a significant influence on arts institutions and on the cultural experiences and perceptions of all who go to them.

Arts institutions in many cases are overcapitalized because some forms of indirect aid—notably, the property tax exemption and the exemption of capital gains tax on donations of appreciated property—are tied to capital investment. Moreover, donors are notoriously loath to make cash gifts to an arts institution that are not linked to a "building fund" or some other cause, such as the purchase of a specified painting (examples of this can be found in Chapter 6). The tax advantages of a gift of cash—that might be spent heating the rehearsal studio—are precisely the same as the tax advantages of one for the premiere of a new ballet.

The existing indirect government aid system thus gives added leverage to the preferences of wealthy donors. While they certainly are entitled to express their preferences when they make gifts from their own pockets, the charitable contribution deduction gives them the power to control the government-financed portion of the gift, which increases with the individual's tax bracket. One consequence is to heighten the already consider-

214 PATRONS DESPITE THEMSELVES

able incentives for museum professionals to woo wealthy benefactors.

The incidence of indirect government aid to arts institutions is, as previously seen, middle-of-the-road in its effects, transferring money from the well-to-do to those slightly less well-to-do in the enjoyment of art. It is neither extremely redistributive nor regressive. Many alternative funding mechanisms would operate similarly in this regard, so that changes in the current system will not substantially alter the overall incidence of income to the arts and will be able to retain the slightly redistributive nature of the system. This is particularly true of the reforms proposed in this chapter because they fit comfortably within the range of alternatives tested in Chapter 4.

Indirect government aid to arts institutions is sometimes defended as encouraging decentralization in decisionmaking. The merit of this defense, as we have suggested, depends on the kind of decentralization sought or implied. In its present form the federal income tax deduction places control of arts institutions in the hands of a relatively small group of rich donors. Since this property of the indirect system is so pervasive, and since taxpayers in the higher income brackets are responsible for so much of the support for cultural institutions, the present system resembles a matching grant arrangement for its participants. An explicit matching grant program—such as conversion of the charitable deduction into a credit—could achieve a kind of decentralization more rationally linked to individual effort.

Indirect aid is not necessarily more secure than direct aid. Changes in other provisions of the Internal Revenue Code, ostensibly unrelated to charity, affect the flow of funds to the arts, often adversely. The simplest example is the recent reduction in income tax rates included in the Reagan administration's 1981 tax bill, which we predict will reduce both the induced gift and the tax expenditure to arts institutions.

Although little of the government tax aid benefits artists directly, artists do not suffer greatly from unfair tax burdens as is frequently asserted. With the modifications suggested below, the tax treatment of artists would be in agreement with accepted principles.

On balance, the indirect aid system is neither a shocking giveaway to the wealthy nor the cornerstone of American cultural life, and its alteration or replacement would not bring the whole structure tumbling down. In this chapter we describe a number of different proposals that would reform or replace the current system of tax expenditures. Relatively simple reforms can improve the efficiency of the system; more far-reaching reforms are necessary to improve its equity.

INCOME TAX

Disclosure of Data

The public deserves a clear picture of what is done with money that otherwise would be collected as taxes. At present, the federal government does not and cannot provide this information. This glaring defect in information on federal tax collecting and tax spending relates directly to the principal difficulty encountered in the present study, namely, the wholly inadequate records for the indirect subsidy system. Even under the existing charitable contribution deduction system, this lack could be significantly redressed if taxpayers were required to itemize charitable deductions by categories. To ease the administrative burden on tax return filers, taxpayers could skip categorizing contributions if their total contributions did not exceed a ceiling of, say, $500.

At present, the regulations require a donor of property who claims a deduction over $200 to report his basis; together with

the value claimed, this data determines the unrealized appreciation in the property. The IRS, however, does not publish aggregate information that would disclose the capital gains tax expenditure for such gifts. It should.

Historically, the Internal Revenue Service has resisted collecting information other than that required to administer the tax code. We believe it should view its mission more broadly and include among its responsibilities reporting to the public not only where tax monies come from but also how efficiently the tax system as a whole is working.

Alternatives to the Charitable Deduction

The major defect of indirect aid through a charitable contribution deduction lies in the different treatment accorded different donors; the higher the individual donor's taxable income the more of the tax expenditure he is allowed to allocate with each of his own dollars. Charity becomes the province of the wealthy, not only because of their personal tastes and their ability to donate, but also because of the extra tax benefits they are given by the indirect aid system. Economists, lawyers, and public policy analysts have proposed a variety of mechanisms that would retain certain characteristics of the present system, but treat individual donors more equitably in comparison with one another in the benefits and incentives received for each donation.[1]

All current proposals to reform the charitable deduction within the general framework of indirect aid retain two elements of the current system: (1) the opportunity for the individual donor to determine the recipient of his and the government's largesse, and (2) a matching grant structure through which the donor's private contributions are matched in some manner by government funds. Despite the impossibility of assuring that all individual decisionmaking will be in accord with good public pol-

icy, individual choice has been staunchly defended as a prime virtue of the current system, and it is appropriate—if not politically inevitable—that this characteristic of the system be retained. And a matching grant is a logical way to channel government money to charities according to individual preferences. Finally, the advantages of preserving government amplification of philanthropy in some way may not be merely political and equitable but, according to Hansmann, are efficient as well. His study of nonprofit performing arts organizations concludes with an endorsement of matching grants, in general terms, as a well-conceived policy to support the nonprofit structure, a structure he shows (at least theoretically) to be an efficient accommodation to market defects afflicting the industries commonly organized in nonprofit form.[2]

In this section we discuss the three major matching grant proposals: the tax credit, the percentage contribution bonus, and the sliding matching grant. The tax credit allows each donor to subtract the same percentage of any charitable gift directly from his tax liability. With some experimentation, the government, if it so desired, could set the matching rate to maintain the present level of charitable funding or to achieve any desired level of reward for charitable giving. Unlike the current rates, which are determined by the donor's marginal tax rate, the matching rate would be determined independently and the government could adjust the system more easily.

Although the tax credit can be adjusted to maintain the present net flow of gifts to charitable institutions, the results will differ across charitable sectors. Feldstein has estimated, for example, that substituting a 30-percent tax credit for the current system of charitable deductions would increase total charitable giving by approximately 17 percent, but that not all charitable sectors would benefit.[3] While religious, health, welfare, and some other institutions would experience an increase in their reve-

nues from charitable contributions, educational institutions would experience a drop of approximately 20 percent—as would cultural institutions. The relative incentives for different donors change in different ways in moving from a deduction to a tax credit system, and these differences explain why the distribution of charitable funds would change: individuals in higher income brackets would have a lower incentive to give while individuals in lower income brackets would have a higher incentive to give.

Under a second matching grant proposal, the percentage contribution bonus, the government pays a flat matching grant directly to each charity based on the total donations to the charity. It is economically equivalent to a tax credit, but moves the government contribution from the individual's tax return to a direct payment to the charity. It eliminates extensive reporting on income tax forms, substituting an abbreviated reporting burden placed on the charitable institution, since all of the gifts it receives will be matched at the same rate.

The British system of matching grants to charity, constructed around a written agreement between the donor and the charity known as a Deed of Covenant, is similar in many respects to the percentage contribution bonus.[4] Under a Deed of Covenant the donor agrees to give to the charity of his choice a predetermined amount annually for at least seven years. The donor's payments are in after-tax income. The charity then reclaims from the government the taxes paid on that income as if they had been paid at the lowest marginal tax rate, 35 percent. Only individuals who pay taxes are eligible to make donations via a Deed of Covenant, and all such donations are matched at the same minimum tax rate independent of the marginal tax rate the donor actually paid. (A similar covenant exists for corporate donations.) Functionally, this system is the equivalent of a 35-percent tax credit, but like the percentage contribution bonus it

operates outside the tax system, avoiding the problem of the charitable institution perceiving the public contribution as private.

The third proposal, the sliding matching grant, is designed to achieve a middle ground between the inequity of the existing charitable deduction and the redistribution of funds among charitable sectors that would occur with a tax credit or a percentage contribution bonus. Under the sliding matching grant the size of the federal match is determined by the percentage of the donor's income given to charity during the year: the matching rate increases as the percentage of income donated increases. Greater incentives are offered to those who show greater "effort" in their giving. The ideal of equity employed in this proposal is to treat individuals the same if they expend identical portions of their incomes rather than just treating all of them the same. It also has some curious side effects: single people and childless couples who have more discretionary income and can better afford to make charitable contributions will probably be awarded a higher match.

McDaniel has used several matching rate schedules to estimate the net results for charity of certain sliding matching grants.[5] He concludes that a reasonable system could keep aggregate giving at the same level, result in a moderate increase in funds to religion, and correspondingly moderate decreases in funds to other charitable institutions (including, presumably, cultural institutions). This result is similar to, but less marked than, the estimated result for a tax credit. The sliding matching grant also ensures that federal support of all types of charitable organizations can be relatively evenhanded; in McDaniel's example, the federal share for each charitable sector comprises about 18 to 20 percent of the total charitable contributions received by that sector. Again, the critical question is whether the improved equity, effectiveness, pluralism, and rationality within

the tax system are worth the price of shifting funds away from certain charitable sectors and toward others.

We recommend that the charitable contribution deduction in the federal tax structure be replaced by a tax credit of approximately 30 percent. This option is particularly desirable because it would entail only minor changes in existing tax law. We recognize that a tax credit at this rate might present a net cost to the arts, but direct government aid could be modified accordingly. It is also essential that any reform of direct government aid include the built-in flexibility to respond to shifts in indirect aid. To make this change effective, record-keeping and data collection would have to be expanded and made responsive to current needs.

Policymakers would have to determine, first, how much money the government should provide to arts institutions overall and, second, how the money that would be provided should be distributed. We think an important benefit of changing from a deduction to a tax credit is that it would force these decisions to be explicit. A virtue of a tax credit, as opposed to a deduction, is its adjustability. For example, suppose Congress elected to compensate arts institutions for the loss of financial support they would incur upon conversion of the charitable contribution deduction into a credit. Analysts might use econometric techniques to form a reasonable estimate of the dollar loss— both through reduction of the tax expenditure and the likely reduction in the induced gift—and an equivalent sum might then be distributed to arts institutions in the form of direct grants.[6]

Gifts of Property

Income tax deduction rules for gifts of property (see Chapter 3) to charitable institutions at present provide an additional bonus

to the donor. He can deduct not only the price he paid originally for the property, but also any appreciation in value without paying tax on the appreciation. For example, a painting bought for $75,000 and donated when its market value is $125,000 generates a tax deduction of $125,000, with no tax payable on the $50,000 gain. If the donor sold the property and gave $125,000 cash, he would get a $125,000 deduction, but $20,000 (40 percent of $50,000) would be added to his income as a capital gain, for a net deduction of $105,000.

We favor putting gifts of property on the same footing as gifts of cash, by allowing only the basis of the property gift plus 60 percent of its appreciated value to be deducted: in the illustration, $75,000 plus $30,000 (60 percent of $50,000), or $105,000. This would, in effect, result in collection of the capital gains tax that would have applied had the property been sold. We favor the same rule for gifts of securities and other intangible appreciated property. It should be recognized that some donors are unlikely to be as generous with gifts of property under these proposed laws as they are now because the effective price to the donor of making such gifts would rise.

Artists

Contrary to their advocates' assertions, artists are not discriminated against by federal tax laws. There is, however, a problem—arising from the different sources of artists' incomes—that should be remedied. The artist's ordinary income—value added to materials through labor—should be treated as service income but the appreciation on his work should be taxed at capital gains rates. Because the artist becomes an investor in his own work when he holds it after creation, the same status as an art collector should be granted him. What is discriminatory is the inability of the artist now to treat his own work as a capital invest-

ment, combined with the tax consequences of a charitable contribution. In contrast, an entrepreneur who founds a company can realize a capital gain by owning stock in the company if the stock appreciates in value.

In particular, the artist should be permitted to separate his income into two parts, paying ordinary income tax on the professional-services part and capital gains tax on the appreciation part. More specifically, the artist should be able, for tax purposes, to treat a finished work as producing income in the amount of its market value, even when he does not sell it. Suppose, for instance, that a painter completes a painting that an art dealer appraises at $1,000. He should be able to elect to include the $1,000 in his income, and then treat the painting as an investment.

The result would be that the artist would pay a tax, otherwise not owed, on the declared value of the painting when created. Thereafter, however, the declared value would be the tax basis for future sales, and the artwork could be treated as a capital asset by the artist. A year or more after holding a work in this manner, a sale would generate a capital gain or loss. Thus, if the artist sold his painting two years later for $5,000, the artist would treat $4,000 as a long-term capital gain. Donations to a nonprofit arts institution after a year would be fully deductible at fair market value. To discourage the artist from undervaluing his artworks, he would be required to advertise the works for sale at the chosen price ($1,000 in the illustration).

If the proposal operated effectively, the artist would have to decide in each case whether to elect such treatment. The choice could provide possible benefits vis-à-vis a tax enacted in the future. If the artist holds on to his work indefinitely, of course, the election would become improvident.[7]

Other tax problems, for the most part, are either illusory or represent special pleading. The artist has no estate tax problem,

for example, that does not also plague any small businessman. In sum, it is perfectly appropriate for artists to seek special favors from the government, but it is equally appropriate for the plea to be ignored.

State Income Taxes

State income tax codes, as noted earlier, often allow charitable contribution deductions, either directly or as a percentage formula based on the federal deduction. State expenditures are far more inefficient than federal tax expenditures, for they subsidize the federal government, as well as charities and charitable donors, through the interplay between reduced state income tax liability, reduced deduction for federal income tax purposes, and increased federal income tax liability.

A proposal in a given state legislature to repeal or modify tax expenditures favoring the arts would, in most cases, conflict with the state's policy of maintaining uniformity between federal and state income taxes. If the federal income tax deduction were replaced with a tax credit formula, this problem would be largely nullified.

FEDERAL ESTATE AND GIFT TAXES

The federal estate and gift taxes allow unlimited deductions for charitable contributions, a rule that raises some of the same questions as the income tax deduction. Elimination of any offset against these transfer taxes for charitable gifts has been proposed on the ground that the present rule represents an "unjustifiable and extraordinary exception" to the taxation of transfers representing power over wealth.[8] Whatever the merits of repeal on this ground, a change from a deduction to a credit or matching grant system would have far less effect than the com-

parable income tax change. Given the relatively small number of taxpayers involved, any such change is unlikely to alter significantly the decisions of arts institutions. An important detriment to testamentary gifts discussed in Chapter 6, donor restrictions, can better be handled directly.

RELAXING DONOR RESTRICTIONS ON CHARITABLE GIFTS

As suggested in Chapter 6, many of the problems associated with the indirect aid system stem from donor restrictions on the use of their donations. The problems arising from donor-imposed restrictions can be remedied in large part within the current indirect aid system without major changes in that structure. In this section we propose several ways to limit donor restrictions. The first and second proposals deal generally with donor restrictions. The third proposal deals specifically with the problem of misallocation of donated artworks. It is possible to design a general policy to deal with all types of donor restrictions that will have low administrative costs and be simple to implement. Two such policies are: partial deductions for restricted gifts and a sunset law on donor restrictions.

A partial rather than full deduction for restricted gifts would discourage donor-imposed restrictions on donated property. Limitation of the deduction in this manner responds directly to the real reduction in the value of a gift relative to its market value imposed by a use restriction. A similar approach has already been used in tax law to provide disincentives for certain types of gifts: the Tax Reform Act of 1969 discouraged donations to private nonoperating foundations by limiting the deduction for gifts of appreciated property to the donor's basis plus one-half of the unrealized appreciation, and by further limiting these gifts to 20 percent of the donor's adjusted gross income with

no carryover of the excess to future taxable years.[9] Under our proposed changes, restricted gifts could give rise only to partial deductions, prorated according to a variety of criteria bearing on the type or extent of the restriction. Unfortunately, while this proposal would probably stop donor restrictions in overt form, it might just drive them underground. Managers of arts institutions might substitute secret gentlemanly undertakings, on which they would not renege for fear of offending donors.

Whether the tax law is changed or not, we suggest eliminating the long-range effects of restrictions through sunset legislation. Under such a provision, restrictions on the use of a charitable gift would lapse after a reasonable period, perhaps 25 years. After the expiration of the restriction neither the donor nor the donor's heirs would have any legal recourse against an institution that chose to ignore the restriction. The institution becomes the custodian of the public interest in deciding whether or not to continue to honor it. Museums still could make agreements with prospective donors about the intentions of the museum to honor the donors' wishes beyond the time set by law, but such agreements would not be binding on the institution after the time period had expired. Equally important, the moral right of the institution to make its own decisions would be endorsed by law.

A sunset law would allow a museum to deaccession donated artworks, to break up a collection and stop exhibiting it *in toto*, or to spend its previously restricted endowment in any appropriate manner. To be sure, the law might not alleviate the incentives for overcapitalization; once a building is built it is unlikely that it will be soon torn down. But the sunset law may strengthen the bargaining position of the museum when it is initially negotiating for such a major gift; presumably the museum would feel that its goals would be better served by not restricting these gifts in perpetuity. It is likely that donor restric-

tions placed on the plastic arts, particularly on museums, have more enduring effects than restrictions on other types of arts institutions or media. A donor-financed production will only stay in the opera company's repertoire for a limited number of years anyway, and other donations are typically made for particular programs in the upcoming season. Performing arts institutions as a group tend to be less dependent on donor largesse for buildings (many of them rent or occupy halls owned by governments or educational institutions) or for physical objects that lend themselves more easily to restrictions in perpetuity. Thus, to the extent that a sunset law does limit donor restrictions, it is likely to have a more significant impact on the operation of certain types of institutions.

Sunset legislation would not necessarily end donor restrictions on arts institutions. The institutions might be reluctant to stop honoring such restrictions after their expiration because to do so might make future donors less willing to donate to that institution. As long as society relies on an indirect aid system to provide aid to the arts, donors and recipients will be able (and encouraged) to make under-the-counter deals with other people's—the taxpayers'—money. But with a sunset law the donor's bargaining position is considerably weaker.

A sunset law is, in many ways, similar to a provision already in existence in another form of indirect aid to the arts: the limitation on the duration of patents and copyright protection. For works created after January 1, 1978, the new copyright law provides copyright protection for the author's life plus 50 years.[10] (In the case of works done for hire, protection is limited to the shorter of 75 years from publication or 100 years from creation.) Society offers a period of rigorous copyright protection in exchange for the promise that protected material will eventually become widely available for public use. The sunset law on restricted gifts would also be analogous to the "rule against per-

petuities" in property law which limits the restrictions that may be placed on the transfer of property.

In Chapter 6, we argued that allowing individual donors to determine the recipients of their gifts and to restrict those gifts in perpetuity leads to a distribution of artworks among museums on the basis of individual wishes and tastes and economic incentives but not necessarily in accordance with professional expertise nor with accepted public policy. Some artworks are given to the museums for which they have the most value (as among the many museums in which they might reside), but most often the gift is conditioned by the donor's association with the museum in question and, more often than not, the geographical location of the donor. Frequently the museum is diffident about, or prevented by the terms of a gift from, selling the work (even to another museum) when it is redundant or inappropriate for its own collection. It is expecting too much of a museum, operating within the current indirect aid system, to risk losing the gift or the donor's goodwill by negotiating the terms of the gift with the donor. Nevertheless, from the public policy perspective, the wrong museums often receive these gifts.

It is difficult if not impossible to determine the "best" allocation of these works of art through a centralized system. While art scholars may benefit from having dozens of Rodin sculptures located in the same institution, the art-enjoying public arguably would benefit more if these works were dispersed throughout a number of different museums. Without having to choose between these criteria, public policy should allow the institutions themselves to correct the allocation of artworks, constrained by their own budgetary restrictions, within a system minimally constrained by donor preferences. Museums would become the custodians of the public interest in the distribution of artworks, a role which—except for donor restrictions—they play now. This is in keeping with a common ration-

ale for the deductibility of contributions which states that such deductions are good because the institutions are providing services that the government otherwise would have to provide.

An auction mechanism allowing other museums to compete in a market to determine the final allocation of donated artworks would meet these requirements. The auction system, based on a proposal by J. Michael Montias,[11] would operate as follows:

> 1. The donor announces that he wishes to donate a particular work of art to a specific museum.
>
> 2. The museum publicizes this offer—perhaps through a centralized service—and invites other eligible charitable recipients to submit bids for the artwork.
>
> 3. Once bids have been submitted, the designated museum has a choice: it can keep the gift, or it can sell the artwork to the institution that offered the highest bid. In either event, the donor uses the highest bid as his charitable deduction.

The results of the auction would reflect the market value of the gift more precisely, and the outcomes would be more efficient in an economic sense, if individuals were allowed to bid as well. Accepting the proposition that art in the public's possession (donated to any museum) should stay there (in the possession of *some* museum), even at some efficiency cost, our proposal limits purchase to other charities. This proposition is open to debate, and the proposal readily could apply in an open auction.

The museum's ability to use its best professional judgment about acquisition and distribution of its collection would be greatly aided by this proposal. If the designated museum refused the highest bid, the decision to do so would be explicit, and the director and the trustees would be accountable for turning down attractive offers for redundant or inappropriate

objects. Official recognition of the importance of the proper distribution of the nation's art resources would also strengthen the power of individual museums to persuade donors of the advantages not only of giving a valuable object, but also of insuring that it will be in the institution for whose visitors it will have the greatest value.

In addition, this system offers an objective mechanism for establishing the value of the charitable deduction. Instead of relying on the donor's subjective judgment about the appropriate valuation, this mechanism ascertains the actual value of the work to potential recipient institutions by testing what the work would command in the market.

The question of whether the auction would allow the wealthier museums—such as the Getty and the Metropolitan—increasingly to dominate the art market does arise. However, unless these museums are always the designated museums—and since that is not the case now and there is little reason to believe they would be under this proposal—they are not assured of getting the artwork for their collection even if they bid the highest. Even if the wealthier museums did manage to obtain many donated artworks, the auction mechanism would gradually redistribute purchase funds among a number of museums as the major museums bid some art away from designated museums.

REPLACING INDIRECT AID WITH DIRECT AID

The indirect aid mechanism for which we have been able to identify the fewest advantages is property tax exemption. It is particularly subject to erosion by general tax reform and tax limitations, and rewards arts institutions for spending their money in a way that has no discernible link to the public inter-

est (owning real estate). It has specific drawbacks as well, including creation of inequities between central cities and suburban towns and incremental incentives to overcapitalization. Accordingly, we recommend that the property tax exemption for nonprofit institutions be abolished.

Such a change would, of course, be intolerable to the institutions unless implemented carefully. The transition should require payment of at least the last year's foregone taxes to the institution by the local government(s), either forever—allowing inflation to gradually change the real subsidy from automatic to explicit and discretionary—or by diminishing percentages over several years. Thus there would not be a sudden change in the institutions' budgets, but the subsidies provided by property tax exemption would eventually be provided by direct appropriation, rewarding whatever behavior the local legislature thought worthy.

Two things would change quickly: one, the institution's flexibility in allocating its resources between buildings and other parts of its budget; and, two, local governments' flexibility in supporting their institutions. We would expect new and imaginative schemes for distributing local subsidies to nonprofit institutions, each tried out in a small enough jurisdiction to minimize the costs of error and allowing local response to local needs and interests.

Property tax data for nonprofit organizations, including arts institutions, are even harder to obtain than income tax data. As a step toward removal of property tax exemptions, we recommend assessment of the exempt property and publication of its tax values.

To be sure, replacing any indirect subsidy to arts institutions with a direct system, even if legislatures are willing to continue the subsidy in some form, is fraught with difficulties. Since the subsidy will no longer be hidden, at first arts institutions may

discover that it is much harder to build a subsidy with a direct budget price into legislation than it is to preserve the hidden preferences which exist, at no visible cost, in the indirect aid system. The amounts are much larger than the Congress or state legislatures are used to putting in National Endowment or state arts council budgets—even though they *are* the amounts being provided for government arts support—and these appropriations will have to compete directly with other budget priorities. But this competition is appropriate and essential to the rational determination of public priorities.

A switch to more direct government funding would in all likelihood result in a different, though not necessarily drastically different, distribution of arts funding throughout the arts sector, but the funding would then be conducted within a system responsive to public policy goals for arts funding. If we are going to have a public policy for the arts—and it is hard to interpret either the direct system or the indirect system as anything but a public policy toward the arts—then it should be public.

The foregoing chapters have ranged over many issues pertinent to public support for the arts. We are far from putting forth a confident, detailed prescription for reform of the indirect aid system for philanthropy or even for the arts, although we have been able to identify a few needed reforms. We have, however, constructed and exemplified (within the limitations of currently available data) a framework within which to examine reforms and adjustments for the art support system, and of philanthropy generally. At its foundation is a recognition that indirect and implicit support mechanisms are the result of government policy, and should be examined and evaluated like any other policies, whether they are buried in a tax code, a state constitution, or an agency's regulations. Its principal elements are seven fundamental questions to ask about any subsidy program:

Who pays for it?
How?
How much?
Who decides how the money is spent?
Who benefits from it?
How?
How much?

The answers, we hasten to add, are not enough to allow us to choose among government policies. The decision requires that we also decide what we want, and that we mediate between inconsistent wants. But in a complicated world, a framework to help order priorities and describe consequences constitutes an important beginning.

APPENDIX: ESTIMATING
THE TOTAL VALUE
OF TAX-EXEMPT PROPERTY
OWNED BY ARTS INSTITUTIONS

This appendix describes the techniques and data used to estimate the total value of tax-exempt property owned by arts institutions in 1976. We arrived at an estimate of the value in two ways:

Estimate Number One

The first approach extrapolates from data collected for assessed values of exempt property owned by arts institutions in Connecticut, Hawaii, Maryland, Massachusetts, and New Jersey. (See Table A.) These are the only states for which complete data were available.

To predict the total value of arts property in the other states, several bivariate regression models were constructed to relate the dependent variable—value of tax-exempt property owned by arts institutions—to a variety of predictor variables. Because

Table A
Property Tax Exemptions for Arts Institutions—Selected States

State	Year	Value of exempt property ($ millions)	Arts exempt as % of total state exempt	Notes
Connecticut	1973	34.948	.72%	Data from *Quadrennial Statement by the Tax Commissioner of Real Estate Exempted from Taxation 1974.* Used classification: "Educational/private/ history, music, art, science, and politics" and other entries where appropriate.
Hawaii	fiscal 1975–1976	20.769	.58%	Data from Hawaii Department of Taxation files. Total exempt estimated from actual tax expenditure.
Maryland	fiscal 1975–1976	11.598	.22%	Primary data from *Thirty-Second Report of the State Department of Assessments and Taxation.* Augmented by data from City of Baltimore which contains other major arts institutions.
Massachusetts	1976	59.457	.55%	Match of data filed with State Department of Corporations and Taxation with list of arts institutions published by Massachu-

State	Year	Value of exempt property ($ millions)	Arts exempt as % of total state exempt	Notes
				setts Council on the Arts and Humanities. Includes most arts facilities owned by educational institutions.
New Jersey	1974	18.971	.19%	Data from 1974 New Jersey Exempt Property Summary, computer output provided by State Department of the Treasury, Division of Taxation.

we had data for only five states, we had to limit the models to only one predictor variable at a time. Where necessary, assessments were adjusted to 1976 dollars using the Consumer Price Index, as all the states were not able to provide data for the same year.

The following variables were tested to see how well each predicted total assessed value of tax-exempt arts property for the five states: state population (1975 was the latest available), population per square mile (also 1975), per capita income (1975), percent of population living in urban areas (1970 Census data), state appropriations for the arts (fiscal 1975–76), and total grants made to the state during fiscal 1975–76 by the National Endowment for the Arts. The last variable was used twice, once including grants made by the NEA Federal-State Partnership Program and once excluding them. (Even though the Federal-State Partnership funds were primarily distributed on a flat grant basis— $205,000 to each state in 1975–76—other small grants were made

on occasion and, therefore, were treated as part of the Federal-State Partnership funds.)

None of the demographic variables proved to be a good predictor of the total assessed value of exempt property. But NEA grants to states—both including and excluding Federal-State monies—turned out to be an excellent predictor. Table B summarizes the regression results for several of the more interesting and informative models. The model with the highest value of r^2, Model II, is the best predictor of the dependent variable. The value of the F statistic indicates how confident we can be that the observed relationship between the dependent variable and the independent variable is not merely a result of having taken a sample. In this case, F for a 95-percent confidence interval is 10.13. For any model that results in an F statistic larger than this critical value, we can reject the null hypothesis that there is no relationship between the variables. Model II results in the following equation for each of the states and the District of Columbia:

$$Y = \$6{,}017{,}625 + [17.19 \times (\text{total NEA grants to state})]$$

Thus, total exempt value for all cultural property $= (51 \times \$6{,}017{,}625) + (17.19 \times \$82{,}000{,}000) =$ approximately \$1.716 billion.

Estimate Number Two

The second estimation begins with data for all exempt properties in the sixteen states for which data were available. It uses multivariate regression to approximate the value of all exempt property in the United States and applies the ratio of art properties to total properties for the five states for which we had good arts exemption data to estimate the portion of that total value owned by arts institutions.

Table B

Prediction of Total Value of Exempt Arts Property by State—Regression Results

$$Y = \beta_0 + \beta_1 X$$

Model	Dependent variable Y	Independent variable X	Intercept β_0	Slope β_1	r^2	F
I.	Total value of exempt arts property (adjusted by Consumer Price Index to 1976 dollars)	Total 1976 NEA grants to the state excluding federal/state program funds	9,755,554	17.52	.81	12.79
II.	Total value of exempt arts property (adjusted by Consumer Price Index to 1976 dollars)	Total 1976 NEA grants to the state including all federal/state program funds	6,017,625	17.19	.82	13.67
III.	Total value of exempt arts property (adjusted by Consumer Price Index to 1976 dollars)	State arts budget for 1976 excluding NEA federal/state program funds	19,726,910	16.95	.06	.19
IV.	Total value of exempt arts property (adjusted by Consumer Price Index to 1976 dollars and by assessment/full market ratio specified by state law)	Total 1976 NEA grants to the state including all federal/state program funds	10,330,830	15.49	.73	8.11

The most current data on total value of property tax exemptions by state are contained in the 1972 *Census of Governments.* Sixteen states and the District of Columbia provided aggregate data on tax exemptions for the year 1971. We deleted the data for California because they are noticeably incomplete; they do not include estimated exemption values for any government-owned properties. Using this information and other data from the 1972 *Statistical Abstract of the United States* and the 1970 *Census of Population,* several multivariate regression models were constructed to predict the total value of all exempt property in these states.

A variety of model specifications were used; the most interesting results are summarized in Table C. All of the models offer good predictive capability: the R^2 statistics are relatively high and all of the F statistics are larger than those necessary to reject hypotheses of independence between the dependent variable and the independent variable(s) at a 95-percent level of significance.

In each of the models the only variable that has any significant effect on the exempt value is the population of the state. Therefore, we finally considered only Models III and V. Even though Model V did a slightly better job of predicting (R^2 of .76 rather than .71), we rejected it in favor of Model III for two reasons: (1) even though certain states had legislated ratios for assessments as a fixed percentage of full market value, it is impossible to know how closely this ratio is followed in practice (particularly problematic in the case of tax-exempt properties) and (2) to provide a check on the first estimate, a model which provided an estimate for the total *assessed* value of exempt arts property was required.

Using Model III, the value of all exempt property in each state and the District of Columbia can be predicted by the following equation:

$$Y = \$78.36 + [\$1.13 \times \text{(state population in 1971 in 000's)}]$$

Thus, total exempt value for all property = $(51 \times \$78.36) + (\$1.13 \times 206,000) = \$237,000$ million or $237 billion. Using the Consumer Price Index to adjust this amount to 1976 dollars, the model estimates a total assessed value for all exempt property of $331 billion.

To estimate the portion of this total attributable to arts institutions, ratios of arts exemptions to total exemptions were calculated for the five states for which arts exemption data were available. In certain cases both figures were known for 1976; in others the art exemption was known but the total exemption was not known, and in these cases the total exemption for 1976 was estimated by inflating the 1971 exemption total with the Consumer Price Index. Using these five data points a mean arts/total ratio was calculated:

$$\text{Ratio} = (.72 + .58 + .22 + .55 + .19)/5 = .45\%$$

Applying this ratio to the estimate of the total assessed value of all exempt property—$331 billion \times .0045—gives an estimate of $1.448 billion for the value of tax-exempt arts property.

Given the quality of the data, the two best estimates are quite close together: $1.716 and $1.488. In Chapter 3 we use the average of these two estimates, $1.6 billion, to estimate the property tax expenditure for culture. Chapter 3 also refers to data on property tax exemptions in three cities: Baltimore, Boston, and New York City. These data are summarized in Table D.

Table C

Prediction of Total Value of All Exempt Property by State—Regression Results

$$Y = \beta_0 + \beta_1 X_1 + \beta_2 X_2 + \beta_3 X_3 + \ldots$$

Model	Dependent variable ($ millions) Y_i	Intercept $\hat{\beta}_0$	X_1 = population (000's) β_1	X_2 = per capita income β_2	X_3 = median years of school completed β_3	X_4 = percent of population living in metropolitan area β_4
I.	Total value of exempt property in state	12,766.47	1.08 (4.579)	1.84 (.559)	−1627.21 (.548)	−9.09 (.122)
II.	Total value of exempt property in state	−2,701.92	1.10 (5.180)	.70 (.363)	—	—
III.	Total value of exempt property in state	78.36	1.13 (5.933)	—	—	—
IV.	Total value of exempt property adjusted to full value by legislated assessment/full market value ratio for state	−14.10	1.17 (5.876)	.26 (.145)	—	—
V.	Total value of exempt property adjusted to full value by legislated assessment/full market value ratio for state	1,017.59	1.18 (6.648)	—	—	—

Source: 1972 Census of Governments, Statistical Abstract of the United States, 1972, and 1970 Census of Population

Note: The figures in parentheses are the t-statistics for each of the regression coefficients.

Table C
(continued)

Statistics

Model	Adjusted R^2	$F_{calculated}$	F critical at 95% confidence
I.	.64	7.16	3.48
II.	.69	16.49	3.89
III.	.71	35.20	4.67
IV.	.74	20.44	3.89
V.	.76	44.19	4.67

Table D

Property Tax Exemptions For Arts Institutions—Selected Cities

City	Year	Value of arts exempt property ($ millions)	Arts exempt as % of city exempt	Tax rate	Tax expenditure ($ millions)	Notes
Baltimore	fiscal 1976/77	$10.128	1.2%	.0611	.619	Data provided by Supervisor of Assessment for Baltimore City, State Department of Assessment and Taxation
						Data do not include arts facilities owned by arts institutions
Boston	1976	$16.938	.84%	.1967	3.332	Data provided by State Department of Corporations and Taxation
						Data include most arts facilities owned by educational institutions
New York City	1976	$258.377	1.10%	.08795	22.724	Data taken from the City of New York, *Tabulations of 1976 Property Tax Exemptions by Owner and Use*, provided by the Citizens Budget Commission

NOTES

CHAPTER 1

1. See, for example, William F. McDonald, *Federal Relief Administration and the Arts* (Columbus: Ohio State University Press, 1969), or Richard D. McKinzie, *The New Deal for Artists* (Princeton, NJ: Princeton University Press, 1973).

2. Dick Netzer, *The Subsidized Muse* (New York: Cambridge University Press, 1978).

3. Karl E. Meyer, *The Art Museum: Power, Money, Ethics* (New York: William Morrow and Company, 1979); Nathaniel Burt, *Palaces for the People: A Social History of the American Art Museum* (Boston: Little, Brown, 1977); Philip Hart, *Orpheus in the New World* (New York: W.W. Norton, 1973); Thomas G. Moore, *The Economics of the American Theatre* (Durham, NC: Duke University Press, 1968); Glen Withers and C. David Throsby, *The Economics of the Performing Arts* (Melbourne: Edward Arnold, 1979); William J. Baumol and William G. Bowen, *Performing Arts: The Economic Dilemma* (Cambridge, MA: MIT Press, 1966).

4. See Netzer, *The Subsidized Muse*, p. 58.

5. See, for example, Alvin Toffler, *The Culture Consumers: Art and Affluence in America* (Baltimore, MD.: Penguin Books, 1965), pp. 182–208; Rockefeller Panel Report, *The Performing Arts: Problems and Prospects* (New York: McGraw-Hill, 1965), pp. 120–121, 138–143, and chaps. 4 and 5; and Baumol and Bowen, *Performing Arts*, chap. 13 and pp. 348–356.

6. Meyer, *The Art Museum*, pp. 31–36, 256–260; Netzer, *The Subsidized Muse*, pp. 43–45, 50–52. It is interesting to note that the review of Netzer's book in *The New York Times Book Review* of April 3, 1978, emphasized indirect aid mechanisms much more heavily than Netzer had.

7. Stanley Surrey, *Pathways to Tax Reform* (Cambridge, MA: Harvard University Press, 1973).

8. The merits of Surrey's tax expenditure concept have been debated in a number of articles: Boris I. Bittker, "Accounting for Federal 'Tax Subsidies' in the National Budget," 22 *National Tax Journal* 244–261 (1969); Stanley S. Surrey and William F. Hellmuth, "The Tax Expenditure Budget—Response to Professor Bittker," 22 *National Tax Journal* 528–537 (1969); Boris I. Bittker, "The Tax Expenditure Budget—A Reply to Professors Surrey and Hellmuth," 22 *National Tax Journal* 538–542 (1969); Alan L. Feld, "Book Review of Surrey, *Pathways to Tax Reform*," 88 *Harvard Law Review* 1047–1055 (March 1975); Stanley S. Surrey and Paul R. McDaniel, "The Tax Expenditure Concept: Current Developments and Emerging Issues," 20 *Boston College Law Review* 225–369 (January 1979). For an argument that the charitable contribution deduction is not a tax expenditure, see William D. Andrews, "Personal Deductions in an Ideal Income Tax," 86 *Harvard Law Review* 309–385 (December 1972).

CHAPTER 2

1. For a detailed comparison, see Alan L. Feld, "Artists, Art Collectors, and Income Tax," 60 *Boston University Law Review* 625–662 (July 1980). Other articles that discuss the tax treatment of artists and collectors include Renato Beghe, "The Artist, the Art Market and the Income Tax," 29 *Tax Law Review* 491–524 (1974); Ralph F. Colin, "Tax and Economic Problems of Artists," 180 *New York Law Journal* (September 7, 1978, and September 8, 1978); and Robert Anthoine, "Deductions for Charitable Contributions of Appreciated Property—The Art World," 35 *Tax Law Review* 239–284 (1980).

2. Code Section 170(e)(1)(A). The ordinary income character of gain to the art dealer and the artist derives from Code Section 1221 (1) and (3).

3. Robert Anthoine, "Effect on Donors," in Tax Institute of America, *Tax Impacts on Philanthropy* (Princeton, NJ: Tax Institute of America, 1972), pp. 49–66. From 1966 to 1969, the Museum of Modern Art received donations of 321 artworks from 97 artists. In the three years following the passage of the Tax Reform Act of 1969, it received 28 works, mostly prints, from 15 artists. Associated Councils of the Arts, *Word from Washington* 3 (August 22, 1977).

4. The regulations to Code Section 183 list nine relevant factors and allow for others to be considered, Treas. Reg. §1.183-2(b).

5. Code Section 280A.

6. 428 F.2d 1316 (Ct. Cl. 1970).

7. C. West Churchman, 68 T.C. 696 (1977). Other cases that have dealt with the trade or business versus hobby-loss questions for artists include: finding a trade or business, *Rood* v. *United States*, 184 F. Supp. 791 (D. Minn. 1960); Benjamin E. Adams, 25 TCM 1239 (1966); Sebastian de Grazia, 21 TCM 1572 (1962); finding no trade or business, Estate of Hailman, 17 TCM 812 (1958); Louis H. Porter, 28 TCM 1489 (1969), *aff'd. p.c.* 437 F.2d 39 (2d Cir. 1970).

8. Congressman Fred Richmond, press release, "Richmond Introduces Artist Tax Relief Bill," Washington, DC, July 25, 1977, accompanying H.R. 7896, 95th Cong., 1st Sess.

9. Code section 1023.

10. Associated Press item, July 26, 1977, cited in John H. Merryman and Albert E. Elsen, *Law, Ethics and the Visual Arts*, vol. 2 (New York: Matthew Bender, 1979), p. 5–258.

11. Ignace Claeys Bouuaert, *Fiscal Problems of Cultural Workers in the States of the European Economic Community*, Commission of the European Community Report XII/1039/77–EN, August 1977, pp. 24–30. See also Charles J. Haughey, "Art and the Majority," in Stephen Greyser, ed. *Cultural Policy and Arts Administration* (Cambridge, MA: Harvard Summer School in Arts Administration, 1973), pp. 57–59.

CHAPTER 3

1. Compare William D. Andrews, "Personal Deductions in an Ideal Income Tax," 86 *Harvard Law Review* 309, 344 (1972) with Paul R. McDaniel, "Federal Matching Grants for Charitable Contributions: A Substitute for the Income Tax Deduction," 27 *Tax Law Review* 377 (1972).

2. U.S. Department of the Treasury, Internal Revenue Service, *Statistics of Income—1973: Individual Income Tax Returns* (Washington, DC: U.S. Government Printing Office, 1976).

3. For a complete discussion of the rules governing the charitable income tax deduction, see Boris I. Bittker, ed., *Federal Taxation of Income, Estates and Gifts*, vol. 2 (Boston: Warren, Gorham & Lamont, 1981), chap. 35.

4. Code Section 170(c)(2). A similar but not identical list of categories defines the charities that enjoy exemption from federal income tax, Code Section 501(c)(3). Gifts to state or local government entities for exclusively public purposes also qualify for deduction as do certain other miscellaneous contributions, Code Section 170(c)(1), (3), (4), and (5).

5. Code Section 501(c)(3) and regulations thereunder. In unusual circumstances a question may arise as to whether an entity qualifies. Compare Rev. Rul. 66–178, 1966–1 Cum. Bull. 138, with Rev. Rul. 76–152, 1976-1 Cum. Bull. 151.

6. *1975 Statistical Abstract of the United States* (Washington, DC: U.S. Department of Commerce, 1975), Table 381.

7. U.S. Department of the Treasury, Internal Revenue Service, *Statistics of Income—1962: Individual Income Tax Returns* (Washington, DC: U.S. Government Printing Office, 1965), pp. 6–8. An estimate of the federal income tax expenditure for the arts based partly on these data can be found in Kerry Vandell and Michael O'Hare, "Indirect Government Aid to the Arts: The Tax Expenditure in Charitable Contributions," *Public Finance Quarterly* 7, no. 2 (April 1979), p. 172.

8. James Morgan, Richard Dye, and Judith Hybels, "Results from Two National Surveys of Philanthropic Activity," in Commission on Private Philanthropy and Public Needs, *Research Papers*, vol. 1 (Washington, D.C.: U.S. Department of the Treasury, 1977), pp. 157–324.

9. U.S. Department of the Treasury, Internal Revenue Service, *Statistics of Income—1973: Individual Income Tax Returns* (Washington, DC: U.S. Government Printing Office, 1976).

10. Ibid.

11. In our analysis we rely primarily on recent research by Feldstein that found the average price elasticity of giving is less than -1.0; Martin Feldstein, "The Income Tax and Charitable Contributions: Part I—Aggregate and Distributional Effects," *National Tax Journal* 28 (1975): 81–100. Other major studies of the price elasticity (listed in chronological order) include Harry Kahn, *Personal Deductions in the Federal Income Tax* (Princeton: Princeton University Press, 1960); Michael Taussig, "Economic Aspects of the Personal Income Tax Treatment of Charitable Contributions," *National Tax Journal* 20 (March 1967): 1–19; Robert A. Schwartz, "Personal Philanthropic Contributions," *Journal of Political Economy* 78 (1970): 1264–1291; House Committee on Ways and Means and Senate Finance Committee, "Tax Reform Studies and Proposals by Department of the Treasury," 91st Cong., 1st Sess., 1969; Gerard M. Brannon, "The Effect of Tax Deductibility on the Level of Charitable Contributions and Variations on the Theme," Fund for Public Policy Research, mimeo, 1974; Feldstein, "The Income Tax and Charitable Contributions: Part II—The Impact on Religious, Educational and Other Organizations," *National Tax Journal* 28 (1975) pp. 209–226; and Martin Feldstein and Charles Clotfelter, "Tax Incentives and Charitable Contributions in the United States: A Microeconomic Analysis," *Journal of Public Economics* 5 (1976): 1–26. Paul McDaniel provides an excellent, concise review of these studies in "Study of Federal Matching Grants for Charitable Contributions," in Commission on Private Philanthropy and Public Needs, *Research Papers*, vol. 4 (Washington, D.C.: U.S. Department of the Treasury, 1977), pp. 2435–2442. Note, however, that different taxpayers have not been presented with different enough tax brackets at different times to allow really good estimates of this elasticity—which probably varies for different income classes—to be made. The studies cited above, and experts in the field, differ over what the truth is. Worse, while giving to charity is much like buying a good (the charity's welfare), it is not entirely like the sort of consumption behavior for which good economic theory exists. If a study indicated the price elasticity of demand for men's shirts to be positive, then it would be suspect on grounds of consumer theory alone. In the case of charitable contributions, we cannot even be sure of the sign that should appear.

12. The 1973 data are used in order to compare this estimate with that for the individual charitable deduction. By 1979 corporate donations to the arts had grown to $436 million, and the tax expenditure had grown correspondingly.

Corporate donations are the area in which tax expenditures for the arts are experiencing the most dramatic growth. Business Committee for the Arts, "Business Support of the Arts Reaches $436 Million: Highlights of Triennial Survey of Business Support of the Arts" (New York: 1979).

13. U.S., Department of the Treasury, Internal Revenue Service, *Statistics of Income—1973: Corporate Income Tax Returns* (Washington, DC: U.S. Government Printing Office, 1977).

14. Ibid.

15. U.S., Department of the Treasury, Internal Revenue Service, *Statistics of Income—1973: Individual Income Tax Returns* (Washington, DC: U.S. Government Printing Office, 1976), Table 1.2.

16. Total state individual income tax for 1973 amounted to $15.6 billion. *1978 Statistical Abstract of the United States* (Washington, DC: U.S. Department of Commerce, 1978), Table 490, p. 304.

17. Foundation Center, *The Foundation Grants Index—1976* (New York: Columbia University Press, 1977), p. viii.

18. Compare Rev. Rul. 73–105, 1973–1 Cum. Bull. 264 (sale of scientific books and city souvenirs unrelated to museum of folk art) with Rev. Rul. 73–104, 1973–1 Cum. Bull. 263 (sale of greeting card reproductions of art work related to art museum) and Rev. Rul. 74–399, 1974–2 Cum. Bull. 172 (dining room and cafeteria for employees and visitors related to museum).

19. For a discussion of the tax considerations in profitmaking activity by museums, see Michael O'Hare and Alan L. Feld, "Is Museum Speculation in Art Immoral, Illegal, and Insufficiently Fattening?" *Museum News* 51, no. 8 (May 1975): 24–26, 52.

20. Henry Hansmann, "Nonprofit enterprise in the performing arts," *Bell Journal of Economics* 12, no. 2 (1981) 341–361, and "The Role of Nonprofit Enterprise," 89 *Yale Law Journal* (1980) 835–901.

21. Senate Committee on Finance, Hearings on "Major Estate and Gift Tax Issues," Before the Subcommittee on Estate and Gift Taxation, 97th Cong., 1st Sess. (May 1, 1981), Table 9.

22. U.S. Department of the Treasury, Internal Revenue Service, *Statistics of Income—1972: Estate Tax Returns* (Washington, DC: U.S. Government Printing Office, 1977).

23. In fact, this assumption may be too conservative given the occasional extraordinary bequest to the arts (for example, the Lehman and Getty estates, the latter alone amounting to more than $700 million.) See Karl Meyer, *The Art Museum: Power, Money, Ethics* (New York: William Morrow and Co., 1979), p. 59.

24. See *Stockton Civic Theatre* v. *Board of Supervisors*, 66 Cal. 2d 13, 423 P.2d 810 (1967).

25. New York Real Property Tax Law, Sections 420-a, 426, 427, 432 and 434. A recent Appellate Division case involving the Asia Society questions the applicability of the general education exemption to museums.

26. Rev. Code of Washington Annot. §84.36.060. See correspondence from Mary Frye, Community Arts Coordinator, Washington State Arts Commission, August 19, 1977.

27. Correspondence from Daniel Berg, Operations Manager, The Guthrie Theater, August 13, 1976.

28. Pennsylvania Economic League, *The Problems of Tax-Exempt Property in Philadelphia*, Report no. 2, Revenue-Producing Property of Educational Institutions and other Charitable Institutions (Philadelphia: Pennsylvania Economic League, 1967), p. 14.

29. Correspondence from Mary Frye, Community Arts Coordinator, Washington State Arts Commission, August 19, 1977.

30. See David Sokolow, "Trust for Cultural Resources Legislation: A New Funding Source for Cultural Institutions in New York," 10 *Connecticut Law Review* 577–604 (1978); Suzanne Stephens "Trust for Cultural Resources Legislation: Implications for Urban Design," 10 *Connecticut Law Review* 605–619 (1978); and Robert A. Peck, "Living Over the Museum: Mixed-Use Cultural Projects," in *Issues in Supporting the Arts*, Caroline Violette and Rachelle Taqqu, ed. (Ithaca, NY: Graduate School of Business and Public Administration, Cornell University, 1982), pp. 66–75.

31. See, for example, *Switz v. Township of Middletown*, 23 N.J. 580, 130 A.2d 15 (1957).

32. U.S. Advisory Commission on Intergovernmental Relations, *The Property Tax in a Changing Environment: Selected State Studies* (Washington, DC: Advisory Commission on Intergovernmental Relations, March 1974), pp. 1–8.

33. U.S. Bureau of the Census, *Census of Governments 1972*, vol. 2, "Taxable Property Values and Assessment-Sales Price Ratios," pt. 1, "Taxable and Other Property Values" (Washington, DC: U.S. Government Printing Office, 1973), pp. 13–16.

34. For a more detailed discussion of the approaches to valuing exempt property, see G.R. Weir, "Exempt Properties vs. Market Value," *Aspects*, no. 12 (Fall 1973): 4–10. For a helpful survey of the dollar value of new art museum construction, see Karl Meyer, *The Art Museum: Power, Money, Ethics* (New York: William Morrow and Company, 1979), Appendix.

35. U.S. Bureau of the Census, *Census of Governments 1972*, vol. 2, "Taxable Property Values and Assessment-Sales Price Ratios," pt. 2, "Assessment-Sales Price Ratios and Tax Rates" (Washington, DC: U.S. Government Printing Office, 1973), pp. 16–20.

36. These estimates are consistent with the only other known estimate of the property tax expenditure for the arts. Dick Netzer, in his Twentieth Century Fund Study on direct government aid to the arts, mentions the importance of the indirect system and estimates the property tax exemption at approximately $125 million annually. This estimate is based on an average (effective) full market value for the property of $5 billion, which is, in turn, a guess based on 1968

statistics that show the full market value of nonprofit organizations other than colleges and hospitals to be less than $30 billion. See Dick Netzer, *The Subsidized Muse* (New York: Cambridge University Press, 1978), p. 44.

CHAPTER 4

1. National Research Center of the Arts, *Americans and the Arts: A Survey of Public Opinion, 1973* (New York: Associated Councils of the Arts, 1975), and *Americans and the Arts: A Survey of the Attitudes Toward and Participation in the Arts and Culture of the United States Public, 1975* (New York: Associated Councils of the Arts, 1976). After the analysis in this chapter was completed, Louis Harris published another *Americans and the Arts* survey for 1979–80. The data in that study do not alter our conclusions in any significant respect.

2. A criticism of this study from within the arts community can be found in "The Art Study: A Useful Tool or a Waste of Money?" *Art Letter* 6, no. 1 (1977): 2–3.

3. For an interesting compilation of 270 audience studies, see Paul DiMaggio, Michael Useem, and Paul Brown, *Audience Studies of the Performing Arts and Museums: A Crtical Review*, Research Division Report 9 (Washington, DC: National Endowment for the Arts, November 1978). This study, while going further than any other discussion of audience surveys as a group, is not sufficiently wary about extrapolating from the results of this collection of studies. For example, the median income of the arts audience reported is actually the median of the medians reported in each of the studies, with no adjustment for the sample size used in each institution's study or for the fact that the more prestigious institutions are more likely to conduct research of this type.

4. William J. Baumol and William G. Bowen, *Performing Arts: The Economic Dilemma* (Cambridge, MA: MIT Press, 1966), chap. 4.

5. Other writers have used the terms "frequency" and "reach" or "incidence" and "prevalence" to characterize these concepts. We prefer the simpler, more descriptive terms "visits" and "visitors." See Michael O'Hare, "The Audience of the Museum of Fine Arts," *Curator* 17, no. 2 (June 1974): 129.

6. DiMaggio, Useem, and Brown, *Audience Studies*, pp. 28–29.

7. Baumol and Bowen, *Performing Arts*, pp. 71–97.

8. Tabular presentations of these results are available in J. Mark Davidson Schuster, "Income Taxes and the Arts: Tax Expenditures as Cultural Policy" (Ph.D. dissertation, Massachusetts Institute of Technology, 1979), pp. 63–66.

9. Baumol and Bowen, *Performing Arts*, pp. 71–97.

10. DiMaggio, Useem, and Brown, *Audience Studies* summarizes the audience for the arts according to a variety of demographic characteristics.

11. J. Mark Davidson Schuster, "Income Taxes and the Arts," pp. 70–71.

12. For a fuller discussion of the problems associated with allocating tax bur-

dens by household income brackets, see Richard Musgrave, Karl Case, and Herman Leonard, "The Distribution of Fiscal Burdens and Benefits," *Public Finance Quarterly* 2 (July 1974): 259–311.

13. Ford Foundation, *The Finances of the Performing Arts* (New York: Ford Foundation, 1974), app. A, p. 4a.

14. National Research Center of the Arts, *Museums USA: A Survey Report* (Washington, DC: National Endowment for the Arts, January 1975), pp. 409–485.

15. Some portion remains unaccounted for because it flows directly to arts performance centers, such as Lincoln Center, that are not owned by the arts institutions that perform there. (To the extent that income to these centers flows through the individual performing arts institutions' budgets, it has been included.) The surveys probably underestimated as well artistic programs provided directly by government such as summer arts programs paid for by cities; but, again, if these payments go to performing arts organizations included in the survey, they have been counted.

16. For a complete discussion of alternative income formulations (none of which affected the results importantly), see J. Mark Davidson Schuster, "Income Taxes and the Arts," pp. 73–107.

17. Thomas Moore, "The Demand for Broadway Theater Tickets," *The Review of Economics and Statistics* (February 1966): 79–87, reprinted in Mark Blaug, ed. *The Economics of the Arts* (Boulder, CO: Westview Press, 1976), pp. 277–242.

CHAPTER 5

1. The Commission on Private Philanthropy and Public Needs, *Giving in America: Toward a Stronger Voluntary Sector* (Washington, DC: The Commission on Private Philanthropy and Public Needs, 1975), p. 123.

2. Boris I. Bittker, "Charitable Contributions: Tax Deductions or Matching Grants?" 28 *Tax Law Review* 37–63, at 61 (1972).

3. "Getting Credit for Charity," *The Boston Globe*, May 30, 1978, p. 18.

4. The Commission on Private Philanthropy and Public Needs, *Giving in America*, p. 123.

5. Ibid., p. 202.

6. Interesting discussions of the demographic characteristics and politics of boards of trustees can be found in: Karl Meyer, *The Art Museum: Power, Money, Ethics* (New York: William Morrow and Company, 1979), pp. 219–227; Paul DiMaggio, "Elitists and Populists: Politics for Art's Sake," *Working Papers for a New Society* 6 (September/October 1978), pp. 23–31; Paul DiMaggio and Michael Useem, "Cultural Property and Public Policy: Emerging Tensions in Government Support for the Arts," *Social Research* 45 (Summer 1978), pp. 356–389; and Paul DiMaggio and Michael Useem, "Social Class Differences in Exposure to the Arts in America," *Theory and Society* 5 (March 1978), pp. 141–161.

7. National Research Center of the Arts, *Museums USA: A Survey Report* (Washington, DC: National Endowment for the Arts, January 1975), pp. 298–311.

8. Grace Glueck, "Power and Esthetics: The Trustee," in Brian O'Doherty, ed. *Museums in Crisis* (New York: Braziller, 1972), pp. 117–129.

9. Philip Hart, *Orpheus in the New World* (New York: W.W. Norton, 1973), pp. 479–483.

10. Edward Arian, *Bach, Beethoven, and Bureaucracy: The Case of the Philadelphia Orchestra* (University, AL: University of Alabama Press, 1971), pp. 51–83.

11. John McPhee, "A Room Full of Hovings," *The New Yorker*, May 20, 1967, p. 129.

12. For a discussion of the efficiency considerations in delegating decision-making authority to groups of experts, see Steven J. Kelman, "Regulation and Paternalism," *Public Policy* 29 (Spring 1981): 219–254.

13. Several interesting and amusing essays discussing NEA's grantmaking procedures can be found in Michael Straight, *Twigs for an Eagle's Nest: Government and the Arts, 1965–1968* (New York: Devon Press, 1979), pp. 69–99, 113–148, 166–172.

CHAPTER 6

1. For a discussion of such influence, see Gerard M. Brannon and James Strnad, "Alternative Approaches to Encouraging Philanthropic Activities," in Commission on Private Philanthropy and Public Needs, *Research Papers*, vol. 4 (Washington, DC: U.S. Department of the Treasury, 1977), pp. 2361–2388.

2. Interview, *Boston Globe*, 1979.

3. Bruce C. Vladeck, "Why Non-profits Go Broke," *Public Interest* 42 (Winter 1976): 86–101; Henry Hansmann, "The Role of Non-Profit Enterprise," 89 *Yale Law Journal* 835–901 (1980).

4. Karl Meyer, *The Art Museum: Power, Money, Ethics* (New York: William Morrow and Company, 1979), p. 140.

5. Alvin Toffler, *The Culture Consumers* (New York: Vintage Books, 1973), pp. 182–208.

6. Michael O'Hare, "Classroom Utilization and Space Management," (Ph.D. dissertation, Harvard University, Cambridge, 1973).

7. Janet Wilson, "A Stirling Decision for the Fogg," *ARTnews* 81 (April 1982): 173.

8. Dick Netzer, *The Subsidized Muse* (New York: Cambridge University Press, 1978), pp. 117–123.

9. John Kenneth Galbraith, "The Quite Elegant Future of Boston," in Llewellyn Howland, ed., *A Book for Boston* (Boston: David R. Godine, 1980), pp. 159–160.

10. Meyer characterizes these as "donor memorial" museums. Meyer, *The Art Museum*, pp. 62–65.

11. *Commonwealth of Pennsylvania* v. *Barnes Foundation*, 398 Pa. 458, 159 A.2d 500 (1960).

12. Lee Rosenbaum, "The Scramble for Museum Sponsors: Is Curatorial Independence for Sale?" *Art in America* 65, no. 1 (January/February 1977): 10–14.

13. Meyer, *The Art Museum*, p. 65.

14. Ralph F. Colin, letter to the editor, *Texas Monthly*, January 1976, p. 8.

15. Nissa Simon, "The $100,000 Tax Deduction: An Interview with Alan Shestack, Director of the Yale Art Gallery," *Yale Alumni Magazine* 39 (February 1976): 14–17.

16. J. Michael Montias, "Are Museums Betraying the Public's Trust?" *Museum News* 51, no. 9 (May 1973): 25–31.

17. Michael O'Hare and Alan Feld, "Is Museum Speculation in Art Immoral, Illegal, and Insufficiently Fattening?" *Museum News* 53, no. 8 (May 1975): 24–26, 52.

18. H. Rep. No. 680, 94th Cong. 1st Sess., at p. 3 (1975), reprinted in (1975) U.S. Code, Cong. and Adm. News 1640, 1642.

19. Hearings on H. R. 7782, to amend and extend the National Foundation on the Arts and Humanities Act of 1965, before the Subcommittee on Select Education of the House Committee on Education and Labor, 94th Cong. 1st Sess. (1975), pp. 8–9 (Statement of Thomas Hoving).

20. A more detailed discussion on the issues involved in insuring artworks is contained in Irving Pfeffer, "Insuring Museum Exhibitions," 27 *Hastings Law Journal* 1123–1162 (May 1976).

21. See note 19.

22. Michael O'Hare, Conversation with Peter Solmssen, United States Department of State, and National Endowment for the Arts staff, March 1980.

23. Jonathan Barnett, *Urban Design as Public Policy* (New York: Architectural Record Books, 1974), pp. 14–27.

24. Stuart W. Little, *After the FACT, Conflict and Consensus* (New York: Arno Press, 1975), pp. 86–88.

25. The price to the donor of his gift is the fair market value of the gift less the value of the tax benefits to the donor. Martin Feldstein, "The Income Tax and Charitable Contributions: Part I–Aggregate and Distributional Effects," *National Tax Journal* 28 (March 1975): 81–100.

26. In the case of the estate tax, the restriction of government "matching" to the rich is even more striking: for the government to go halves with a living donor through the income tax, the donor must have a marginal tax rate of 50 percent. The 1982 rate schedule hits 49 percent for taxable income of $60,000 for married individuals filing jointly. But a 49 percent marginal estate tax rate applies only to taxable estates of over $2 million, implying a gross estate over $4 million if the testator leaves at least half to a surviving spouse. For 1972, when 120,761 estates were subject to any federal estate tax, only 1,366 estates exceeded a gross estate size of $2 million and 652 of these were gross estates in the $2–$3 million range. (Internal Revenue Service, *Statistics of Income—1972:*

Estate Tax Returns [Washington, DC: U.S. Government Printing Office, 1974], Table 1, p. 12.) Only 693 returns, less than six-tenths of 1 percent of taxable estates, reached a marginal estate tax bracket of 49 percent (ibid., Table 11, p. 28). The number of those who leave taxable estates is itself a fraction of all decedents; in 1972 there were 1.9 million decedents and taxable estates constituted about 6 percent. *Statistical Abstract of the United States—1980* (Washington, DC: U.S. Department of Commerce, 1980), p. 74, Table 110.

Testators appear to respond. Gross estates over $10 million accounted for 5.7 percent of the dollar value of estates subject to tax in 1972 but 41.1 percent of the charitable contributions claimed. (*Statistics of Income—1972: Estate Tax Returns*, Table 1.)

27. Feldstein, pp. 86–87.

28. Martin Feldstein, "The Income Tax and Charitable Contributions, Part II—The Impact on Religious, Educational, and Other Organizations," *National Tax Journal* 28 (June 1975): 209–226.

29. For a more complete discussion of economic and other rationales for government support of the arts, see Netzer, *The Subsidized Muse*, chap. 2; Mark Blaug, ed., *The Economics of the Arts* (Boulder, CO: Westview Press, 1976), pp. 25–83; David Cwi, "Merit Good and Market Failure Arguments for Subsidy of the Arts," *Journal of Behavioral Economics* 8, no. 2 (Summer 1979); and William S. Hendon et al., eds., *Economic Policy for the Arts* (Cambridge, MA: Abt Books, 1980), pp. 21–46.

30. Edward Arian, *Bach, Beethoven, and Bureaucracy: The Case of the Philadelphia Orchestra* (University, AL: University of Albama Press, 1971), pp. 51–73.

31. Ibid.

32. Monroe E. Price, "State Arts Councils: Some Items for a New Agenda," *Hastings Law Journal* 1183–1205 at pp. 1199 and 1202 (May 1976).

33. Meyer, *The Art Museum*, pp. 221–222.

34. Michael O'Hare, conversation with Anthony Bliss, Director of the Metropolitan Opera, June 1977.

35. Rudolf Bing, *5000 Nights at the Opera* (New York: Popular Library, 1972), pp. 323–325.

36. Nathaniel Burt, *Palaces for the People: A Social History of the American Art Museum* (Boston: Little, Brown, 1977), pp. 313–321.

37. D.C. Rich, "Management, Power, and Integrity," in Sherman Lee, ed. *On Understanding American Art Museums* (New York: Prentice-Hall, 1975), pp. 153–154.

38. Michael O'Hare, conversation with Ashton Hawkins, secretary and counsel of the Metropolitan Museum of Art, October 12, 1976.

39. Rosenbaum, "The Scramble for Museum Sponsors," pp. 10–14.

40. Ibid.

41. Allen Hughes, "Joffrey Ballet Cuts Two Year Tie with Rebekah Harkness Fund," *The New York Times*, March 18, 1964, p. 48.

42. Meyer, *The Art Museum*, pp. 74–75.

43. See, for example, "Museum Ethics: A Report to the American Association of Museums by its Committee on Ethics" (Washington, DC: American Association of Museums, 1978) as reprinted in Meyer, *The Art Museum*, pp. 286–306.

44. See Aaron Speiller, "The Favored Tax Treatment of Purchasers of Art," 80 *Columbia Law Review* 214–266 (1980).

45. Leon A. Harris, Jr., "The Taxman Cometh," *Texas Monthly* (November 1975): 50–52.

46. Meyer, *The Art Museum*, pp. 256–260.

47. Harris, "The Taxman Cometh," pp. 50–52.

48. Deborah Rankin, "Taxes: Deducting Art Donations," *The New York Times*, July 31, 1979, p. D2.

49. Simon, "The $100,000 Tax Deduction," pp. 14–17.

50. Ibid.

51. L. Rosenbaum, "Met's Sackler Enclave: Public Boon or Private Preserve," *ARTnews* 77, no. 7 (September 1978); "The Care and Feeding of Donors," *ARTnews* 77, no. 9 (November 1978).

CHAPTER 7

1. In this discussion we omit consideration of "private bill" tax legislation designed to benefit one or a small number of taxpayers in special circumstances. See Stanley Surrey, "The Congress and the Tax Lobbyist—How Special Tax Provisions Are Enacted," 70 *Harvard Law Review* 1145, 1176 (1957). In a recent example, Twentieth Century Fox sought an expansion of the 5-percent taxable income ceiling on corporate contributions and extension of the carry-forward period, for a proposed gift of 60 million feet of old newsreel to the University of South Carolina. *Wall Street Journal*, June 4, 1980, p. 1, "Tax Report." The 1981 act included an expansion, from 5 to 10 percent. Since then, Apple Computers has sought a further expansion, to 30 percent, to help finance a program of gifts of computers to schools. The Treasury has opposed the change.

2. This discussion ignores the income effect resulting from changes in the level of taxation—a person who pays lower taxes has a lower tax incentive to make charitable contributions, but he also has more money in his pocket with which he might make a charitable contribution. Paul McDaniel provides a useful summary of studies that have attempted to estimate the income elasticity of charitable giving in his "Study of Federal Matching Grants for Charitable Contributions," in Commission on Private Philanthropy and Public Needs, *Research Papers*, vol. 4 (Washington, DC: U.S. Department of the Treasury, 1977), pp. 2443–2444.

3. James N. Morgan, Richard F. Dye, and Judith H. Hybels, "Results from Two National Surveys of Philanthropic Activity," Commission on Private Philanthropy and Public Needs, *Research Papers*, vol. 1, pp. 175–324.

4. Code sections 4940–4947.

5. U.S. Congress, House Committee on Ways and Means, *Hearings on General Tax Reform*, 93d Cong., 1st sess., 1973, Pt. 15, p. 6053.

6. Code section 4940. The rate of tax was cut to 2 percent by the Revenue Act of 1978.

7. Code section 4945.

8. Karl E. Meyer, *The Art Museum: Power, Money, Ethics* (New York: William Morrow and Company, 1979), pp. 256–260.

9. See Code Sections 170(f), 2055(e)(2), 664 and 642(c)(5).

10. See Code Section 1011(b).

11. See Reg. Section 1.170A–7(a)(1).

12. For a pre-1969 example of this practice, see *Furstenberg* v. *United States*, 595 F.2d 603 (Ct. Cl. 1979).

13. See Reg. Section 1.170A–5(a)(2).

14. California Revenue and Taxation Code, Section 217 (West's Annot. Calif. Code)

15. Monroe E. Price, "State Arts Council: Some Items for a New Agenda," 27 *Hastings Law Journal* 1183–1205 (May 1976).

16. Revenue Act of 1978, section 515; Windfall Profits Tax Act of 1980, P.L. 96–223, section 401.

17. The House Report estimated that the changes would result in 114,000 fewer taxable estates. H.R. no. 94–1380, 94th Cong., 2d sess., p. 7, reprinted in U.S. Code, Cong. & Adm. News (1976): 3356, 3361. In 1975, 216,000 estate tax returns were filed, some of which reported no tax owing. Commissioner of Internal Revenue, *Annual Report* (March 1977), p. 12.

18. Code sections 6166 and 6601(j). The low interest rate applies to $345,800 of tax less the unified credit, which is the estate tax on $1 million (net after marital and charitable deductions).

19. "Tax Shelters and Artists: Subsidy or Rip-off," *Art Letter*, (January 1978): 104, and "Come to My Place and See My Tax Shelters," *Arts Reporting Service* (February 27, 1978): 4.

20. Revenue Act of 1978, section 201. See Rev. Rul. 77–397, 1977–2 Cum. Bull. 178 (master recording); Rev. Rul. 79–432, 1979–2 Cum. Bull. 289 (lithographs).

21. H.R. 94–658, 94th Cong., 1st sess., p. 22 (1975), reprinted in U.S. Code Cong. & Adm. News (1976): 2897, 2917.

22. Cited by Thomas A. Troyer, "Current Developments and Prospects in Washington," remarks delivered at American Law Institute/American Bar Association conference, "Legal Aspects of Museum Operations," March 23, 1977.

23. Code sections 501(h) and 4911.

24. See also n. 1, *supra*.

25. Charles T. Clotfelter and Lester M. Salamon, *The Federal Government and the Nonprofit Sector: The Impact of the 1981 Tax Act on Individual Charitable Giving* (Washington, DC: The Urban Institute, 1981).

256 **NOTES**

26. For a more complete discussion of the problems associated with property tax exemptions, see Alfred Balk, *The Free List: Property without Taxes* (New York: Russell Sage Foundation, 1971). There are also a number of interesting articles on the topic, including John Quigley and Roger Schmenner, "Property Tax Exemption and Public Policy," *Public Policy* 23 (Summer 1975): 259–297; "Alternatives to the University Property Tax Exemption," 83 *Yale Law Journal* 181–196 (1973); and L. Richard Gabler and John F. Shannon, "The Exemption of Religious, Educational and Charitable Institutions from Property Taxation," in Commission on Private Philanthropy and Public Needs, *Research Papers*, vol. 4, pp. 2535–2572.

27. Balk, *The Free List*, chaps. 4 and 5; Boris I. Bittker, "Churches, Taxes and the Constitution," 80 *Yale Law Journal* 1285–1310 (July 1969).

28. Rountrey and Associates, "Real Property Tax Exemptions and Relief: A Study of Policies, Practices and Impact on the Commonwealth of Virginia," in Governor's Property Tax Reform Study, *Reforming the Virginia Property Tax*, vol. II (Commonwealth of Virginia, 1974), pp. 127–322.

29. New York Real Property Tax Law, section 421(b). In 1981 the provision became section 420-b. See *Assoc. of the Bar* v. *Lewisohn*, 34 N.Y. 2d 143 (1974).

30. Citizen's Budget Commission, *Real Estate Tax Exemptions: Time for a Change* (New York: Citizen's Budget Commission, April 1977), pp. 21–22.

31. New York and New Jersey, for example, have held that arts institutions are "educational" and statutorily exempted. See *Tappan Washington Memorial Corp.* v. *Margetti*, 9 N.J. Super. 212, 75 A.2d 823 (Super. Ct. App. Div. 1950); *Application of the Little Theater of Watertown, Inc.*, 70 Misc. 2d 907, 165 N.Y.S. 2d (Sup. Ct. 1965), *aff'd*, 4 App. Div. 2d 853, 167 N.Y.S. 2d 240 (1957). A recent Appellate Division case involving the Asia Society questions the applicability of the general education exemption to museums. In contrast, California, Kentucky, and Vermont courts have exempted such institutions as "charitable." See *Stockton Civic Theater* v. *Board of Supervisors*, 66 Cal. 2d 13, 423 P.2d 810, 56 Cal. Rptr., 658 (1967); *Department of Revenue* ex rel *Luckett* v. *Issac W. Bernheim Foundation, Inc.*, 505 S.W. 2d 762 (Ky. 1974); *Shelbourne Museum, Inc.* v. *Town of Shelbourne*, 129 Vt. 341, 278 A.2d 719 (1971). Finally, a Massachusetts court held that the institution must be in the nature of a "public charity." See *American Inst. of Econ. Research* v. *Assessors*, 324 Mass. 509, 87 N.E.2d 186 (1949).

32. This observation is based on correspondence with various state departments of taxation, which revealed a surprising variation in exemption policies for arts institutions.

33. Balk, *The Free List*, pp. 136–138; Gabler and Shannon, "The Exemption of Religious, Educational, and Charitable Institutions from Property Taxation," pp. 2558–2560.

34. Gabler and Shannon, "The Exemption of Religious, Educational, and Charitable Institutions from Property Taxation," p. 2559.

35. Correspondence with D.L. Berg, Operations Manager, The Guthrie Theater, August 13, 1976.

36. New York Real Property Tax Law, section 498. For a further discussion of the law, see Citizen's Budget Commission, *Real Estate Tax Exemptions*, pp. 20–21.

37. Memorandum of State Executive Department, McKinney's Sess. Laws, A–111 (1980), no. 2.

38. In 1980, the legislature postponed the effective date to April 19, 1981. 1980 N.Y. Session Laws, chap. 42.

39. McKinney's N.Y. Sess. Laws, 1981, cl. 105, §1.

40. Since 1967, the Twentieth Century Fund has been making voluntary payments to New York City for free municipal services. For arguments supporting this policy for nonprofit institutions, see for example, Director's Report, *Annual Report 1968* (New York: Twentieth Century Fund, 1968).

41. Alfred Frankenstein, "Lords, Ladies and Common Folk at Yale," *ARTnews* 76 (Summer 1977): 42.

42. J. Mark Davidson Schuster, Conversation with Boston Symphony Orchestra management, June 1978.

43. Balk, *The Free List*, pp. 119–120 and 174–175.

44. J. Mark Davidson Schuster, Conversation with Kimball Valentine, assistant to treasurer, Massachusetts Institute of Technology.

45. For several descriptions of Mayor Koch's attempts to obtain voluntary tax payments from property tax exempt institutions in New York City, see Lesley Oelnser, "Tax Exempt Institutions Asked for Voluntary Payments to City," *New York Times*, July 21, 1978, p. 1; "Topics" column on editorial page, *New York Times*, July 26, 1978, p. 20; Lee Dembart, "Koch Gets 8 Letters but No Money in his Appeal to the Tax Exempted," *New York Times*, August 4, 1978, p. 4; Richard Higgins, "Exempt Groups Politely Decline Invitation to Pay Taxes," *New York Times*, July 24, 1979, section 8, p. 7.

46. For examples of these types of programs see Balk, *The Free List*, or Gabler and Shannon, "The Exemption of Religious, Educational, and Charitable Institutions from Property Taxation."

47. Conn. Gen. Stat., section 12–20a (1980 Supp.).

48. Balk lists more than twenty examples of such federal programs. Balk, *The Free List*, pp. 178–189.

49. All of the public opinion surveys mentioned here are summarized in Gabler and Shannon, "The Exemption of Religious, Educational and Charitable Institutions from Property Taxation," pp. 2547–2551.

50. *Serrano v. Priest*, 5 Cal. 3d 584 (1971), reaffirmed in 18 Cal. 3d 728 (1976); *Robinson v. Cahill*, 62 N.J. 473, 303 A.2d 273 (1973). The U.S. Supreme Court declined to apply federal equal protection standards in *San Antonio Indep. School Dist. v. Rodriquez*, 411 U.S. 1 (1973).

51. California Constitution, Article 13A, Section 1 (Jarvis-Gann Initiative).

52. MGLA C. 59, Section 21C.

CHAPTER 8

1. For a detailed discussion of the various types of matching grants refer to "Alternatives to Tax Incentives," in Commission on Private Philanthropy and Public Needs, *Research Papers*, vol. 4 (Washington, DC: U.S. Department of the Treasury, 1977).

2. Henry Hansmann, "Nonprofit enterprise in the performing arts," *Bell Journal of Economics* 12, no. 2 (1981) 341–361.

3. Martin Feldstein, "The Income Tax and Charitable Contributions: Part II—The Impact on Religious, Educational, and Other Organizations," *National Tax Journal* 28 (1975): 209–226.

4. For a more detailed discussion of Deeds of Covenant see J.D. Livingston Booth, "Deeds of Covenant—Their Preparation and Administration," brochure (Tonbridge, Kent, England: Charities Aid Foundation, 1974), or Redmond Mullin, *The Fund-Raising Handbook* (Tonbridge, Kent, England: Charities Aid Foundation, 1974).

5. Paul R. McDaniel, "Study of Federal Matching Grants for Charitable Contributions," in The Commission on Private Philanthropy and Public Needs, *Research Papers*, vol. 4 (Washington, DC: U.S. Department of the Treasury, 1977), pp. 2417–2532.

6. Not every credit proposal rationalizes the system of government subsidy. The Presidential Task Force on the Arts and Humanities proposed a 25 percent credit for the *second* $1,000 of individual gifts to charity, on top of the existing deduction. If this proposal were implemented, it would further skew the subsidy system in favor of wealthy donors, and complicate the tax structure. See Presidential Task Force on the Arts and the Humanities, *Report to the President* (Washington, DC: U.S. Government Printing Office, October 1981), p. 21.

7. See Alan L. Feld, "Artists, Art Collectors and Income Tax," 60 *Boston University Law Review* 625, 657–660 (1980).

8. Russell K. Osgood, "Carryover Basis Repeal and Reform of the Transfer Tax System," 66 *Cornell Law Review* 297, 313 (1981).

9. Code section 170(e)(1)(B)(ii), (b)(1)(B)(i) and (d)(1). The one-half of unrealized appreciation later was increased to 60 percent.

10. U.S. 94th Congress, 2d sess., October 19, 1976. Public Law 94–553: Copyright Law Revision.

11. J. Michael Montias, "Are Museums Betraying the Public's Trust?" *Museum News* 51, no. 9 (May 1973): 25–31, reprinted in Mark Blaug, ed., *The Economics of the Arts* (Boulder, CO: Westview Press, 1976).

INDEX